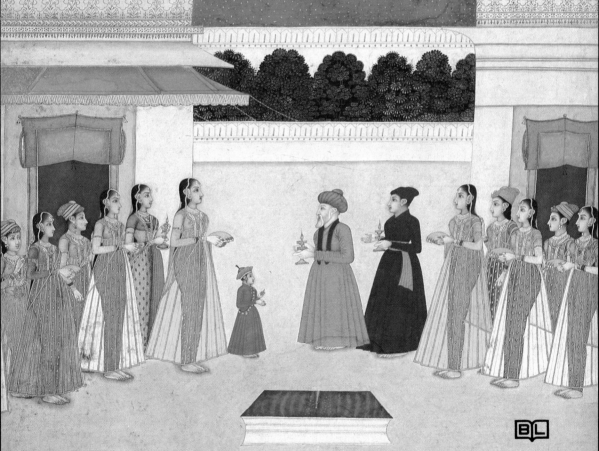

Indian Book Painting

J P LOSTY

The British Library

© 1986 The British Library Board

Published by
The British Library
Great Russell Street
London WC1B 3DG

and 27 South Main Street, Wolfeboro,
New Hampshire 03894-2069

BL British Library Cataloguing in
Publication Data
Losty, Jeremiah P.
 Indian book painting.
 1. Miniature painting, India—History
 I. Title II. British Library
 751.7′7′0954 ND1337.15

 ISBN 0-7123-0116-X

Library of Congress Cataloging in
Publication Data

British Library.
 Indian book painting.
 Bibliography: p.
 1. Illumination of books and
 manuscripts, Indic—Catalogs. 2.
 Illumination of books and
 manuscripts—England—London—
 Catalogs. 3. British Library—
 Catalogs. I. Losty, Jeremiah P. II.
 Title.
 ND 3247.B68 1986
 745.6′7′095407402132 86–19327
 ISBN 0-7123-0116-X (pbk.)

Designed by Roger Davies
Typeset in Monophoto Erhardt by
August Filmsetting, Haydock, St Helens
Origination by York House Graphics,
Hanwell
Printed in England by
Jolly and Barber Ltd, Rugby

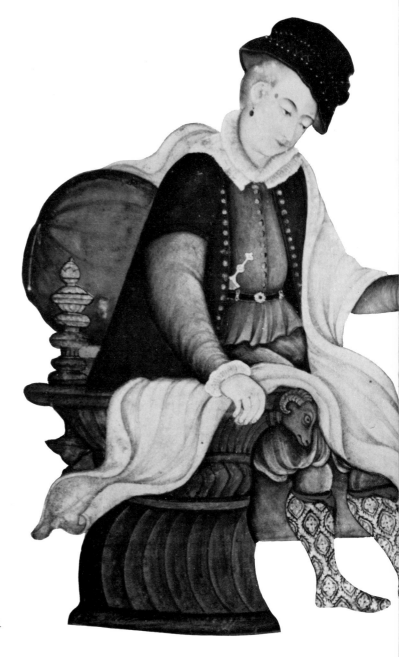

Front cover: A girl at a window. Mughal,
c. 1660. By Raghunandan. (See page 42.)

Back cover: Dabshalin visits the sage
Bidpay. Mughal, *c.* 1604, from Allahabad.
By Abu'l Hasan. (See page 42.)

Title-page: A ceremony by night on a
terrace. Mughal, *c.* 1730. By Govardhan.
(See page 70.)

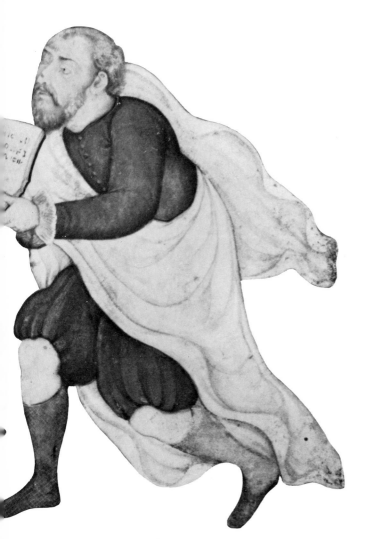

Contents

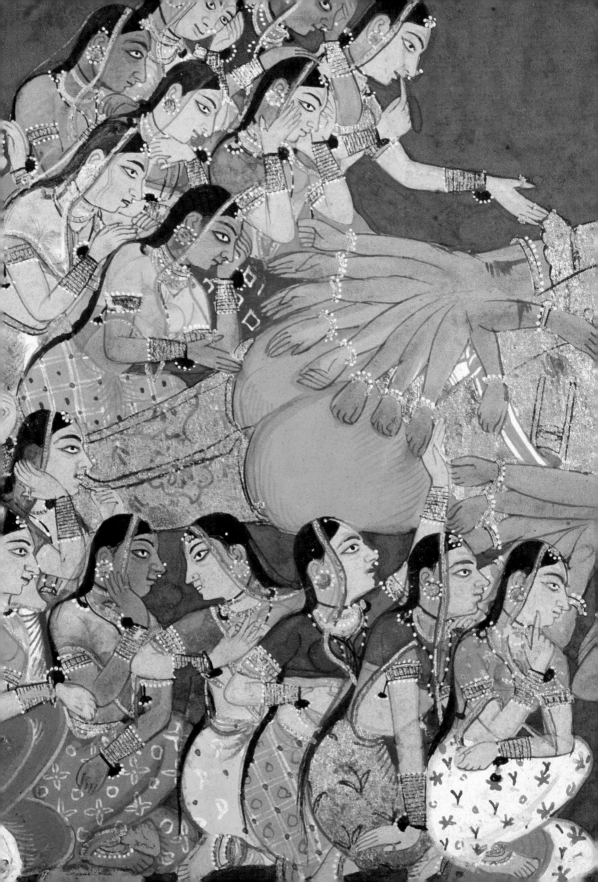

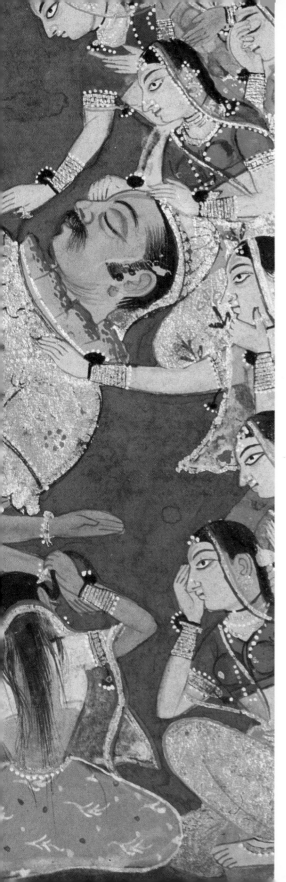

Introduction

Indian painting over the last 1,000 years has largely been an art of miniature painting, whether in manuscripts to illustrate texts or mounted in albums; a private art, for the delight of the individual patron. Using only mineral or earth pigments, finely ground and mixed with a little gum and water, paintings were built up in layer upon layer of pigment, and then burnished, imparting a brilliance to the finished product.

The British Library collection of Indian paintings is one of the finest in the world. It is built up from two sources; from the British Museum's great collection of illustrated Indian manuscripts, which passed to the British Library in 1973 (now in the Department of Oriental Manuscripts and Printed Books, OMPB); and from the great series of albums in the India Office Library and Records (IOLR), which were formed by Richard Johnson in Lucknow in the 1780s, and were purchased for the library of the East India Company in 1803. These joined the collections when the IOLR became part of the British Library in 1982. Presented here is but a small selection.

The Early Period

1 Trisala's sorrow and joy.

Gujarat, 1445.
[OMPB. or. 13700, f.23b.
(111 × 83 mm.)]

Jainism, like Buddhism, began as a warrior-class revolt against the stifling orthodoxy of the ritual cults presided over by the Brahmins in the first millennium BC. In the Jaina hagiographies of the founders of their system, there is a curious survival of this antagonism: all of the Jinas are said to have been conceived in the wombs of Brahmin women, but transferred under divine intervention to those of women of the warrior class.

Here Mahavira, last of the founders, keeps perfectly still in his mother's womb to avoid hurting her; she grieves, thinking him dead, then rejoices when he stirs.

Although Jaina painting in Western India of the 12th century was much like its Buddhist counterpart in the east, by the 15th century it had stiffened into pattern-making; planes of bright colours are used, with almost hieratic distortions in bodily and facial features, including the 'further eye' projecting beyond the facial outline into space.

Little is known about book painting in the classical period of Indian civilization. From the surviving evidence, it seems possible that the art was not practised before about the year 1000 AD, for the palm-leaf format of the typical Indian manuscript of the time hardly lends itself to illustration. From the 11th century we find illustrated manuscripts of Buddhist and Jaina sacred texts such as the Perfection of Wisdom (2 and 3), in the former of which the miniatures of the Buddha and Buddhist divinities serve to protect the manuscript and impart spiritual benefit to donor and artists.

The Muslim conquest of northern India in the 13th century totally changed the pattern of patronage of painting. Bringing with them into India the Semitic prohibition on figural representation, the Muslims' control of artistic patronage resulted only in the decoration of mosques and manuscripts of the Koran. We know little of Hindu patronage of painting in northern India during the early centuries of Muslim rule. In the Middle East and Iran, however, princes and noblemen established court studios for the production of paintings illustrating the classics of Persian literature; and from the 15th century we find this sort of work taking root in India, although we have as yet no evidence to determine who the patrons were.

Manuscript illustration among the Jainas of western India had continued at a very low quality for several centuries after 1200, but in the 15th century too this school begins to flex its muscles and expand. Interaction between – and then fusions of – native Indian and Persian painting towards the end of the 15th century resulted in various styles of what is termed Sultanate painting, but only two court studios, in Mandu and Bengal, have so far been definitely pinpointed.

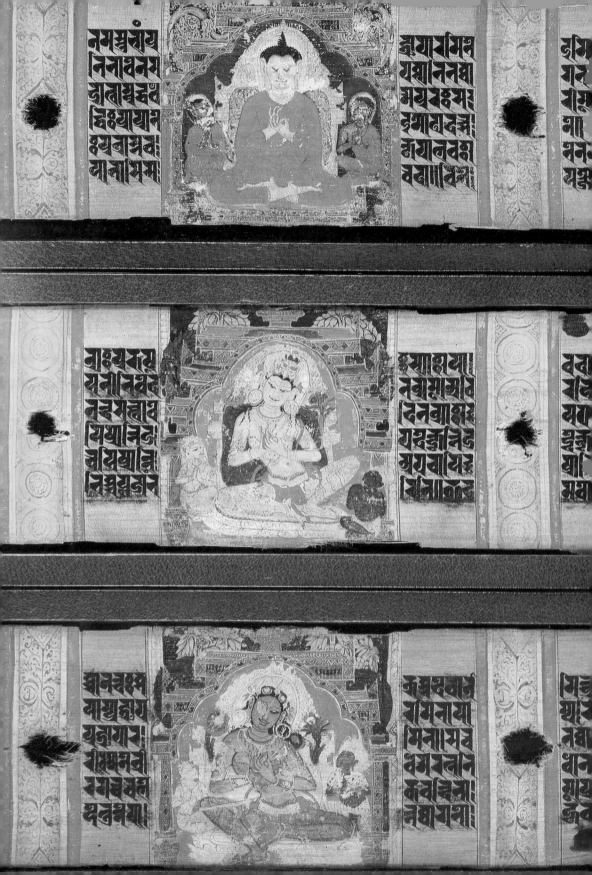

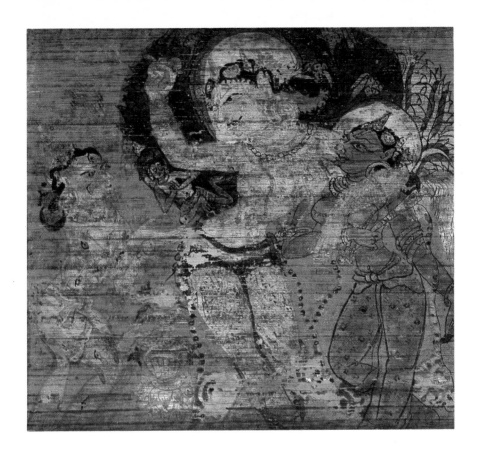

2 The Buddha, Manjusri and Tara.

Vikramasila monastery, Bihar, about 1145.

[OMPB Or.6902, ff.1b, 336b, 337a. (Each miniature about 69 × 69 mm).]

The Buddha sits enthroned, in the teaching position, which embodies his First Sermon in the deer-park at Sarnath, while Manjusri, the compassionate Bodhisattva (future Buddha), is depicted as an heroic, youthful king, wearing only a waist-cloth and lavish jewels and a crown. His hands are in the teaching gesture, and to his left, on the blue lotus, is the book which embodies his wisdom. Below is Tara, the Saviouress, also in the teaching position. All three

are depicted as images seated within a shrine, the details of whose architecture are picked out in red and blue, giving the effect of a brilliant jewelled reliquary.

These miniatures are notable for their superbly balanced composition and colour. The divinities' enigmatic yet compassionate faces and gently swaying bodies contribute to their almost hypnotic beauty.

3 The birth of Gautama, the Buddha.

Eastern India, 1130–50.

[OMPB Or.12461, f.149a, detail (58 × 63 mm).]

Queen Maya's child, the future Buddha or Enlightened One, was

born, miraculously, from her side as she was passing through a grove of *asoka* trees, springing into the arms of the waiting gods. Taking seven steps to the north, he announced that this was his last birth.

With her right hand holding a branch of the tree which bent down to her, her left arm round her sister Mahaprajapati and her legs elegantly crossed, this graceful image as interpreted by painters in the 12th century faithfully follows the traditional iconography established in stone a millennium before, save only for the extreme distortion (*tribhanga* or triple flexion) of her body.

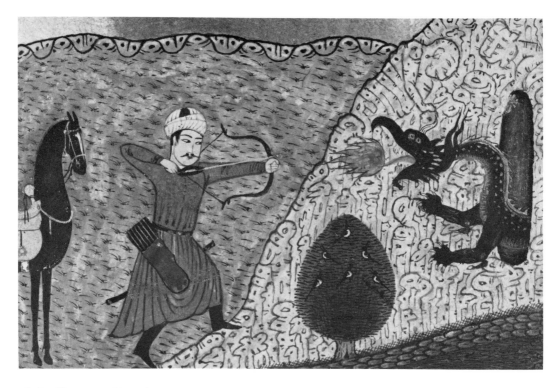

4 Isfandiyar attacking the dragon.

Sultanate, 1438.

[OMPB Or.1403, f.377b (80 × 120 mm).]

'Sultanate' is the term used to describe paintings illustrating manuscripts of Persian literature, commissioned by Muslims in India after the conquest. In the middle of the 15th century, such painting was closely linked to work produced in the southern Iranian school of Shiraz, but we do not yet know who was commissioning such work in India, or precisely where.

In this miniature from the great epic of Persia, the hero Isfandiyar is setting about a startled dragon. Although the elongated neck of the horse is typical of Shiraz work 1420–40, other details (such as the leaves at the water's edge, laid so regularly) suggest a non-Persian provenance.

5 Koran leaf.

Delhi(?), about 1350–70.

[OMPB Or.14147a. (285 × 180 mm).]

After Muslim peoples had conquered northern India at the beginning of the 13th century, being in a totally alien land they depended at first on imports to sustain the literary and artistic life to which they were used; it was not until the end of the 14th century that Indian manuscript and Koranic illumination is demonstrably different from Persian, with distinctive scripts and illuminative motifs. This 'dispersed' Koran perhaps represents a slightly earlier stage. The splendid Muhaqqaq script of the text is indistinguishable from contemporary Iranian work, but the commentary in the margins, in red Kufic against gold scroll-work and with startling corner medallions, is something new and suggests kinship with the massively dignified Tughluq remains of 14th century Delhi. An eastern Islamic provenance is demonstrated by the Persian translation, written between the lines.

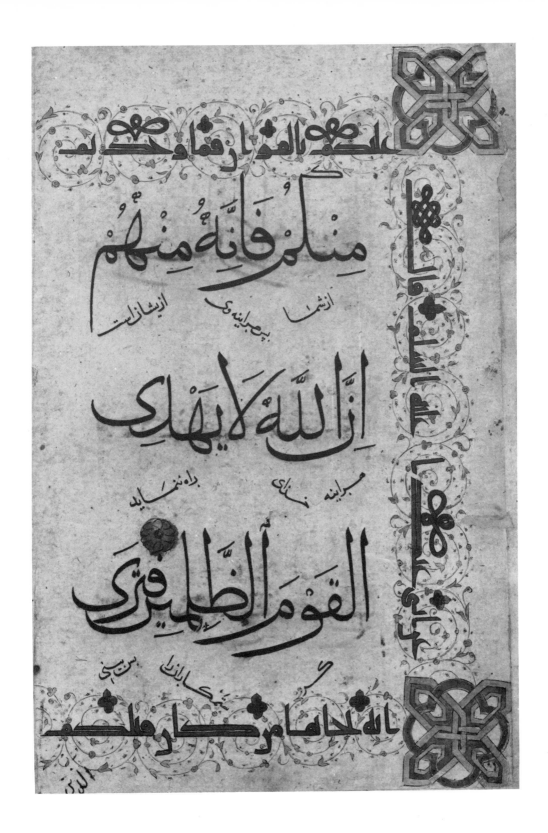

6 Alexander receives Roshanak, the daughter of Darius.

Bengal, 1531.

[OMPB Or.13836, f.32a (165 × 139 mm).]

The legend of Alexander the Great was no less potent a story in eastern medieval literature than in western, not least in Persia, the overthrow of whose greatest dynasty had been accomplished by him. Alexander was in fact incorporated into the Persian epic as a wrongly disinherited scion of the Achaemenids. After the defeat of Darius, Alexander marries his daughter, Roshanak, here depicted being brought to him by her attendants.

In Bengal, the influence of 15th-century Shiraz painting had long been established, sufficiently so by 1531 to have been transformed into this purely Indian version of it, which, in addition to the normal Sultanate features, includes Bengali architectural characteristics and a penchant for bright primary colours.

7 Joseph is ill-treated by his brothers.

Deccan(?), about 1540–60. By al-'Abd Sayyid Shams ad-Din.

[OMPB Or.4535, f.57b (172 × 118 mm).]

The Biblical story of Joseph – his being ill-treated by his brothers and sold into slavery in Egypt, where Potiphar's wife desired him – is well-known also in Islamic sources, where Potiphar's wife is given the name Zulaykha.

Early Deccani painting is shrouded in obscurity; yet it must have existed, in order to burst into exuberant life at the end of the 16th century. The extravagance of the rock and cloud formations in this picture and the brilliant use of colour suggest a Deccani provenance, perhaps Bijapur, shortly before the intrusion of Hindu elements into the style which followed the defeat of the Hindu kingdom of Vijayanagar in 1565.

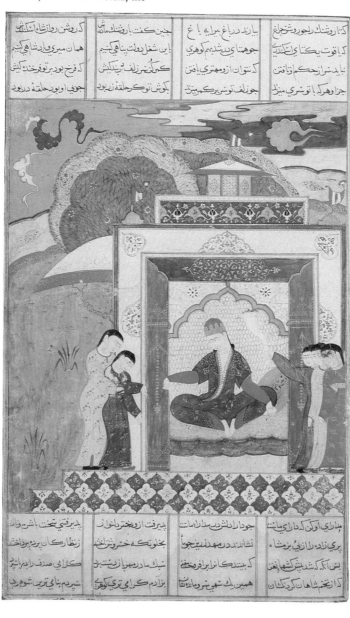

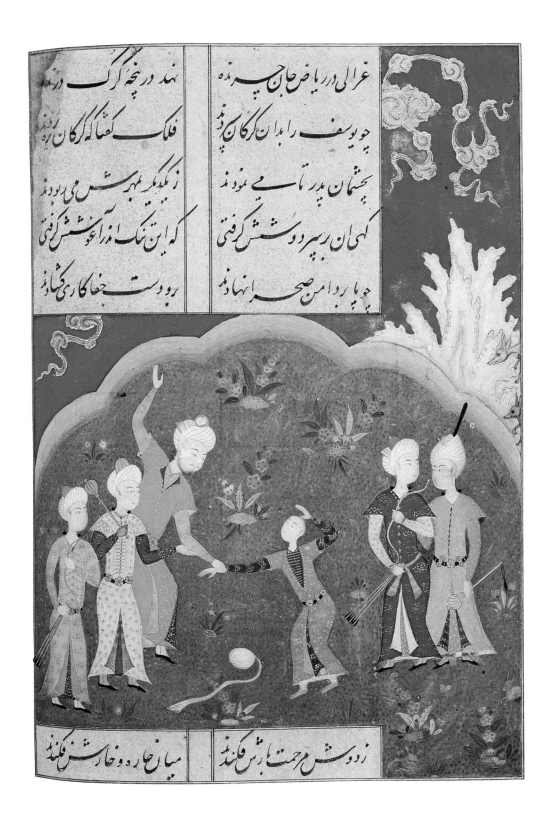

غزال اندر بار اضحاب چرنده
نهد در پنجهٔ گرگ

چو یوسف را ابان کرگان در
فلک کشاله کرگان کرده

چشمان پدر تا می نمودند
ز ملک دگر مهرش می بردند

کهان سر پرده و ششش گرفتی
که این تنگ اندر آغوش گرفتی

چو یاربود امین صحرا نهادند
برو دست جفاکاری کشادند

زدوسش مرحمت بارش فکند
میان خاره و خارش فکند

8 Krishna and the cowgirls, and the incarnations of the god Vishnu.

North Bihar, 1491

[OMPB Or.13133, wooden covers (each 52 × 366 mm).]

On the top cover, Krishna, the divine lover of the cow-girls of Brindaban, is playing his flute to entice them into his net – a Hindu metaphor for the call of the Divine. On the bottom cover are the ten incarnations of Vishnu, the earliest known painted version. There is little surviving evidence for pre-Mughal Hindu painting, and the available documents are hotly disputed by scholars. This rare example painted on the covers of a palm-leaf manuscript shows a fresh spirit stirring in medieval India, distancing itself from the angular distortions of Jaina painting and attempting not just to make iconic statements for worship but to communicate a poetic mood.

9 Bahram Chubin slaying the standard-bearer.

Sultanate, 1438–9.

[OMPB Or.11676, f.80b. (119 × 111 mm).]

Bahram Chubin was a usurper of the Sassanian throne, who was ousted by the
true heir Khursraw Parviz (Chosroes II), with the help of the Byzantine
Emperor Maurice. Here he is depicted in the final battle with Khusraw in AD
590, slaying his opponent's standard-bearer. This is a much more sophisticated
version of the Shirazi style (see **4**). Especially good is the portrayal of the
standard-bearer's startled horse.

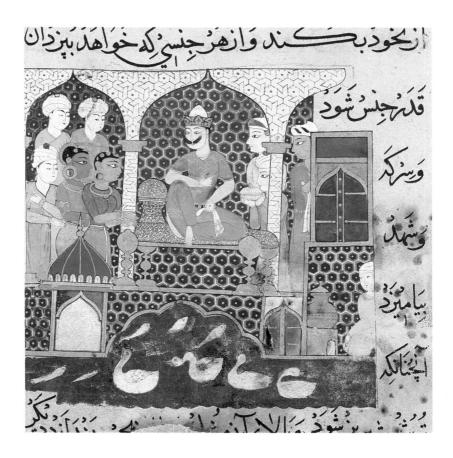

10 The Sultan of Mandu in his private apartments.

Mandu, about 1500.

[IOLR Pers.MS.149, f.144a. (115 × 127 mm).]

Sultan Ghiyath ad-Din Khalji, Sultan of Mandu 1469–1500, was a sybarite, who cut himself off from the cares of state to amuse himself with food and drink and, above all, his innumerable women. Here an attendant is shown waiting to present a dish, but the Sultan seems unable to tear his eyes away from the two Indian women.

By this time in north Indian medieval painting, the two sources, Persian and Hindu/Jaina, have combined to produce a fairly unified style. Different conventions are still used in portraiture, however: three-quarter profile is reserved for Persians and other non-Indian Muslims, who wear foreign turbans, while Indians are shown in full profile with distinctly Indian turbans, and Indian women always in their colourful costumes and elaborate gold jewellery.

11 Joseph is taken away to prison.

Deccan(?), about 1540–60. By al-'Abd Sayyid Shams ad-Din.

[OMPB Or.4535, f.109b. (176 × 140 mm).]

Joseph, shackled and riding an ass, is led away to prison after being denounced by Zulaykha. The artist has delightfully caught the consternation in Potiphar's household as well as Zulaykha's regrets.

Architectural details often reveal an Indian rather than a Persian provenance for manuscripts and paintings which are otherwise enigmatic, and here the artist, normally brilliantly assured, is none too clear about how to finish the top of his building or how to suggest the heavy, overhanging eave typical of Indian architecture. Fortunately the text panel has come to his rescue! Notice too the way the men on the left are standing on another text panel, an effect typically Sultanate, showing an Indian artist's native dislike of fixing his figures in space and preference for the horizontal viewpoint.

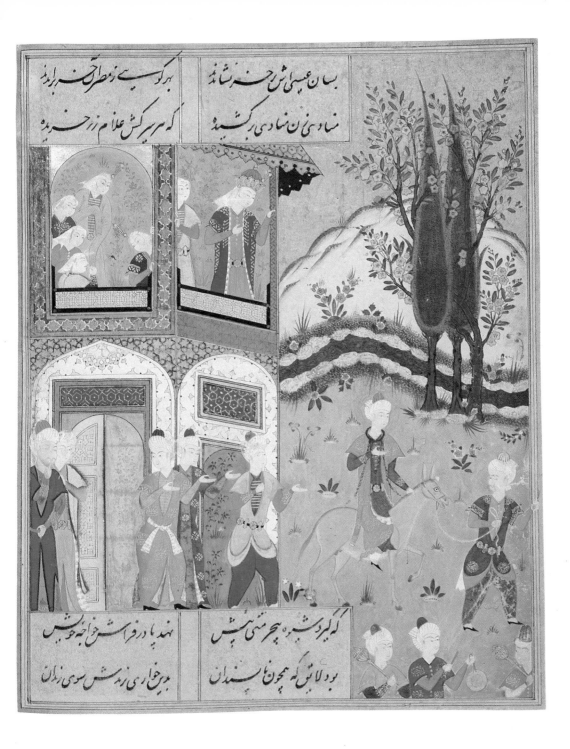

Mughal painting — the reign of Akbar

In 1526, Babur, a central Asian prince of mixed Turkish and Mongol (Mughal) descent, won by force of arms the throne of Delhi, and he and his son Humayun brought a renewal of Persian cultural influence in India. The latter's son Akbar (reigned 1556–1605), an immensely talented and energetic man, firmly established his family's hold on the throne, and then proceeded to the conquest of the rest of northern and central India. Akbar set up an immense manuscript studio, employing calligraphers, painters, illuminators, binders and all the other craftsmen necessary for the production of illustrated manuscripts of the finest quality.

The earliest work produced shows that painters from several different Indian provincial styles were already present in the studio. Under the guidance of two Iranian masters, first Mir Sayyid 'Ali and then 'Abd as-Samad, who had both earlier entered Akbar's father's employ, the early Mughal style was formed, combining Persian skill at draughtsmanship and composition with Indian colouring and naturalism. To this was added a realism derived from European painting, gained from contact with the Portuguese in Goa – resulting, particularly, in the beginning of portraiture in India.

At first used in the illustrating of adventure stories and books of fables – perhaps reflecting the youthful Akbar's taste in literature – the mature style was used in the 1580s for illustrating great manuscripts of histories and of Persian translations from the Sanskrit. Only towards the end of the 1580s and during the 1590s did the studio produce the illustrated manuscripts of the Persian poetic classics which were the staple of the Iranian studios.

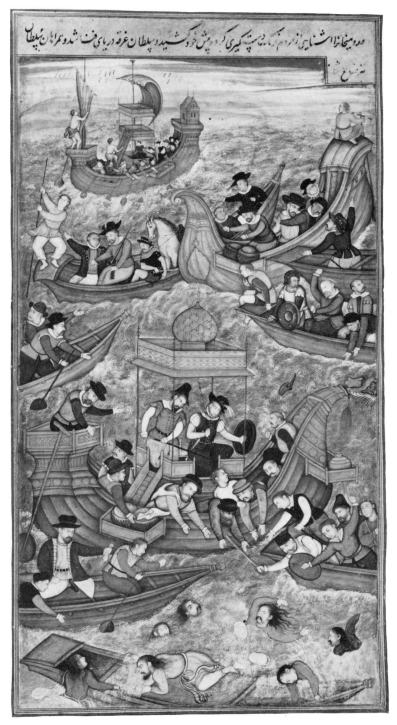

12 The death of Sultan Bahadur of Gujarat.

Mughal, about 1604. By La'l.

[OMPB. Or. 12988, f.66a
(239 × 127 mm).]

The Portuguese had arrived in India in 1499, and their ships dominated the Indian Ocean throughout the 16th century, controlling the lucrative sea-borne trade of the littoral states from such strongholds as Goa and Daman and Diu on the coast of Gujarat. In 1537, Sultan Bahadur (reigned 1526–37) took refuge from the victorious armies of the Mughal Humayan in the Portuguese fort at Diu. During the negotiations with the Governor on board ship, the Portuguese tried to capture him. Bahadur jumped into the sea with some followers, and according to the *Akbarnama*, from which the miniature comes, was drowned. Our artist here appears to be following a different Persian history which relates that the Sultan was killed by Portuguese soldiers while attempting to swim to safety, and even shows the Portuguese Governor of the Indies, Nuno da Cunha, directing the operation from the small boat in front.

La'l was an artist entrusted with a great deal of the design work of the major Mughal manuscripts from the 1580s. Less idiosyncratic than many of his colleagues, his work perhaps typifies the mature Akbari style at its finest.

13 Babur visits the Arvahi valley outside Gwalior in 1528.

Mughal, about 1591. By Dhanraj.

[OMPB. Or.3714, f.478a (311 × 166 mm).]

The great fortress of Gwalior, south of Delhi, with its lovely palace built by Raja Man Singh Tomar in the early 16th century, commanded much of central India, and its capture by Babur was essential to his progress in conquering Hindustan. Gwalior was also famous for its high rock-cut statues of the nude Jaina *tirthankaras* or founders of the Jaina faith, which so scandalised Babur that he ordered them destroyed (in fact they were only mutilated).

Though Mughal artists were not noted for topographical accuracy until the 19th century, Dhanraj has produced an instantly recognisable version of this famous fort, even including the (now vanished) stone elephant on the bastion outside the main gate which gave the latter the name of Hathipol, or Elephant Gate. Perhaps the greatest delight in this picture, however, is provided by the depiction at the bottom of the page of Indian village life carrying on, untroubled by the passing of kings or the conquest of fortresses.

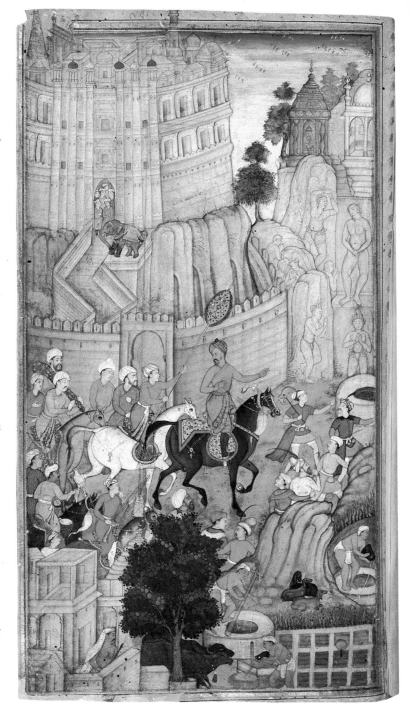

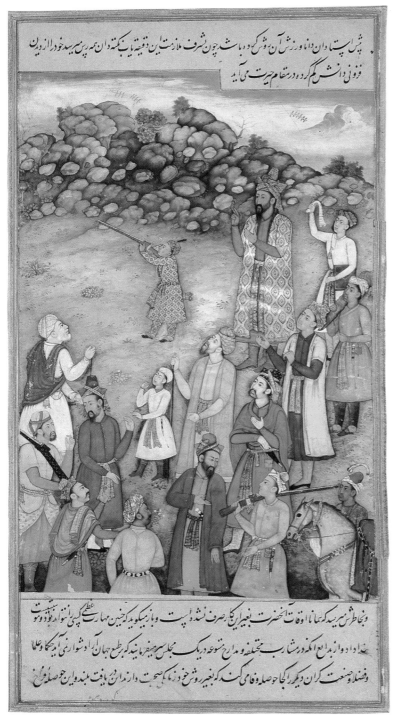

14 Bairam Khan watching the young Akbar shooting.
Mughal, about 1604. By Govardhan.
[OMPB. Or. 12988, f.158a (239 × 128 mm).]

The powerful Bairam Khan acted as tutor and mentor to the young Akbar, until the young monarch grew tired of his tutelage and asserted his independence in 1560.

This strange painting is the earliest known work of one of the greatest 17th century Mughal painters, Govardhan, who was at his finest perhaps when depicting ascetics and sages. In this early painting, the effect is somewhat undisciplined, as Govardhan has not coordinated the boy's aim with the spectators' gaze.

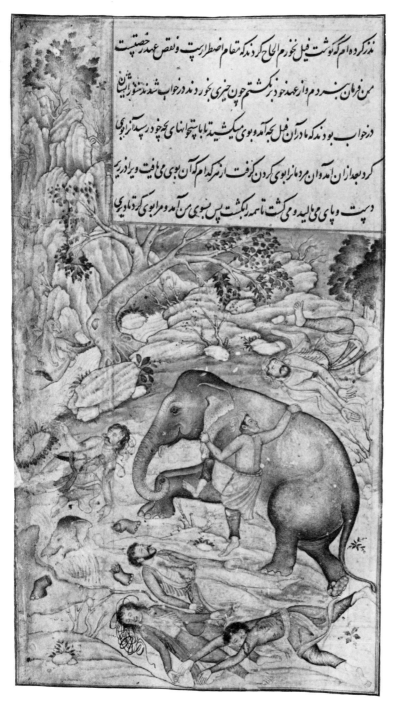

نذر کرده ام گوشت فیل نخورم الحاح کردند که مقام اضطرار ست و نقض عهد خجست است

من فرمان بندم و از عهد خود بر نگشتم چون خبری نخورد و نذر در خواب شد نذر دنور راایان

در خواب بودند که مادر آن فیل بجه آمد و بوی میکشید تا با پستحوانهای بچه چو ردر سدک آزادی

کردن بعداران آمدوان مردماز ابوی کردن گرفت از هر کدام که آن بوی می یافت و بر او زیر

دست و پای می مالیده و می کشت تا همه راکشت پس نبوی من آمد و مراابوی کردوداوی

15 The elephant spares the man who desisted from slaying her calf.

Mughal, 1605.

[OMPB. Or.1362, f.69a (210 × 118 mm.]

In this strange story from a book of hagiography of Muslim saints and mystics, a she-elephant savages the band of men who had dismembered her calf, save only for the one man of the group who had not, whom she takes to safety. A pair of jackals watch the scene from across the little river. The painting is executed in the *nim-qalam* or 'grisaille' style, like many others from the early years of the 17th century, in which imitations of European techniques became common. The purpose seems to have been to imitate the effect of the European print, but always in the Mughal versions the greys or browns are enlivened with pale washes of pink or blue, with some effects in full colour.

16 The monkey leads the bears into the desert.

Mughal, 1600, from Ahmedabad.

[OMPB. Or.6317, f.124b (190 × 113 mm).]

Into a pitiless landscape of burning sand, the horizon obscured by haze, the cunning monkey leads the bears who have invaded the territory of his tribe.

In this stark painting, the unknown artist has gone to the heart of the tale and stripped away all of the inessentials from the Mughal style to produce an almost terrifyingly realistic study of animals in distress. With their lolling tongues and gesticulating hands, they reel across the painting in a nightmare vision. This superb painting comes from a manuscript of a fable-book produced for the governor of the province of Gujarat in 1600.

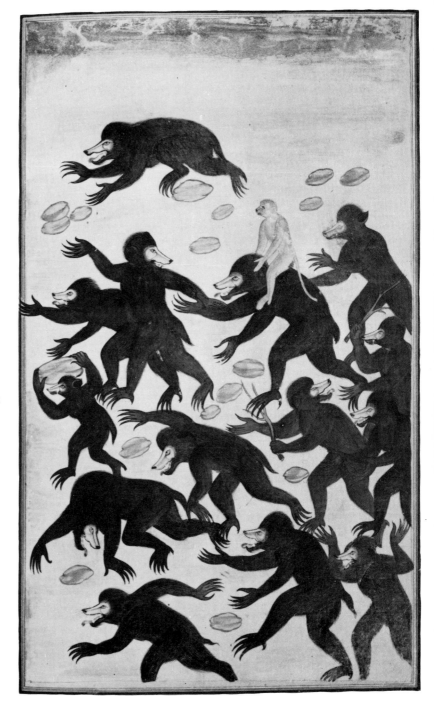

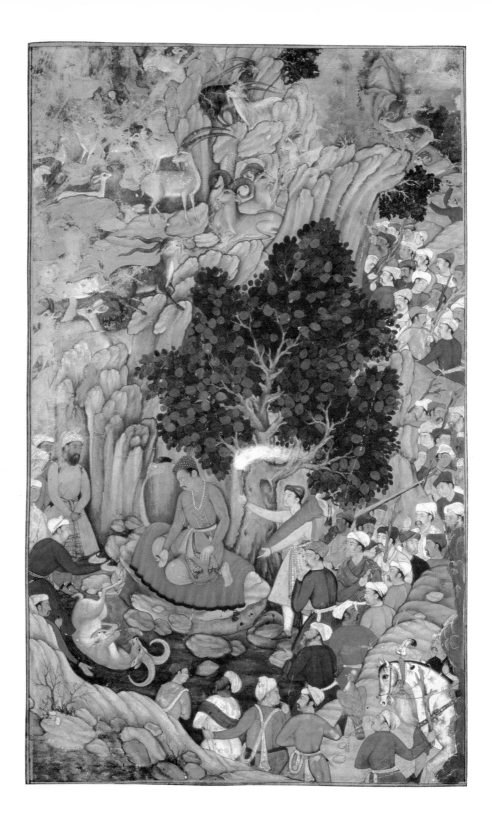

17 Akbar resting during a hunt.

Mughal, about 1590.

[IOLR. Johnson Album 8, no. 4 (306 × 185 mm).]

Hunting animals was not only a pastime for the Mughals but a necessity, for much of their time was spent in travelling. Here a *qamargha*, in which the beaters enclose the animals in a ring where they can be slaughtered, is illustrated. Akbar grew sick of this practice while out hunting one day in 1578; this painting showing him sitting under a fig tree pensively gazing at a slaughtered mountain-goat may actually illustrate the incident. The ring of beaters is in place and the goats are crowded on to crags awaiting their fate, while Akbar is beseeched to give the signal to commence the slaughter.

18 Washermen at work.

Mughal, about 1575–80.

[OMPB. Or.4615, f.4a (333 × 192 mm).]

The Indian *dhobi*, the washer-man who brings clothes down to the river and pounds them against the rocks, has always been a noteworthy feature of Indian life, and in this, the earliest known study of this ubiquitous phenomenon, the artist's fascination in his theme is obvious. The concentration on the work in hand, the sense that these men are individuals, not types, make this one of the most remarkable of early Mughal paintings, the charm of which is increased by the animals all around.

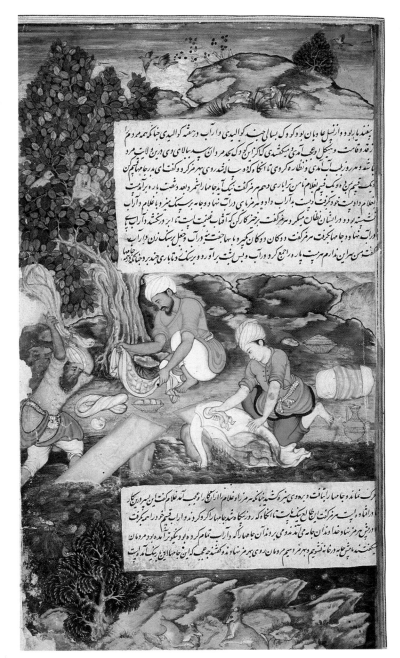

19 Krishna's ladies are shown the sacrificial horse.

Mughal, 1598. By Bhagvan.
[OMPB. Or.12076, f.17a.
(237 × 146 mm).]

One of the most ancient Indian rituals of kingship was the horse-sacrifice, in which a specially chosen and consecrated horse was allowed to wander at will for a year, followed by the King's army. The army enforced the King's rule over any other countries it wandered into. Only the greatest monarchs performed it, because of the risks involved in defeat. Here in an episode from the *Mahabharata*, the Great Indian Epic, Bhima has brought the sacrificial horse to the Pandavas' ally Krishna, who has helped them regain their kingdom. It is being shown to the ladies of Krishna's harem, while Bhima tries to persuade Krishna to join the army following the horse.

This painting is in a manuscript commissioned by a patron who had access to artists of the imperial studio, but for whom they worked in a simplified version of the high Mughal style. Bhagvan indeed here appears to be very close to the Rajput tradition (see p. 51).

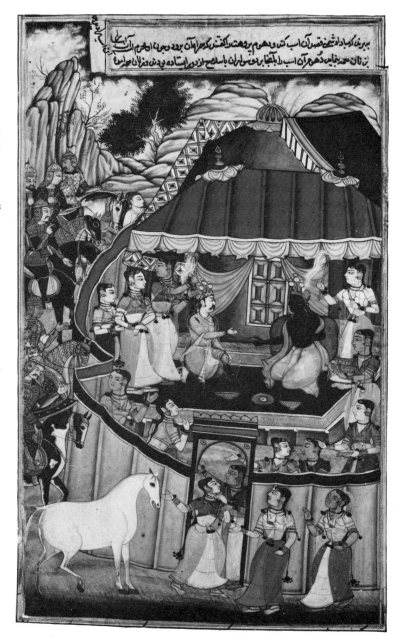

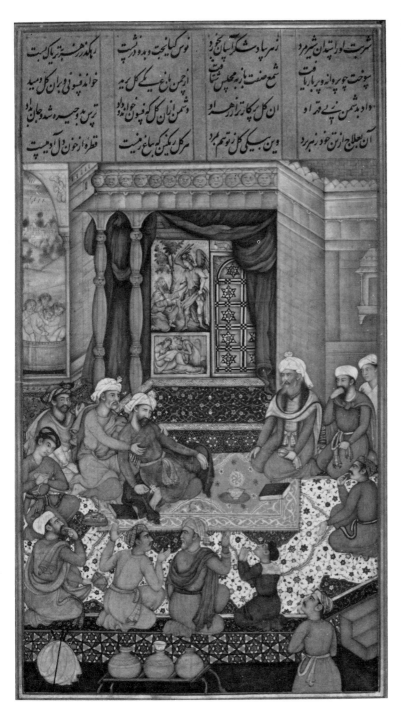

20 The physicians' duel.
Mughal, 1595. By Miskina.
[OMPB. Or.12208, f.23b
(175 × 109 mm).]

Two physicians are competing to show who has the greater skill in poisons. One prepares a lethal potion for the other to drink, which he is able to survive with the help of an antidote. The latter has only to breathe a spell upon a flower, for the first physician to die of fright.

Apart from Miskina's mastery of volume and space, techniques learnt from European examples, this miniature is also remarkable for its depiction of the decorations of a Mughal palace. The court was in Lahore in 1595, and the wall-paintings depicted in the miniature perhaps reflect those in the Mughal palace in Lahore. Christian subjects are in fact found in some of the palace chambers, but dating from the next reign. The main panel of the wall-painting in the miniature perhaps represents the revelation of St. John.

21 Viravarman falling to
the ground as Hanuman
overturns his chariot
with his tail.

Mughal, 1598. by Ibrahim
Kahar.

[OMPB. Or.12076, f.80b
(206 × 109 mm).]

Hanuman, the monkey-god,
son of the wind, was helpful
to the Pandavas in their great
battle, and made himself very
small to act as the standard
on Arjuna's chariot. In a later
episode of the Great Epic, he
came to their assistance again,
when Viravarman, King of
Sarasvata, tried to capture the
sacrificial horse. Hanuman
wrapped his tail round the
king's chariot and bounded
into the air, dashing the king
to the ground.

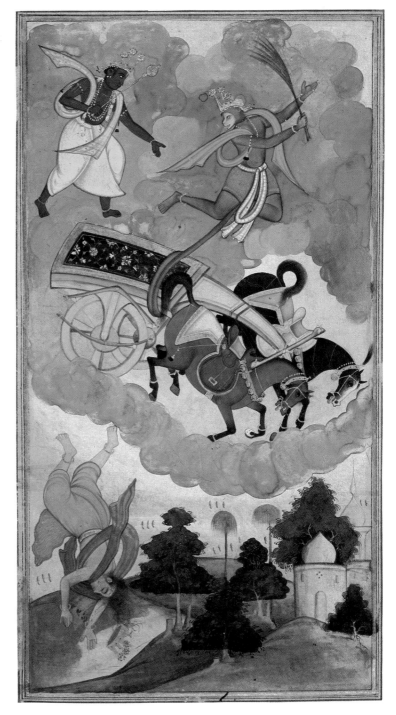

22 Europeans in an antique scene.

Mughal, about 1590.

[IOLR. Johnson Album 16, no.6 (264 × 175 mm).]

From about 1570, Mughal artists were exposed to European paintings and prints, brought originally to the Portuguese city of Goa and sent from there as presents to the Mughal Emperor. Akbar valued highly European pictorial realism, and hoped to instil this into his own artists, both through copying European originals and also (as here) getting them to paint 'conceits' in a European style. Of course to the modern eye, the confusion of theme, religious imagery mixed with late 16th-century costume, is faintly ridiculous; but the figures, especially the attendant pouring wine, have an intentness of purpose and solidity within the landscape (even if the chief figure's chair does not bear too close an inspection) that is a new and exciting development in Mughal painting and one which was to yield great results in the next reign.

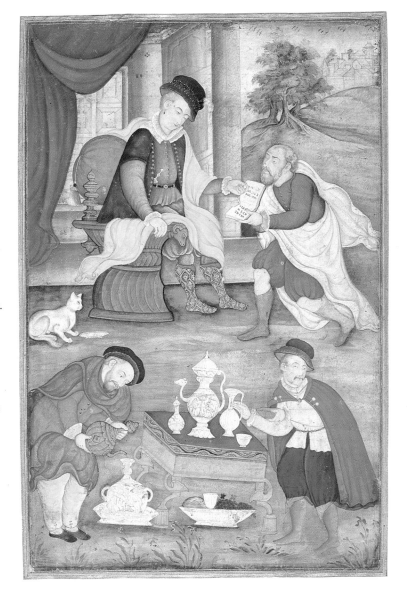

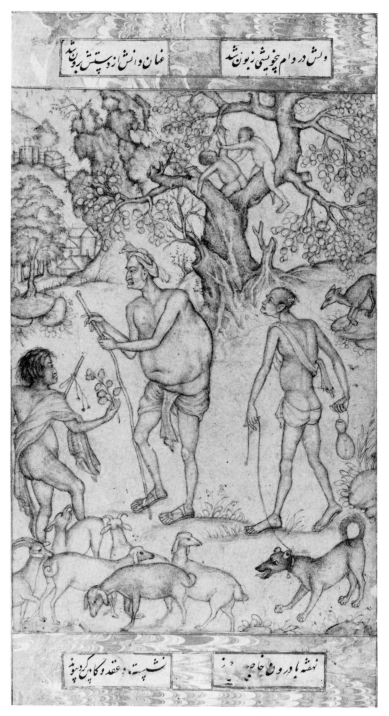

23 A shepherd offers flowers to an ascetic. Mughal, about 1585–90. By Basavan.

[IOLR. Johnson Album 22, no.13. (185 × 127 mm).]

Ascetics have always been both venerated and ridiculed in Indian society. The exposure of Indian artists in the 16th century to European drawings and caricatures by such masters as Dürer resulted in a long-continued exploitation of the latter. Here a shepherd shyly proffers a flower to the bloated ascetic who proudly marches on his way, ignoring him. The disciple behind, gazing devotedly at his master, provides the reason – it is food for his ritual-pot that they want, not flowers. The dog worrying the sheep perhaps suggests a way out that his masters would find satisfactory!

Mughal composition even at its finest is an uneasy compromise between European and Indian views of the world. Our artist has made excellent use of European techniques of pencil drawing and shading to impart volume and three-dimensionality to his figures, at the same time as retaining the Indo-Persian tradition of bodies having to be viewed almost frontally – even though, as here, side views would better accord with the faces in profile.

24 Zain Khan Kokah.

Mughal, about 1595. By 'Inayat.

[IOLR. Johnson Album 18, no.18 (102 × 69 mm).]

Zain Khan was the son of Akbar's nurse Pichah Jan, and hence Akbar's foster-brother, *kokah*. He died a few years before Akbar, in 1601. Akbar's biographer, Abu'l Fazl, tells us that towards the end of his life Akbar 'sat for his likeness and also ordered to have the likenesses taken of all the grandees of the realm. An immense album was thus formed: those that have passed away have received a new life, and those who are still alive have immortality promised them'.

Many of the portraits which have survived from this album bear the same characteristics of exquisitely modelled and detailed figures standing against a plain green ground, with Jahangir's characteristic scrawl identifying the subject and the artist. Originally they were mounted four to a page.

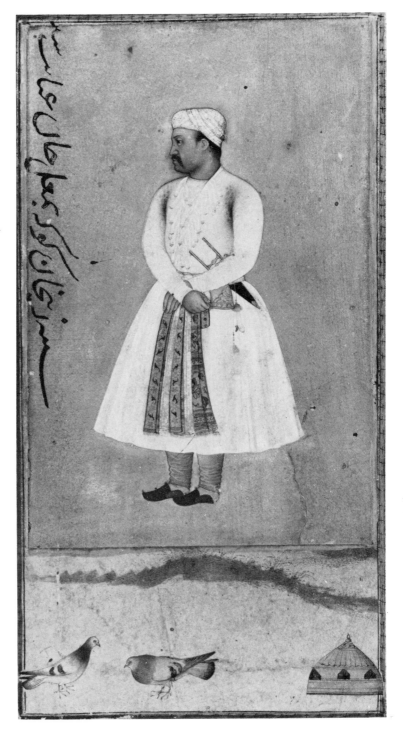

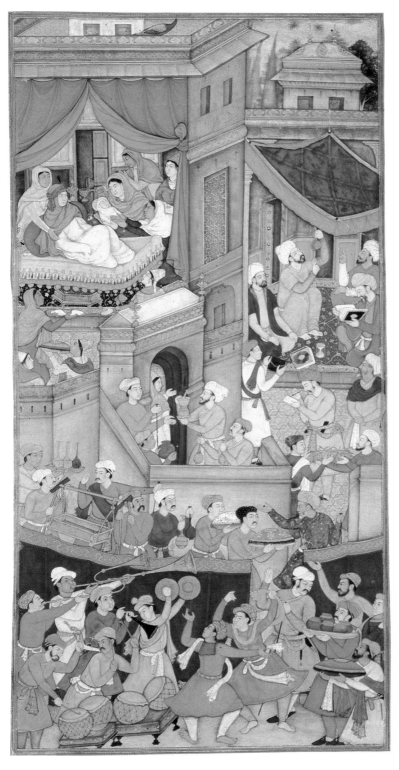

25 Celebrations at the birth of Timur.

Mughal, about 1604. By Sur Das Gujarati.

[OMPB. Or.12988, f.34b (236 × 122 mm).]

The spectator's bird's-eye view allows us a most privileged glimpse behind the walls of a harem at the moment when Timur the Lame, conqueror of half of Asia and ancestor of the Mughals, was born in 1336. Drums, cymbals and blaring horns greet the birth, while food, drink and a cradle are brought in. The eye is subtly led up the picture through the screens and walls to where astrologers are busy casting the baby's horoscope and finally to the birth-chamber itself.

Sur Das would have had no access to royal Mughal women, so his treatment of Timur's mother and female relatives is somewhat vapid, contrasting with his brilliant studies of the musicians and bearers at the bottom of the picture. Here, we feel, are real people, the actual attendants at the Mughal court, maybe the very musicians whose noise announced the dawn and all imperial entrances into the palace.

26 Darab and his beloved Tahrusiyya entertained by 'Umar. Mughal, about 1575–80. By Nanha.

[OMPB. Or.4615. f.24a (321 × 205 mm).]

Darab is the hero of a complicated romance in the Persian epic tradition, in which he eventually establishes his claim to the Persian throne. In the early part of the story, he is befriended by Tahrusiyya. The details need not concern us, any more than they did the artist Nanha, a Hindu artist, probably from the Deccan, who uses the subject of the feast in the tent to display his mastery in the depiction of the working man, the cook intent on his job, and the hunchback waiter.

Mughal artists were still experimenting with formats at this stage in the development of the style. Whereas a Persian artist would have been content with extending his subject into the left margin and perhaps with protrusions above, Nanha has boldly utilised the whole page. This has the effect of floating the text panels in front of the painting, and obviated the necessity to provide linkage between foreground and background where the Mughal style was still, at this stage, technically deficient.

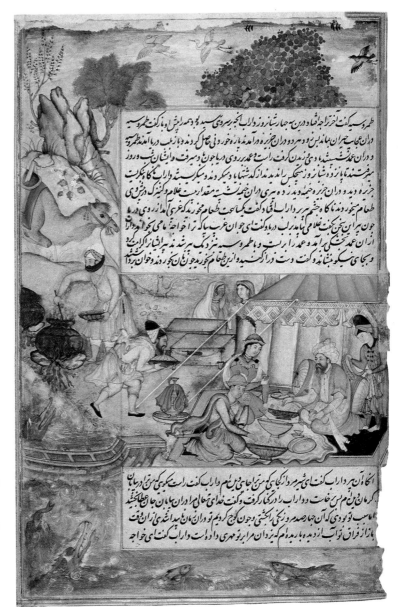

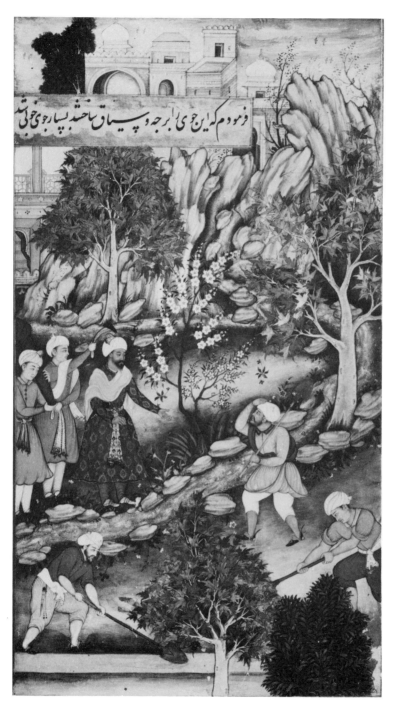

27 Babur orders the course of a stream to be diverted at Istalif.
Mughal, about 1591. By Mahesh.
[OMPB. Or.3714, f.180b (274 × 154 mm).]

The Mughals loved gardens – ordered arrangements of water and trees enclosed by walls, a refuge from the heat and dust outside. Babur, the founder of the Indian dynasty, brought this inheritance with him from Central Asia, and after his capture of Kabul in 1504 he had gardens laid out and a stream diverted in order to achieve a more formal arrangement. Babur stands on the bank of the winding stream, while below workmen dig a channel to form its new bed.

28 Khusraw hunting.

Mughal, 1595. By 'Abd as-Samad.

[OMPB. Or.12208. f.82a (243 × 147 mm).]

Khusraw Parviz (Chosroes II) was the ruler of Persia, whose love for Shirin, the queen of Armenia, formed one of the great romances of Persian literature. Here he is depicted out hunting, in a late painting by the master of the studio, 'Abd as-Samad.

'Abd as-Samad was one of the two artists working for Shah Tahmasp of Persia whom Humayun brought back to India with him after his period of exile, and who managed the studio during much of Akbar's reign. Although the fully developed Akbari style was formed under his influence, his personal style was still very conservative in the Safavid manner, his figures set against a flat background. Nonetheless, his mastery is impeccable and his command of detail absolute. This last dated work by one of the key figures of the Akbar period, nearly fifty years after he entered Humayun's service, is one of the most moving of Mughal paintings.

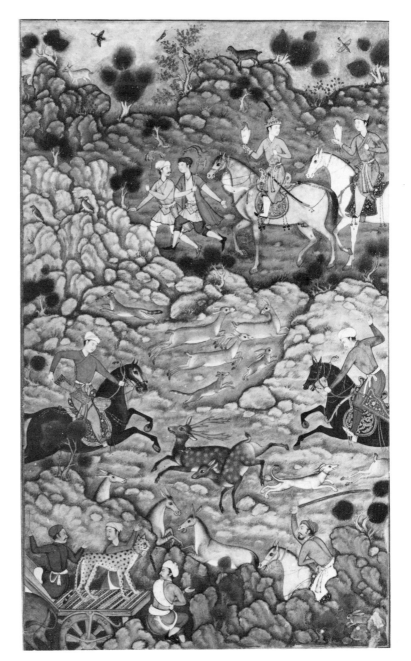

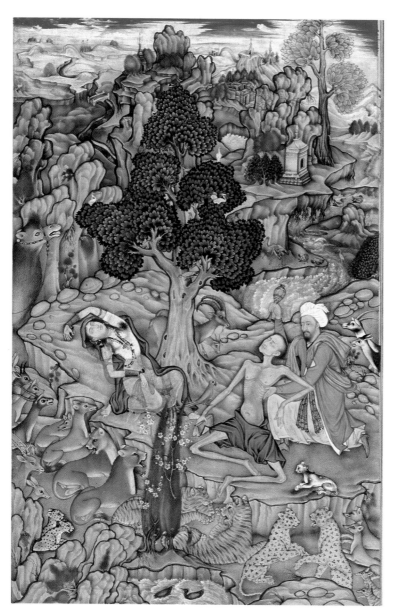

29 Layla and Majnun in the desert.

Mughal, 1595. By Farrukh Chela.

[OMPB. Or.12208 f.123a (171 × 110 mm).]

Layla and Majnun were childhood sweethearts, separated by the enmity between their families. Driven mad by his longing, Majnun became a recluse in the desert, where the animals took pity on him – though their pairings served only to remind him of his own loneliness. Here the now-married Layla comes to him in the desert, and both faint in the intensity of their emotions.

In this densely coloured but subdued study, the eye is led straight to the principal actors by their vivid blue and red garments and by the extravagance of their gestures. Layla seems to owe much to a European exemplar. Their extraordinary behaviour contrasts delightfully with the consternation displayed by the animals – the startled deer and puzzled leopards and lions. One tiger, at least, finds such emotionalism totally uninteresting.

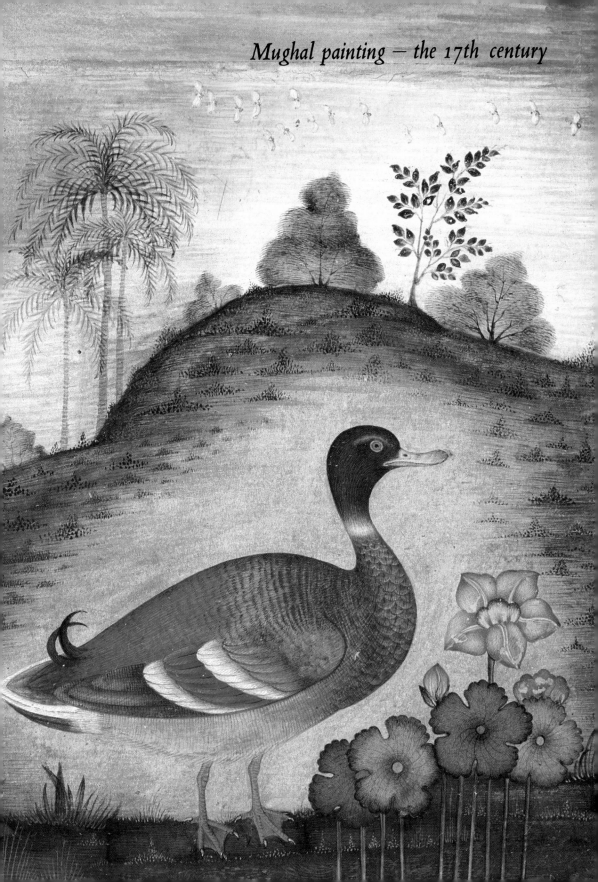

The mature Akbari style underwent a process of refinement in the early years of the 17th century, under the patronage of Jahangir (who reigned from 1605 to 1627). Jahangir wanted his artists to produce many fewer but more refined paintings. The bustle characteristic of paintings from Akbar's reign gave way to static court scenes and studies of flora and fauna, with details exquisitely rendered, down to the minutest hairs on an animal's coat. Under Shah Jahan (1627–58), the studio was neglected – apart from the production of paintings for the official history of the reign – although the style if anything advanced still further in refinement. The puritanical Aurangzib (1658–1707) disapproved of painting, although many fine paintings were still being produced in his reign.

30 (*overleaf*) A drake.

Mughal, about 1635.

[IOLR. Add.Or.3129, f.10a (163 × 101 mm).]

Like 42, this comes from an album assembled by Dara Shikoh. The drake stands on the edge of a pool from which rises a strange species of water-lily or lotus. The bird's magnificent plumage is most beautifully caught. The painting has been extended at the top to fit into the album.

31 The Emperor Jahangir greets his son Shah Jahan.

Mughal, about 1630.

[IOLR. Johnson Album 4, no.2 (296 × 208 mm).]

This preparatory drawing allows the quality of Mughal draughtsmanship to be fully appreciated. The principal characters are lightly sketched in, and the artist's real interest lies in the assembled courtiers in the front of the drawing, and the superb elephant. Such sketches were then transferred, usually same size, to the final paper, often through the agency of 'pouncing', using a *charba* (perforated gazelle skin). This particular example, however, seems too worked up and therefore unlikely to have been suitable either as a base for colour or for transfer.

 Both Jahangir and Shah Jahan had prepared official illustrated histories of their reigns, of which Shah Jahan's tends towards recording only the most formal occasions. The array of presents and the depiction of the Emperor rising to greet his son suggest that the occasion is the latter's triumphant return from a campaign. The drawing was composed over ten years after the event.

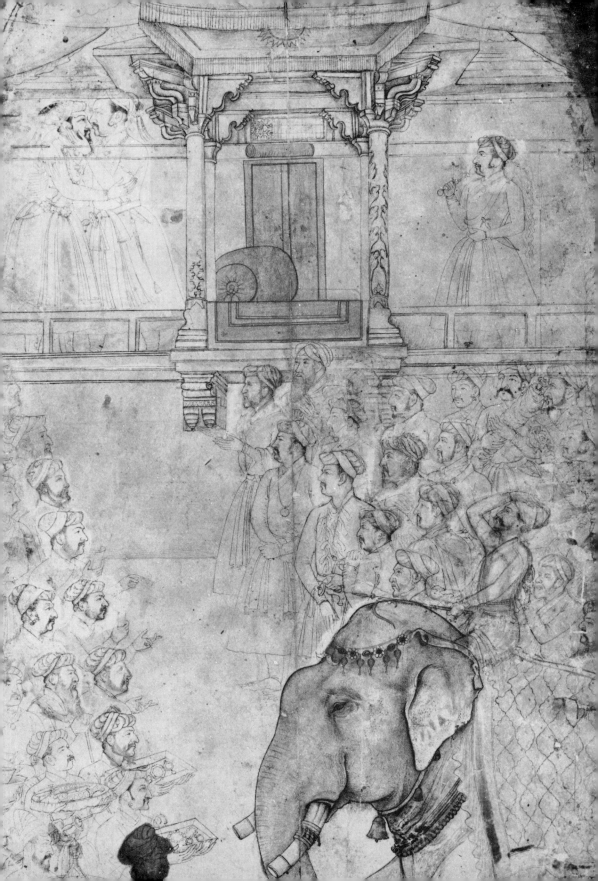

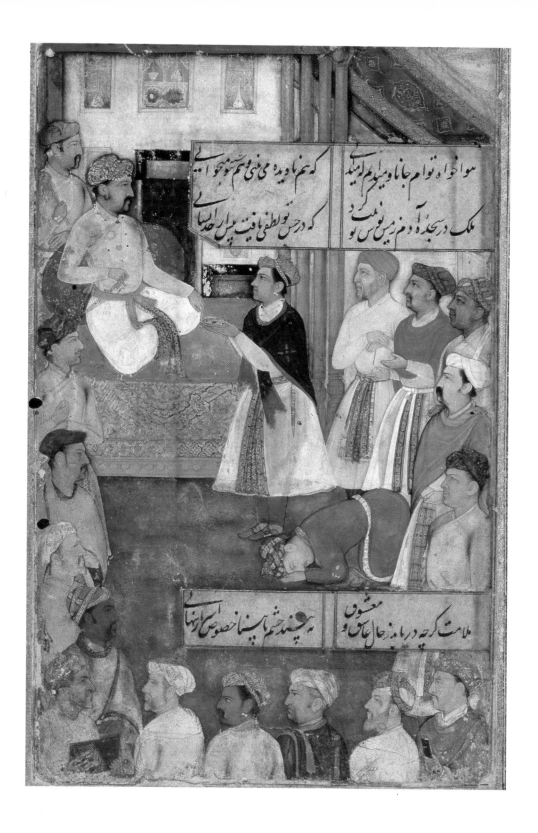

32 Prince Khurram presents jewels to Jahangir.

Mughal, about 1611.

[OMPB. Or.7575, f.249a (113 × 73 mm.]

In Jahangir's reign important events were recorded in pictorial form, worked up by artists from sketches and from the pre-existing gallery of portraits of those known to have been present. Some such paintings were meant for inclusion in the official history of the reign, others in albums, while others, such as this one, were added to favourite manuscripts, in this case a pocket-size copy of the poems of Hafiz, a text much used by Jahangir for augury.

That this is an important event is self-evident. Prince Khurram, the emperor's second son, who succeeded him in 1627, is presenting a small gold tray with jewels on it. We do not know who the prostrating figure is. The chief minister, Itimad ad-Daulah, stands immediately behind Khurram, while the former's son, Asaf Khan, who became Jahangir's brother-in-law in 1611, stands behind the Emperor with a fly-whisk. Immediately to the Emperor's right is Parviz, his eldest son. The composition resembles a similar scene in the Rampur State Library signed by Govardhan, but perhaps Abu'l Hasan is a more likely candidate for our miniature's execution.

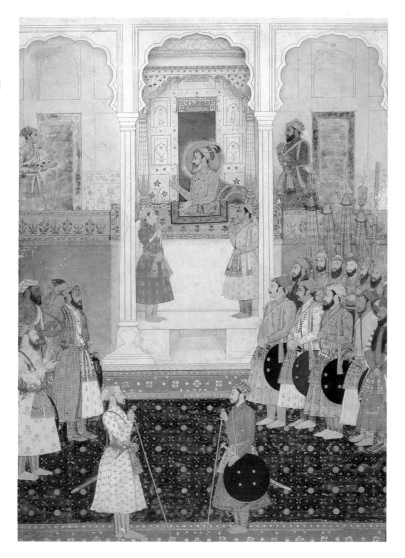

33 Shah Jahan in durbar.

Mughal, about 1660(?)

[IOLR. Add.Or.3853 (305 × 220 mm).]

The Emperor Shah Jahan sits in the throne platform high above his assembled courtiers in one of his daily 'durbars' or public audiences. His second son, Aurangzib, salutes his father from below, the inference being that the jewels which are being presented are his gift.

Under Shah Jahan, the artists' principal duties were to record such formal occasions for inclusion in the imperial manuscript of the history of the reign. The formality of such occasions, and the necessity of the painting having to be worked up after the event from the pre-existing portraits of those known to have been present, produces a stiffness of effect characteristic of the painting of this reign. There is, however, a possibility of this being a later copy.

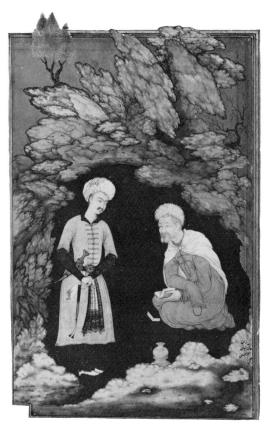

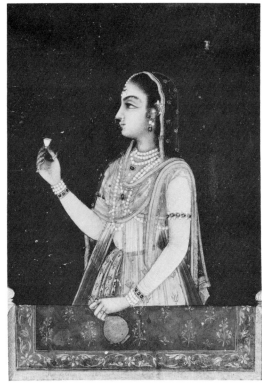

34 Dabshalim visits the sage Bidpay.
Mughal, 1604, from Allahabad. By Abu'l Hasan.
[OMPB. Add. 18579, f.41b (150 × 94 mm).]

The sage Bidpay, whose fables formed perhaps the
most celebrated work in Arabic and Persian literature,
sits in his cave in the mountains; interrupted in his
reading, he raises his eyes to his respectful young
visitor the Prince Dabshalim who has come to him for
instruction and listens courteously, though one feels
that the Prince does not interrupt the telling of his
beads with his right hand, nor probably his train of
thought. The mind revealed by this face could do
many things simultaneously. This masterly study by
Abu'l Hasan was painted when the artist was only
twenty years old, and was done for Prince Salim (the
future Jahangir) in Allahabad where he had set up a
rival court to that of his father.

35 A girl at a window.
By Raghunandan. Mughal, about 1660.
[IOLR. Johnson Album 4 no.5v (73 × 51 mm).]

'Window-portraits' such as this are common in
Mughal painting from the later 17th century. In this
painting, the artist manages to avoid any stereotyping,
and succeeded in portraying a girl of ravishing
beauty. She holds a wine-bottle and a tiny porcelain
cup, objects held by many such young ladies in the
portraits of this period. They hint perhaps of the rôle
performed by such women in the Mughal court, where
ladies of rank were strictly enclosed and not available
even for formal portraits.

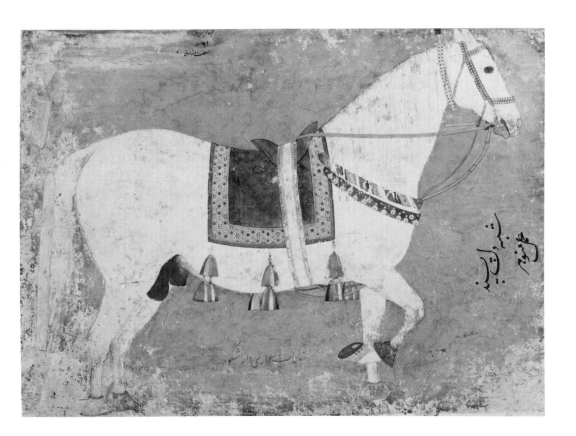

36 Dara Shikoh's horse.

Mughal, about 1630. By Manohar.

[IOLR. Johnson Album 3, no.1 (260 × 361 mm).]

Dara Shikoh was Shah Jahan's eldest and favourite son, and was always meant to succeed him. He was however defeated in battle by his younger brother Aurangzib, in the wars of succession at the end of Shah Jahan's reign; shortly afterwards he was put to death.

Dara Shikoh was about fifteen years old at the time of this painting of his horse Dil Pasand (Heart's Love). It was painted, perhaps as a present for him, by one of the great masters of the studio.

37 The assembly of the birds.

Mughal, 1604–10.
By Husayn(?).
[OMPB. Add. 18579, f.201b (123 × 72 mm).]

A group of birds meet to decide who shall be their chief. A passing crow is consulted on the merits of the owl, and he dissuades them from choosing as king a bird who, though wise in appearance, is in fact stupid and ill-tempered. The birds are persuaded, and the furious expression worn by the rejected owl is a harbinger of the future perpetual enmity between owls and crows. The moral drawn by the story-teller is the unwisdom of needlessly making an enemy.

It is the beauty of the individual studies of birds which impresses most in this painting, rather than the composition as a whole. Several Mughal manuscripts are decorated throughout with studies of birds.

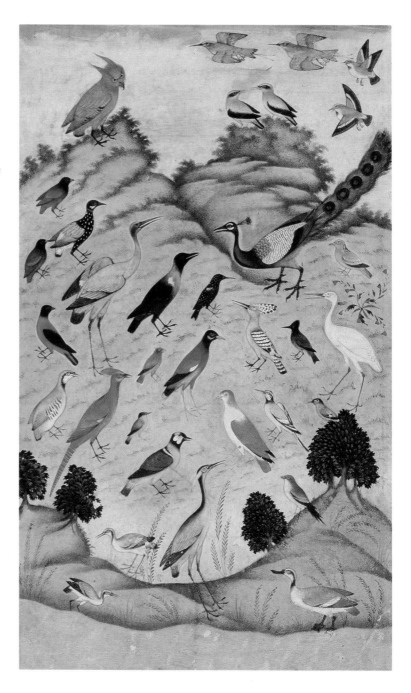

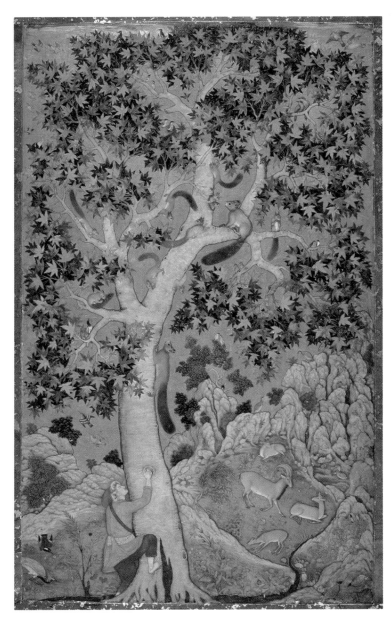

38 Squirrels in a plane tree.

Mughal, about 1610.
By Abu'l Hasan.
[IOLR. Johnson Album 1, no.30
(362 × 225 mm).]

Could these squirrels be painted other than from the life, their gambols and sudden stillnesses so brilliantly captured by Jahangir's greatest artist? Yet they are European red squirrels, unknown in India. Mughal natural history studies are believed to have been done from observation of dead specimens, yet this family group can only have been painted by one who had observed them. No European original has yet been traced to resolve the dilemmas posed by this painting, one of the most enigmatic and delightful works of Indian art. Here the disciplined observance of nature instilled in Akbar's artists has borne fruit in the next generation in a masterful and totally natural realism.

39 The Sultan of Baghdad and the Chinese slave-girl. Mughal, 1604–10. By Bishndas.

[OMPB. Add. 18579, f.320a (117 × 75 mm).]

The Sultan of Baghdad had fallen in love with a Chinese slave-girl to such an extent that he neglected all his cares of state. Day and night he spent in her company, and gave no thought to his people or his throne. Here in the harem he has eyes only for her as she dances before him.

Bishndas was the nephew of Nanha (see **26**), both artists coming from the Deccan, probably from Bijapur. Bishndas's instantly recognisable, but ugly, women are related to those in Bijapuri paintings of the 1590s (see **46**, **48**). He subsequently became Jahangir's favourite artist for formal portraits, and was sent on an embassy with Khan 'Alam to Persia in order to take portraits of the Shah and his nobles.

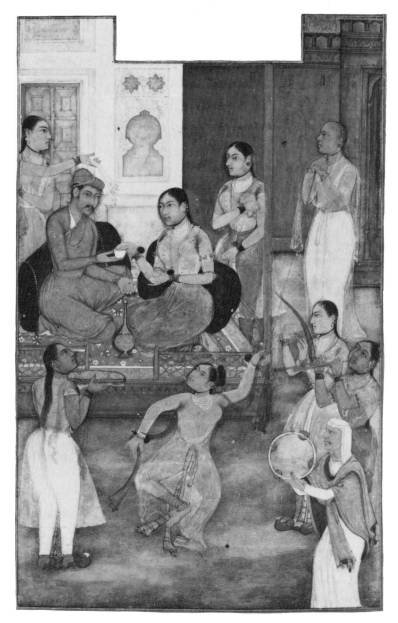

40 Jahangir as a young man.

Mughal, about 1620.
[IOLR. Add.Or.3854 (158 × 80 mm).]

Prince Salim, aged about twenty, stands examining a flower, his head and upper body superbly finished, the rest of him more sketchily treated. This type of retrospective portraiture became quite common in Jahangir's reign and that of his son Shah Jahan, when illustrated official histories were produced needing portraits of the principal participants at different ages. Jahangir was born in 1569, and no contemporary portrait of him at this age is known. This version must have been painted after 1614, when Jahangir had his ears pierced for earrings.

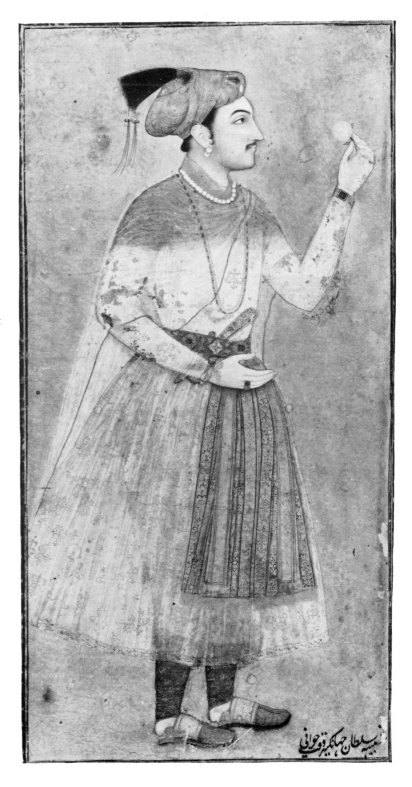

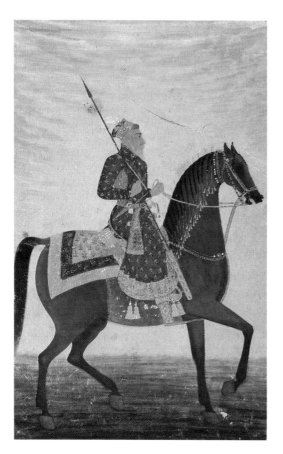

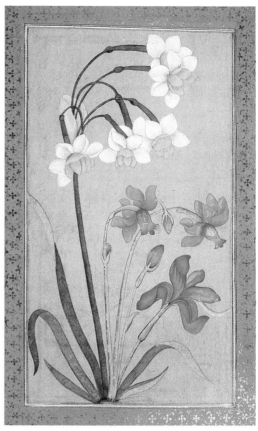

41 Khan Jahan Bahadur on horseback.

Mughal, about 1690. By Hunhar.

[IOLR. Johnson Album 18, no.12 (284 × 179 mm).]

The subject of this painting was foster-brother (*kokah*) to Aurangzib, a relationship which traditionally led to later favour, in this case to governorships of three of the great Mughal provinces.

Equestrian portraits became fashionable in the second half of the 17th century, perhaps because of Aurangzib's incessant wars. Hunhar's work spans much of the 17th century, and this seems to be a painting from his old age. The theatricality of much of Mughal painting of this period is vividly suggested by the gaudily streaked sky, arranged like curtain swags.

42 Narcissus and iris.

Mughal, about 1635.

[IOLR. Add.Or.3129, f.66a (175 × 98 mm).]

Flower studies survive in fewer numbers than animal or bird studies from the greatest period of Mughal painting, yet were as often commissioned. Jahangir on his visit to Kashmir in 1620 ordered his natural history specialist, Mansur, to produce an album of the flowers which carpeted the land. More are known from a slightly later period, but the inspiration is no longer purely studies of nature; here a six-flowered narcissus shares a common root and leaf system with a fantastic blue-trumpeted, red-petalled narcissus as well as a blue iris. Compositional imagination is judged more important than truth to nature; and this withdrawal of Mughal painting from the real world typifies the new style under Shah Jahan, when art was made to serve political purposes. This painting is included in an album commissioned by Dara Shikoh as a present for his wife.

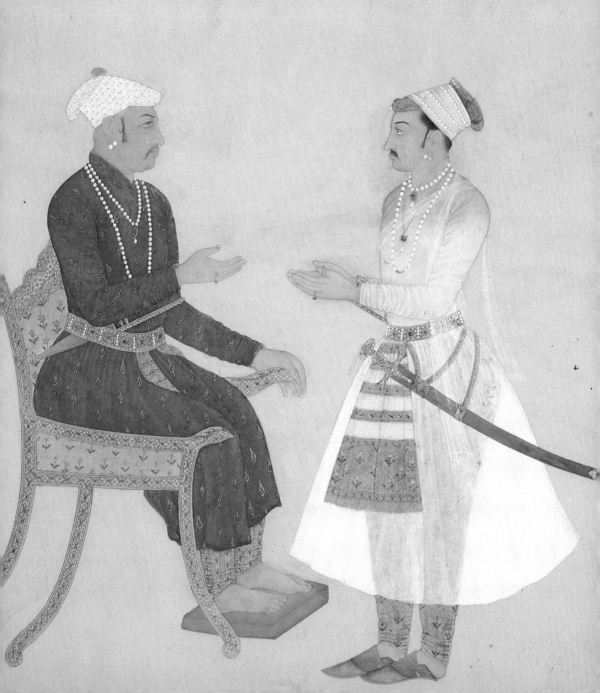

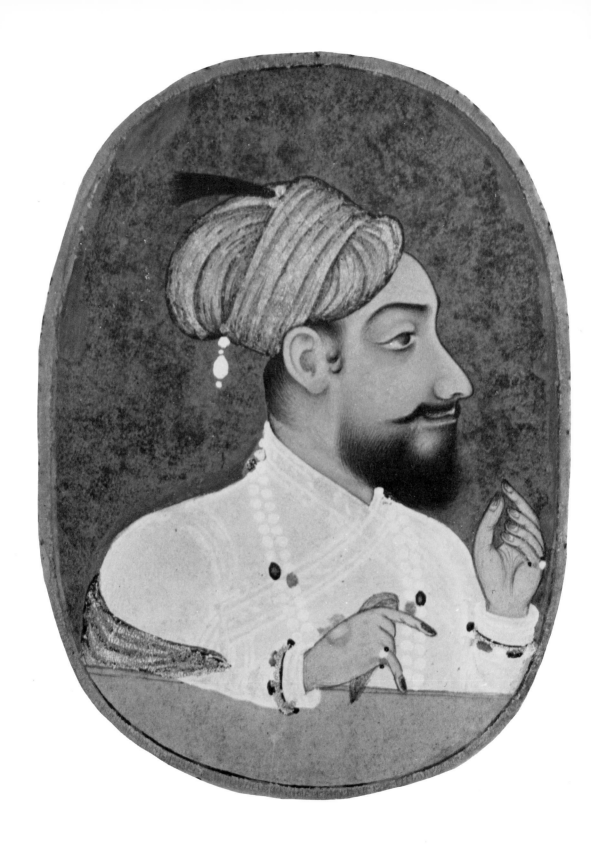

Outside the Mughal empire in the late 16th century, we find paintings being produced only in the capitals of the three Islamic kingdoms of the Deccan. Late developers, apparently, they inherited two Sultanate traditions exemplified by 7 and 11, and by 10, the latter probably when Mandu fell to the Mughals in 1561. Deccani painting combines elegance and sumptuousness, characteristics that do not come readily to mind in describing the contemporary Mughal style. Although much influenced by Mughal traditions from 1630 on, particularly in portraiture, Deccani painting remains distinctly individual until Aurangzib's conquests of Bijapur and Golconda in 1686–7.

In the Rajput princedoms of western India such as Amber and Bikaner, which Akbar had wisely brought into his empire by marriage alliance rather than conquest, court studios were set up from the late 16th century at least, practising a more courtly version of the style of 8. Under Mughal example horizons were expanded to include portraiture, but the basic concern of Rajput studios such as that in Udaipur in the 17th century was textual illustration, whether small sets of miniatures illustrating the musical modes or vast manuscripts of the great epics of Hinduism. In each court the style may be derived directly from pre-Mughal painting, or via the medium of sub-imperial Mughal painting (compare 19 with 55), or may be borrowed directly from the imperial style itself (43).

43 (*page 49*) Jai Singh of Amber (1625–68) and his grandson Kishen Singh, son of Ram Singh.

Amber(?), about 1685.

[IOLR. Add.Or.4244 (226 × 149 mm).]

Seated on a gilt chair of European design, Jai Singh, the Mirza Raja of Amber, one of the greatest princes and generals of 17th-century India, faces the prince, who stands respectfully before him. Ram Singh succeeded in 1668, and it is possible that this painting was produced to mark his son's death in 1683.

Painted with an exquisite attention to detail that recalls the highly 'Mughalised' style of Bikaner at this period, it yet seems highly probable that this double portrait would have been painted at Amber itself, from whose art at this period little has so far come to light.

44 Muhammad II 'Adil Shah.

Bijapur, about 1640. By Muhammad Khan.

[IOLR. Johnson Album 1, no.9 (76 × 55 mm).]

Muhammad 'Adil Shah, whose grandiose tomb dominates the skyline of Bijapur, is portrayed with a gently quizzical air in all his suriviving portraits, as if surprised to find himself ruler. His appearance in an oval frame is a Deccani adaptation of the European oval miniature portrait, brought into India by such ambassadors to Jahangir as Sir Thomas Roe, sent by James I, but also doubtless by the Portuguese in Goa.

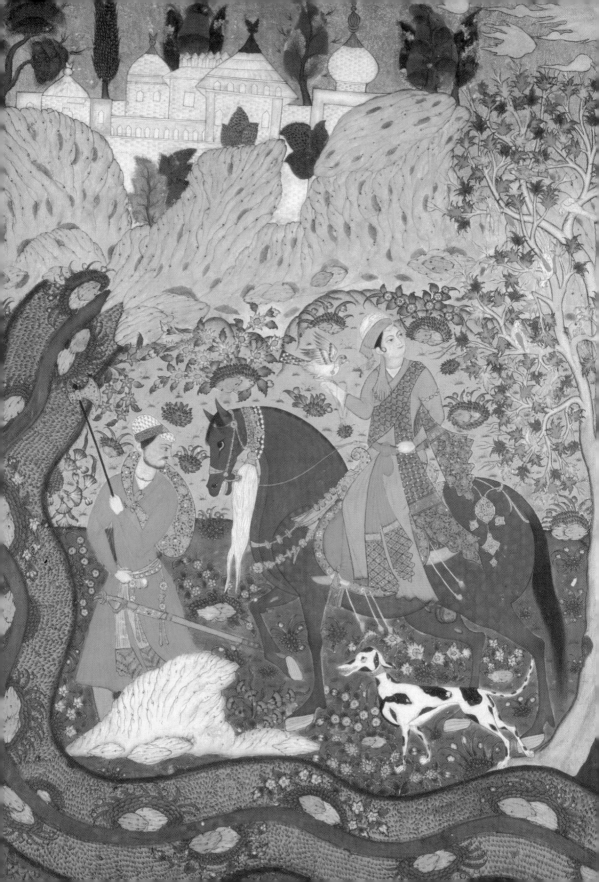

45 A prince hawking.

Golconda, about 1620.

[IOLR. Johnson Album 67, no.3 (296 × 220 mm).]

In a flower-strewn meadow traversed by a brook, a prince on horseback turns round to look at what has been agitating his hawk – the birds in the plane tree. The groom likewise turns, but his attention is fixed on the grinning dog.

The lush landscape and the palace-capped hills suggest that this painting is based on a now lost Bijapuri version. Its extreme flatness however betrays its Golconda origins, for being the furthest away from the Europeans at Goa and the Mughal court, the Golconda style was the last to introduce European recessional techniques. How old-fashioned the Golconda style still was at this time is shown by the carefully arranged verges of the stream, which are based on a Sultanate convention seen in **4**.

46 Mahji and Shahji's interview.

Bijapur, 1591.

[OMPB. Add.16880, f.210a (169 × 92 mm).]

Shahji has almost gained his beloved, but various obstacles remain to be overcome. In this interview in the *zenana*, a curtain still decorously separates them – to their obvious despair. The scarves waved over them are traditional insignia of royalty, as is the handkerchief Shahji clutches in his left hand.

This artist's highly distinctive style, with its elongated, ugly women, contrasts with the more obviously brilliant style of **48** from the same manuscript, eschewing inessentials such as architecture or landscape in favour of a powerful concentration on the essentials. His handling of the curtain suggests he too had been exposed to European influence.

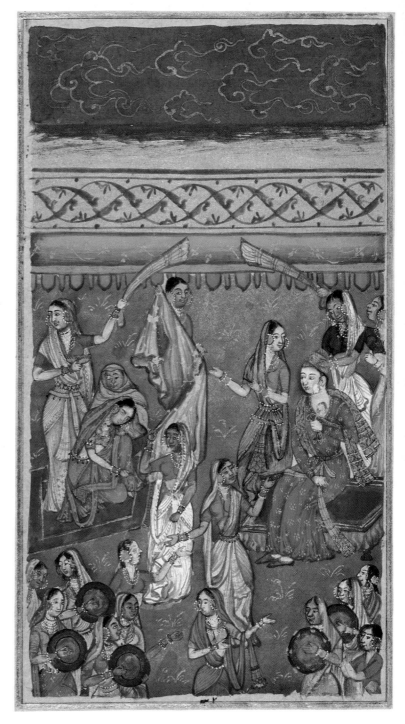

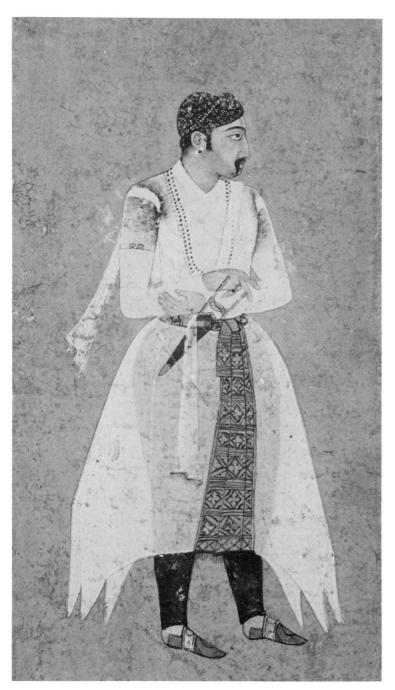

47 Raja Bhao Singh of Amber.

Amber(?), about 1620.

[IOLR. Johnson Album 24, no.11 (118 × 64 mm).]

Precisely drawn, yet flat, and lacking the finish of the best Mughal paintings, this powerful portrait of the ineffectual Bhao Singh (reigned *c.*1615–22) may in fact have been produced at Amber itself.

This leading house of Rajputs allied itself early on to Akbar, whose eldest son Jahangir was born to a princess of Amber, while the famous Man Singh of Amber was one of Akbar and Jahangir's greatest generals.

48 Mahji pines for her beloved.

Bijapur, 1591.
[OMPB. Add.16880, f.138a
(160 × 91 mm).]

It is *holi*, the spring festival, and the girls are squirting the traditional coloured waters at one another in riotous play. The princess Mahji, however, can think only of her beloved, and sits pining for him, the flames of her desire engulfing her.

The brilliant colours of the girls' saris (a predominantly southern garment, not used in the north until centuries later), set against the gold ground, produce the sumptuous effect beloved of the Deccani artists. Although imprisoned still in the Persianate tradition of landscape, the artist has given a three-dimensional effect to his characters that indicates contact with European paintings in nearby Goa.

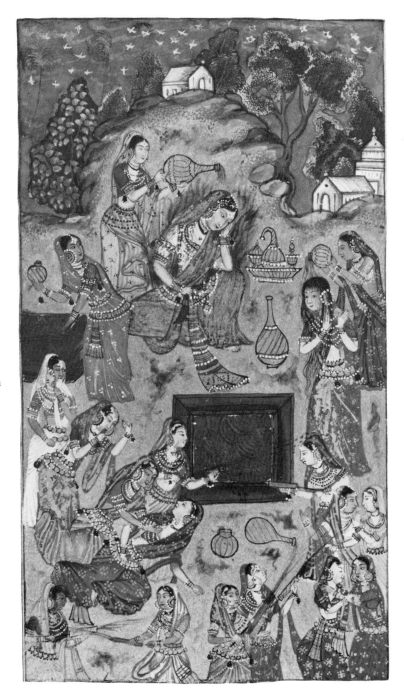

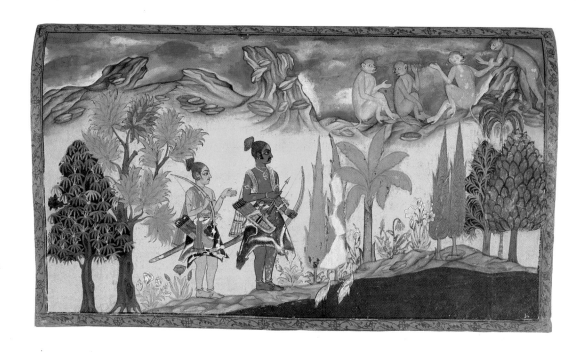

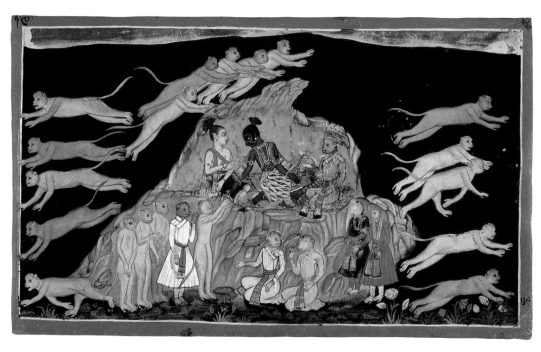

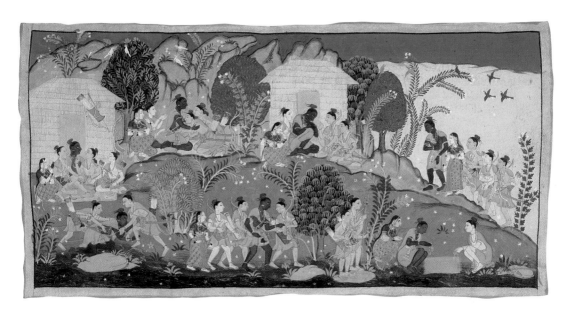

49, 50 (*Above left*):
Rama and Laksmana
arrive in the Kiskindha
forest and are seen by
the monkeys.
(*Below*): Rama gives
Hanuman his ring as a
token.
Udaipur, 1653.
[OMPB. Add.15296(2). ff.2a,49a
(220 × 380 mm).]

Above, Rama's wife Sita has been
abducted by the demon Ravana,
and he and his brother in their
search for her have arrived at the
borders of the monkey-kingdom of
Kiskindha. The monkeys on the
rocks have seen the two brothers,
and discuss animatedly what to do.

Below, Rama has been of the
greatest service in helping Sugriva
the monkey-king to regain his
throne, and in gratitude Sugriva
sends out search parties of his
monkeys to look for Rama's
abducted wife Sita. Rama gives

Hanuman his ring as a token,
should he find her.

This Udaipuri manuscript dates
from a time when Mewar painting
was exposed to influence from the
Deccan, largely caused by Mewar
nobles returning from service with
the Mughal armies in the south.
In these paintings the
characteristic Rajput fiery reds
have been displaced by a subtle
and dramatic Deccani palette. At
the same time, unlike in Rajput
painting, the artist has used colour
and composition as aids to drama.
In both these illustrations, a single
dramatic episode is shown. It is
interesting to contrast the effect
with **51** below, which in
characteristic Rajput fashion
provides a simultaneous viewing of
several episodes in a story.

Few Indian artists, in any style,
could match the dramatic force of
the painting of Rama and
Hanuman (opposite, below).

51 Bharata brings the news
of their father's death to his
brother Rama.
Udaipur, 1650.
[OMPB. Add.15296(1), f.114b
(172 × 352 mm).]

This is a superb example of the
Rajput technique of telling an
entire story within a single picture.
Rama is in exile in the forest with
his wife Sita and brother
Laksmana, the two men dressed as
hermits in bark and skins. His
other brothers Bharata and
Satrughna arrive to tell them of
their father's death. The action
starts in the far right and
continues in an anti-clockwise
direction. The guests (dressed also
as hermits) are brought to the
reed-hut, where they tell the sad
news to their eldest brother who
comforts them. They then all go
down to the river, where Rama
and Laksmana perform the ritual
sipping of water. Although the five
characters appear seven times,
there is no crowding, and the
layout succeeds in leading the eye
round in the required direction.

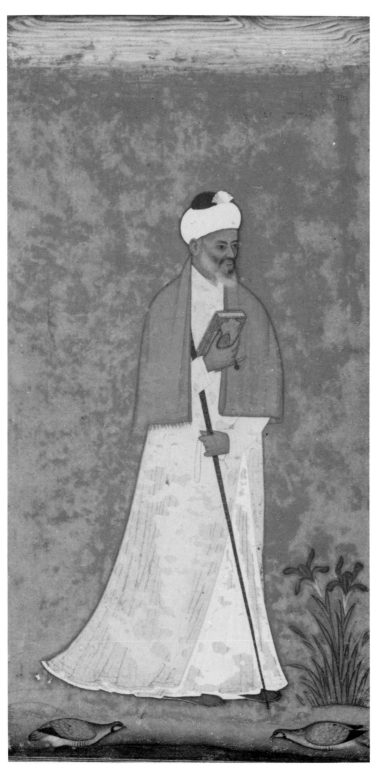

52 A mullah.
Bijapur, about 1610.
[IOLR. Johnson Album 25, no.14 (150 × 75 mm).]

He stands stern but withdrawn, holding a staff, rosary and a beautifully bound book, no doubt the Koran, depicted against a severely plain background, with at his feet a little stream with two partridges and a clump of irises.

This portrait typifies the enigmatic schools of the southern Muslim kingdoms of the Deccan. We do not know who the subject is, but it would scarcely make any difference if we did, so representative is he of the stern, ascetic upholders of the Islamic faith. To this pinpointing of a type, even though idealised, our unknown artist has brought a formal perfection of composition that makes this one of the most moving of all Indian portraits.

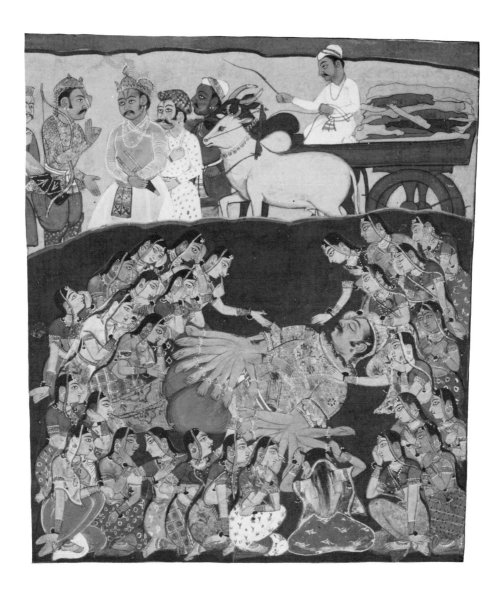

53 Ravana is mourned by his wives.

Udaipur, 1652. By Sahib Din.

[OMPB. Add.15297 (1), f.173a (detail) (complete painting: 210 × 320 mm).]

The monster Ravana, whose ten heads and twenty arms were cut off by Rama, lies on the
battlefield mourned by his wives, while orders for his funeral pyre are given above.

Within the conventions of Rajput painting, deep emotion is expressed not by contorted
features and extravagant gestures, but by much subtler means – the hands reaching out to
touch the corpse, the arching bodies of the women at the rear, the unbinding of the tresses of
the chief wife Mandodari, whom we see at the bottom of the picture with her back to us,
watched sympathetically by those closest to her. All these combine to waken the spectator's
pity, the aim of the artist. (*See also pages 4–5*)

54 The attack on Lanka.

Udaipur, 1652. By Sahib Din.

[OMPB. Add.15297 (1), f.7a (210 × 355 mm).]

In a scene previous to that illustrated overleaf, Rama
and his monkey allies have arrived at Lanka, where
Sita has been brought captive by the ten-headed
demon Ravana. In a quiet moment before the assault,
the leaders take counsel with their chief advisers as to
how to proceed, while the monkeys encircle the gold
city to take up the best positions.

Sahib Din was the principal artist working in Rana
Jagat Singh's court studio, and his output spans the
reign of his monarch (1628–52). He brought to the
traditional painting of Mewar an awareness of the wider
horizons of Mughal painting, thus allowing the
creation of complicated compositions such as this.

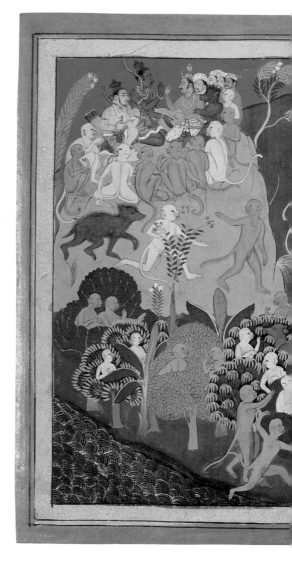

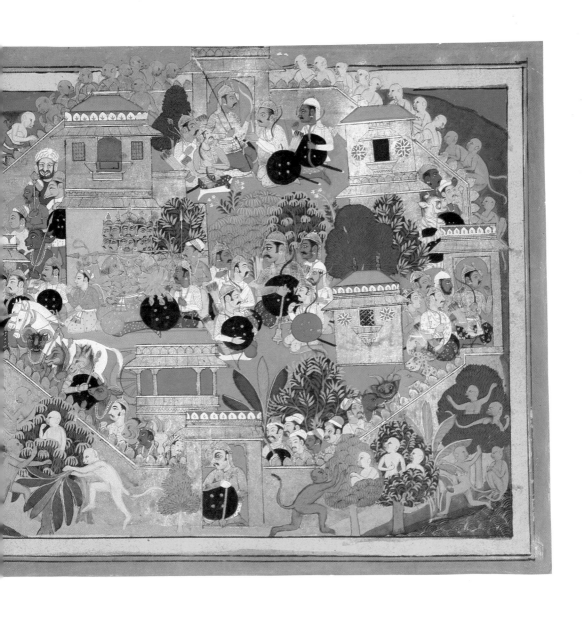

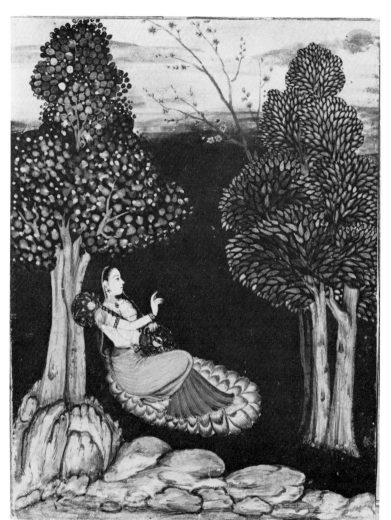

55 Gujari *ragini*.
Bikaner(?), about 1650.
[IOL.R. Johnson Album 30, no.2
(152 × 115 mm).]

Sitting on a carpet of lotus
petals, separated from her
lover, she sings softly,
accompanying herself on the
vina.

Collections of *ragas*, the
Indian musical modes, and
raginis, their 'wives', is a
conceit of Sanskrit
musicological literature which
in the late medieval period
also bore pictorial fruit, when
artists painted the scene
conjured up by the poet's
vision of the *raga*.

Such collections, known as
ragamala, 'a garland of *ragas*',
were especially popular in
Rajasthan. Here the soft
colours and gentle mood
suggest the Rajput style of
the Bikaner court studio, the
most 'Mughalised' of the
Rajput schools of the 17th
century.

56 Raja Sambhaji.

Northern Deccan, about 1690.

[OMPB. Add.21475, f.1a (171 × 111 mm).]

Sambhaji was the son of the great Shivaji, leader of the Hindu Maratha resistance to the imperial ambitions of Aurangzib in the northern Deccan. It was not until after Shivaji's death in 1680 that Aurangzib could escape the harassment on the flanks of his empire and proceed to the final reduction of Bijapur. Sambhaji was taken prisoner by Aurangzib in 1689, blinded and executed. This rare portrait shows him seated in reflective pose on a terrace. Its precise draughtsmanship and dark flat colours point to the northern Deccan, that is, to a Maratha provenance that cannot be much removed in date from Sambhaji himself.

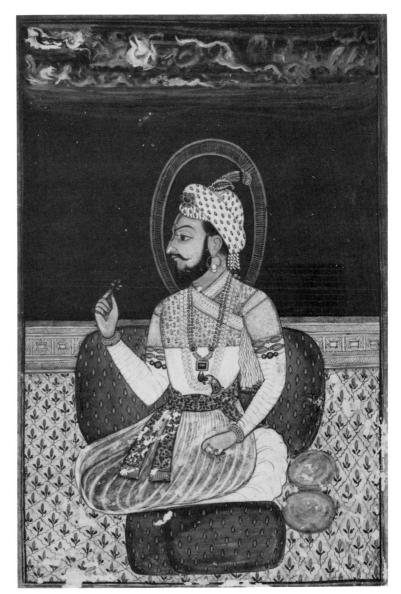

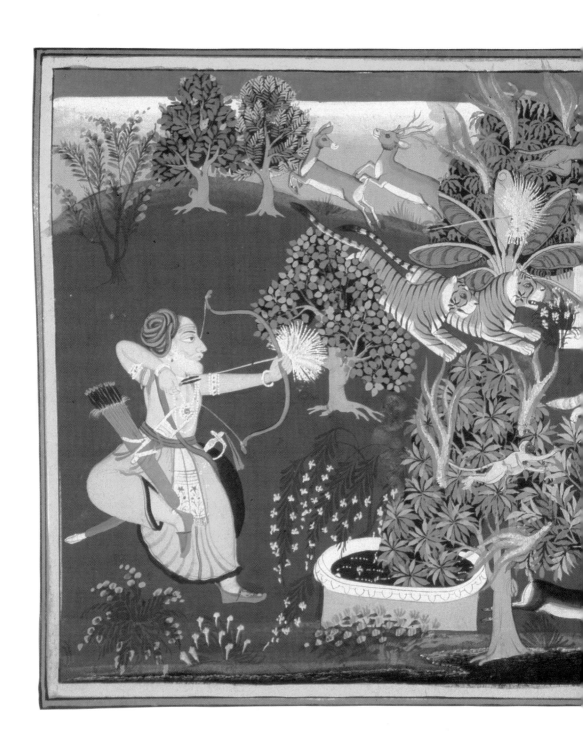

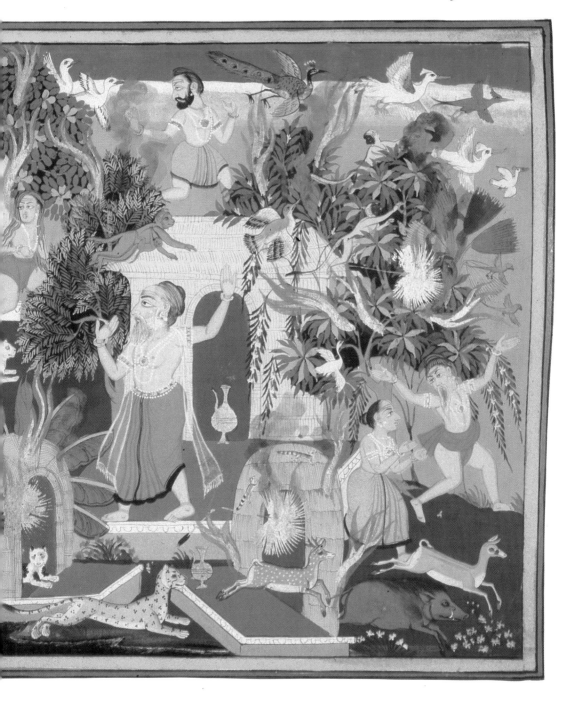

The sack of Delhi by the Afghan Nadir Shah in 1739 and the collapse of Mughal central authority which led to the semi-autonomous provinces of Hyderabad, Bengal and Oudh becoming independent for all practical purposes, and subsequent disasters, resulted in an exodus of artists to man the studios of the provinces. Painting in distinct variants of the Mughal style was practised at Hyderabad in the Deccan, Murshidabad, the capital of Bengal, and Faizabad and Lucknow, the capitals of Oudh. Artists from Delhi had little effect on the studios of Rajasthan itself, but considerably influenced developments in the studios of the Rajput rulers of the Panjab Hills.

The British had been slowly strengthening their position in Bengal during the 18th century, and became patrons of Indian artists, not only buying pictures but actively commissioning them. Under British patronage techniques changed; lighter washes of more transparent watercolour rather than traditional gouache with a burnished finish were used, while in portraiture the British did not favour the full profile but preferred the three-quarter view-point. Painting was commissioned by the British almost exclusively as a factual record of India – its people, its monuments, its flora and fauna and its landscapes so that when photography came to India in the 1850s, the new medium rapidly displaced the old.

57 (*overleaf*) Visvamitra attacking the heritage of Vasistha.

Udaipur, 1712.

[OMPB Add. 15295 (1), f.154 (175 × 322 mm).]

The hermit Visvamitra had been born a king, of the *ksatriya* or warrior caste. After an earlier encounter with the great sage Vasistha, he had become convinced of the superiority of spiritual to temporal powers, and performed the most severe penances to force the gods to grant him their weapons. To revenge himself on Vasistha, he is attacking his hermitage with the weapons of the gods, but Vasistha is soon able to repel them through his spiritual powers.

Mewar book painting had lost much of its grandeur by the early 18th century, but retained a fluent narrative technique and a lively charm in the best examples.

58 Rao Sardar Singh of Uniara and his sons.

Uniara, 1761. By Dhano.

[OMPB. Or.13934, f.78b (232 × 185 mm).]

Uniara was a small princely state in eastern Rajasthan, disputed between its bigger neighbours Jaipur and Bundi for most of the 18th century. Culturally Uniara owed more to Bundi than to Jaipur for much of this period, and its earliest painting style is identical to that of Bundi, whence its artists, such as Dhano, had come.

Sardar Singh reigned from 1740 to 1769, and had two sons, Jaisvant Singh and the illegitimate Maha Singh, who are both depicted here. The composition is typical of royal Rajput portraits, though here an unusual touch is that the artist Dhano has depicted himself, holding a picture of an elephant. The birds and a rabbit add a charming note to this colophon portrait to a manuscript of animal fables, commissioned by the young Jaisvant Singh.

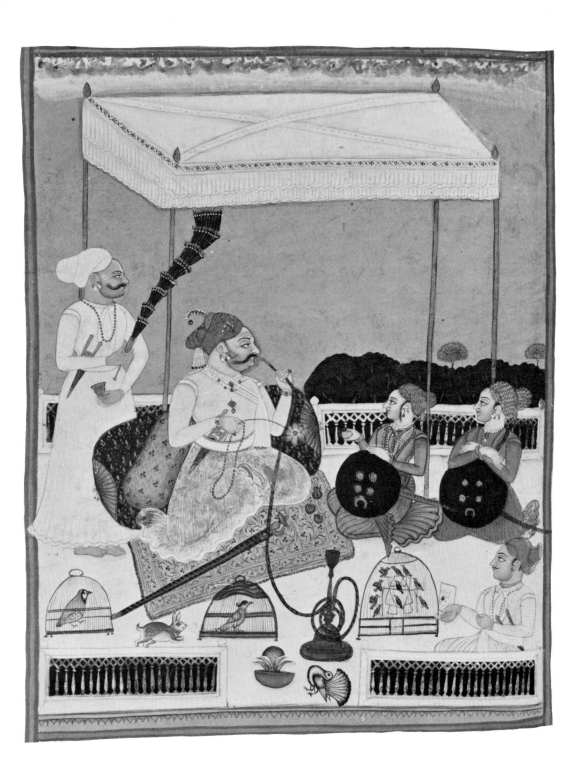

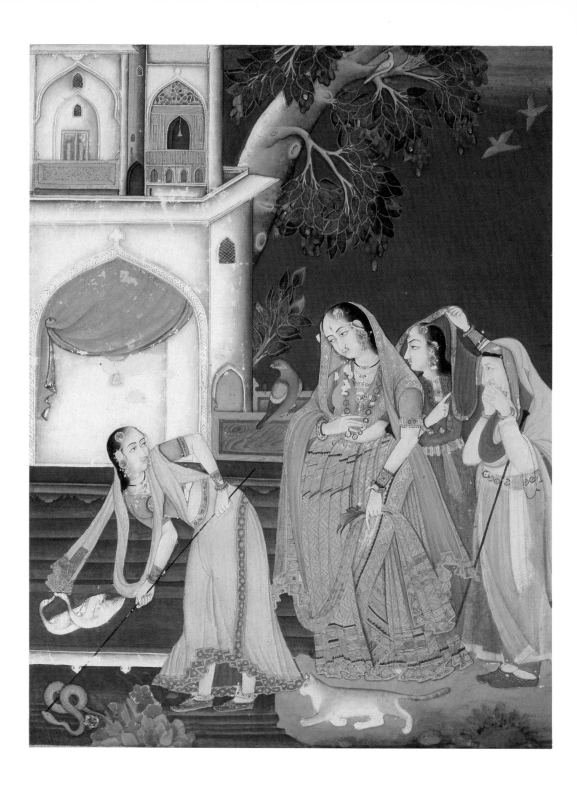

59 A princess watching a maid kill a snake.

Faizabad, about 1770. By Mir Kalan Khan.

[IOLR. Johnson Album 15, no.8 (213 × 168 mm).]

This strange subject no doubt reflects an actual incident in the life of a princess. The painting is a copy of a now lost original from Bijapur, as shown by the princess's costume (the voluminous Bijapuri sari as worn by Mahji in **46** for example), the architecture and the rich colouring. Characteristic of the early Oudh school under Mir Kalan Khan are the women's large oval faces and the brilliant yellowish light that plays upon them before a dark background. This artist and his school were much influenced by European *chiaroscuro* techniques.

60 Colonel James Skinner.

Delhi, about 1830.

[OMPB. Add.27254.f.4a (162 × 111 mm).]

James Skinner, the son of a Scottish father and Rajput mother, was one of the most interesting figures in India in the 19th century. Founder of the (still existing) regiment of Skinner's Horse, his famous 'Yellow-boys' – so-called from the colour of their uniforms – he patronised artists and men of letters from his base at Hansi in the Panjab, and was also himself an accomplished writer in Persian.

Delhi artists at this period were capable of working in a variety of styles, depending on whether the patron was

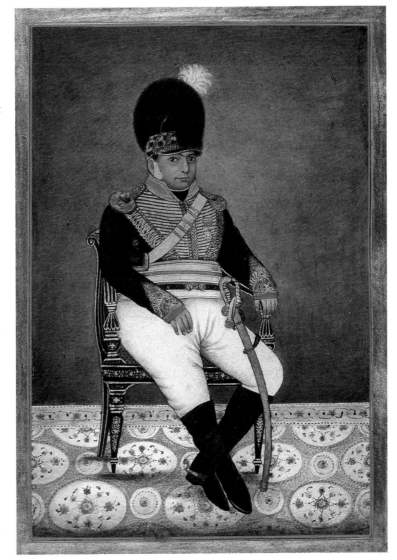

Indian or European. Skinner commissioned the Mughal artist Ghulam Murtaza Khan (see **63**) to paint his portrait in 1834, and this brilliantly incisive portrait may be an earlier version by the same hand. It is included in a manuscript of Skinner's notes on the royal houses of Rajasthan and the Panjab dated 1830, but it could have been pasted into the volume at a later date.

61 A ceremony by night on a terrace.

Mughal, about 1730. By Govardhan.

[IOLR. Johnson Album 1, no.28 (340 × 220 mm).]

A boy and a soberly dressed mullah and his assistant occupy the centre places in this enigmatic scene, perhaps representing the boy's initiation into an order. On either side stand girls and youths, gorgeously dressed and bearing gifts, their features exquisitely rendered in Govardhan's characteristic manner. The terrace and pavilions are bathed in a cold grey light from the star-sprinkled sky, a chilly effect much beloved of later 18th-century painters. (*See also the title page.*)

62 Bhajan Das Vairagi.

Delhi, about 1825.

[OMPB. Add.27255.f.376b (198 × 136 mm).]

Illustrated volumes of the castes and sects of the Hindus figure prominently in the books produced in the first half of the 19th century, and one of the most distinguished of them was commissioned by Colonel James Skinner (see 60). In it he had incorporated some powerful portraits of holy men, including this study of the Vairagi (or Vaishnava) ascetic Bhajan Das. Here the artist, who is possibly Ghulam 'Ali Khan, has found a most attractive compromise between Indian stylisation and European naturalism, using watercolour rather than the usual Indian medium of gouache.

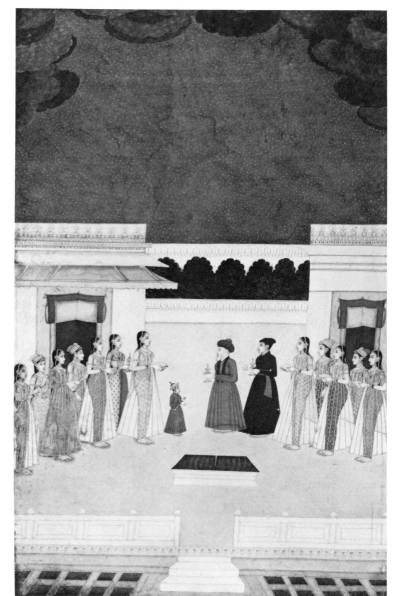

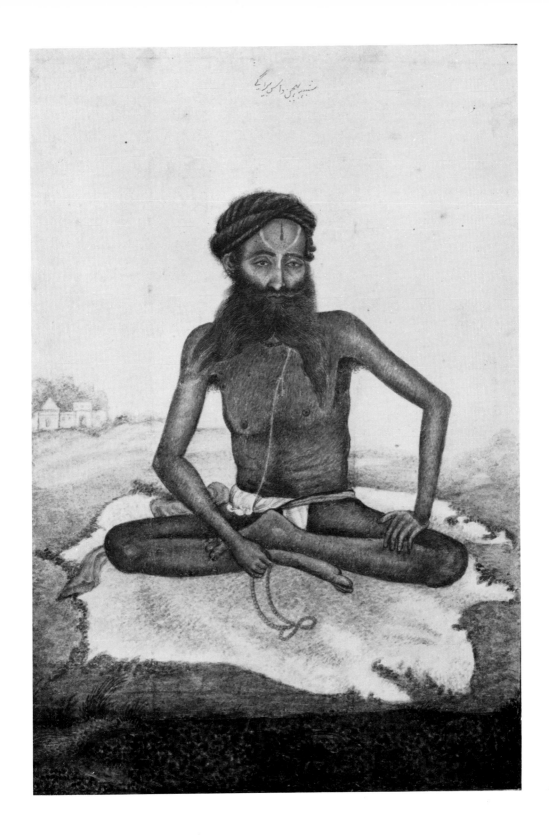

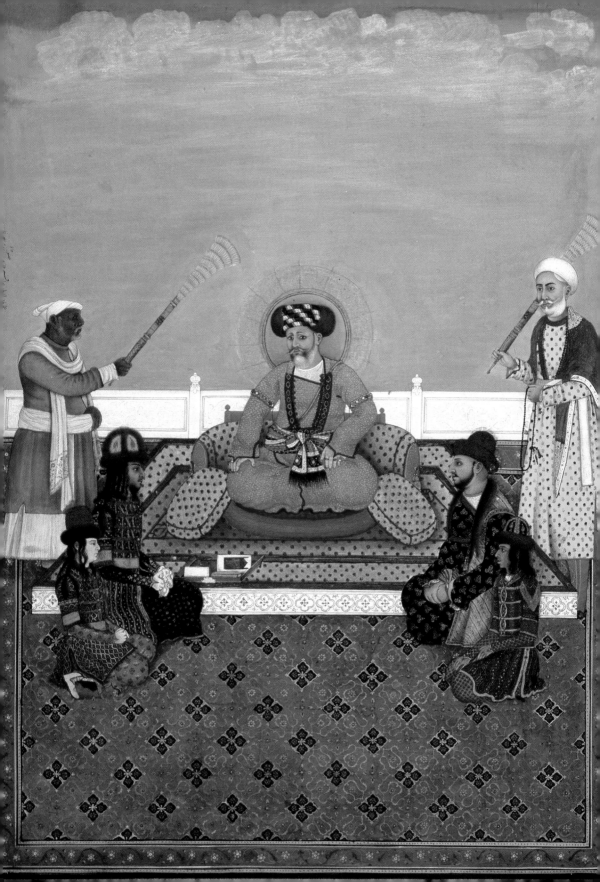

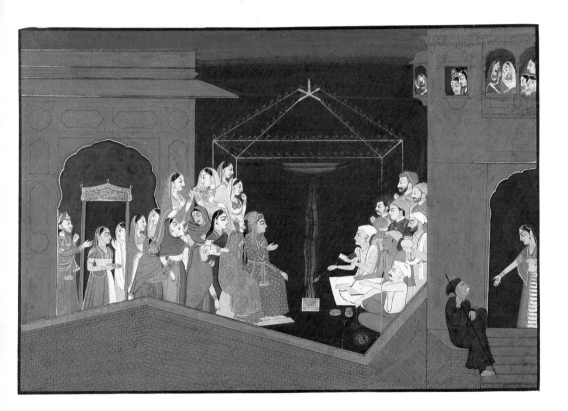

63 Akbar Shah II with his sons.

Delhi, about 1820. By Ghulam Murtaza Khan.

[IOLR. Add.Or.342 (382 × 279 mm).]

The penultimate Mughal Emperor, who reigned from 1806 to 1837, sits on a low dais, his pensive – indeed worried – gaze reflecting no doubt the reduced state of the Mughal emperors. Before him are four of his sons, the one nearer to him on his left being his eldest son, who succeeded him in 1837 and was deposed by the British for alleged conspiracy in the Indian Mutiny in 1857.

There are several such studies of the last emperors by this important artist, who was sufficiently accommodating to be able to change his style when painting commissions for British (or half-British) patrons such as Colonel James Skinner (see 60).

64 The marriage of Vasudeva and Devaki.

Basohli, about 1760.

[IOLR. Add.Or.1811 (227 × 334 mm).]

Within the high walls of a palace and under the night sky, Vasudeva and Devaki, the future parents of Krishna, are married. They wear the traditional marriage costumes, while the priests facing them add ghee to the sacred fire and chant the Vedic *mantras*.

Originally a 'fiery' Rajput school, Basohli work grew progressively 'cooler' during the 18th century, when it came under heavy Mughal influence. Here the vivid costumes of all the participants recall the original fiery reds of the Rajput style, in the midst of the cool greys, browns and mauves.

65 Lady on a terrace.

Patna, about 1764. By Dip Chand.
[IOLR. Add.Or.735 (209 × 131 mm).]

The lady sits confidently on a
European chair smoking a hookah,
on the bank of the Ganges, whose
immense width at Patna is
admirably caught by the artist. On
the reverse the initials 'W.F. 1764'
indicate that it was part of William
Fullerton's collection, formed
mostly when he was surgeon to the
Patna Agency from 1763–6. The
lady, whose name is given as
Muttubby by Fullerton, has a
companion portrait in mirror
reverse of Ashraf 'Ali Khan,
foster-brother of the Mughal
Emperor Ahmad Shah but who
resided in Patna, suggesting that
she was Ashraf 'Ali's mistress.

66 The Emperor Muhammad Shah and his Vizier.

Mughal, about 1735. By
Govardhan.
[IOLR. Johnson Album 38, f.7b
(192 × 148 mm).]

Muhammad Shah (reigned
1719–48) presided over the
catastrophic decline of the Mughal
empire from imperial splendour to
abject dependence on the whim of
semi-barbarous guerilla chieftains,
and witnessed in 1739 the sack of
Delhi by the Afghan Nadir Shah
and the looting of the accumulated
treasure of two centuries. Painting
in his reign is characterised by an
assured technique accompanied by
a hardness of line and an icy
stiffness and formality.

Here the Emperor is depicted
holding a turban jewel, with
before him his Vizier, Itimad ad-

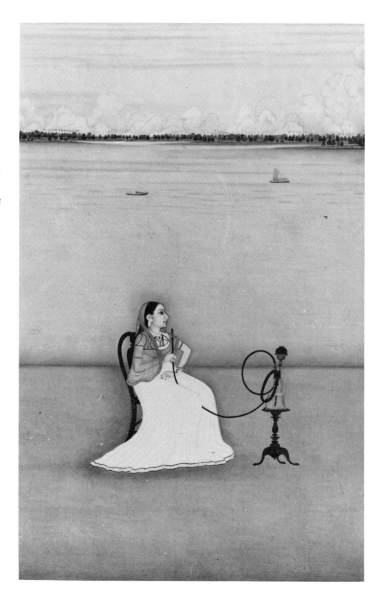

Daula Qamar ad-Din Khan
(d.1748). This double portrait
forms the frontispiece to a
romance in Persian by the Hindu
poet Rai Anand Ram, who held an
official position under the Vizier,
and who dedicated the work to the
Emperor.

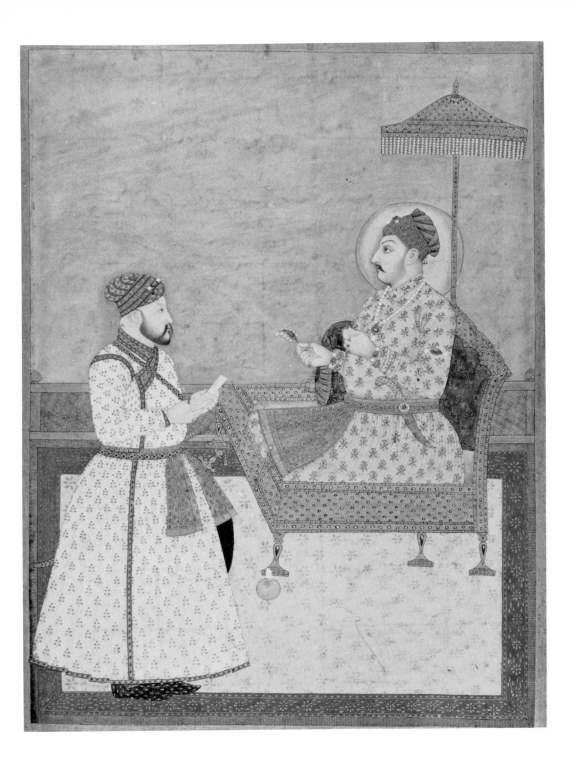

67 The death of Krishna.

Murshidabad, about 1780.

[OMPB. Add.5640, f.418b (232 × 293 mm).]

At the end of the *Mahabharata*, the Great Epic of India,
Krishna is shot by mistake by a hunter, and the arrow pierces
the sole of his foot, his only vulnerable part. Seated under a
great fig tree, Krishna reassumed his divine form to the
accompaniment of the heavenly musicians and watched by sages
and princes.

This painting is part of a set of *Mahabharata* paintings
commissioned by Sir Elijah Impey, Chief Justice of Bengal in
Calcutta from 1774 to 1783, from artists in Murshidabad, the
chief centre of painting in eastern India in the second half of the
18th century.

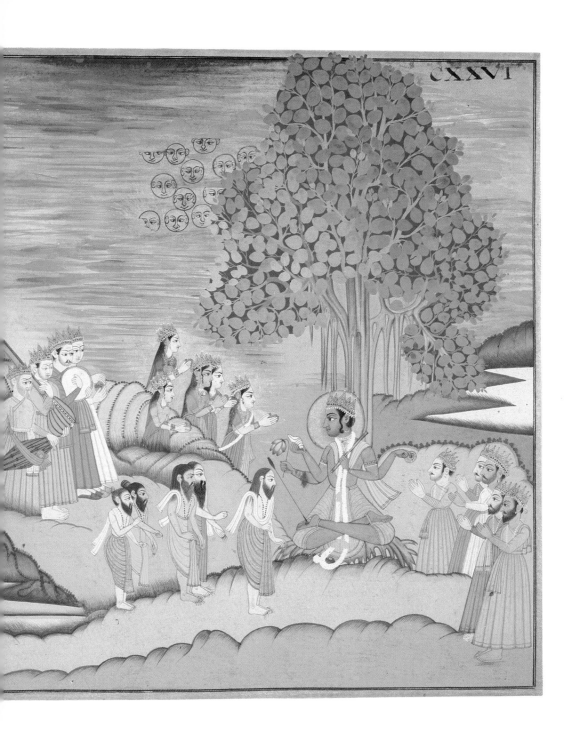

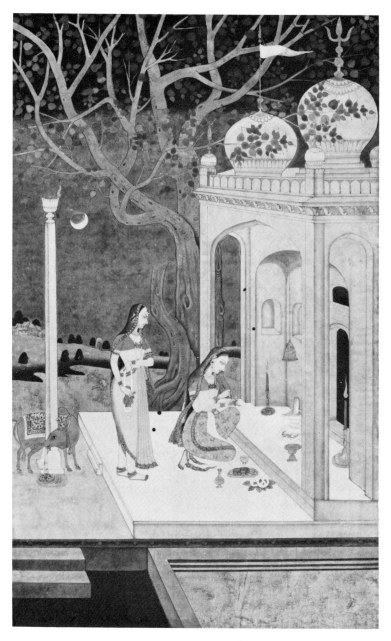

68 Bhairavi ragini.

Hyderabad, about 1760.

[IOLR. Johnson Album 37, no.35 (240 × 150 mm).]

One of the most common examples of Indian painting in the 17th and 18th centuries was the *ragamala* album, consisting of (usually) thirty-six paintings illustrating verses in Sanskrit or Hindi which describe one or other of the Indian *ragas*, or musical modes. The origins of this fusion of music, poetry and painting are obscure, but certainly it was a much-favoured subject among Hindu patrons, and by this date also among Muslim patrons.

Here, from a brilliant album produced in Hyderabad in the mid-18th century, a maiden brings offerings to a shrine to the god Siva. Like many in this set, the action takes place at night.

69 Durgashankar Pathak and his nephew.

Benares(?), about 1840.

[OMPB. Or.5259.f.29a (202 × 160 mm).]

Durgashankar Pathak was a famous Benares astronomer, who is here depicted teaching his nephew Jatashankara to use an instrument for calculating the sun's elevation.

Dwarfed both by the huge apparatus and the immensity of the sky above, the two astronomers are rendered in a precisely detailed fashion that suggests descent from the provincial Mughal style, or more likely, a Delhi artist working in Benares.

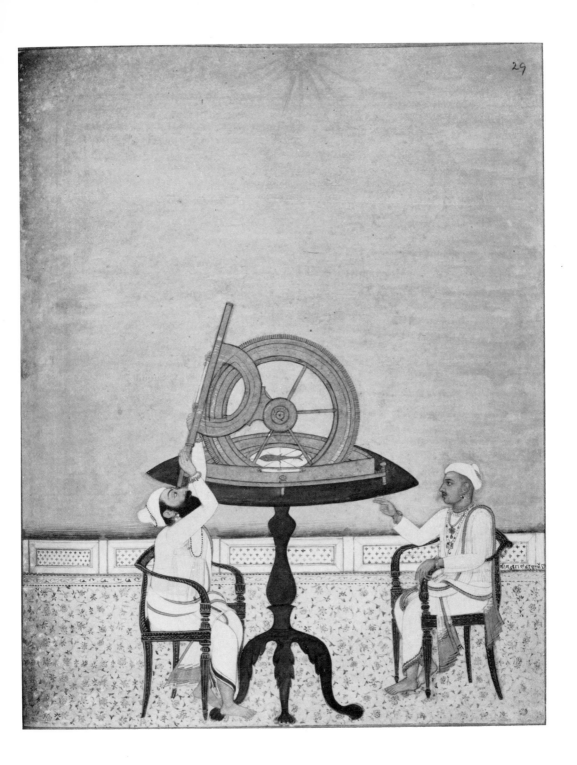

Guide to further reading

For a general overview of Indian painting, the best book remains D. Barrett and B. Gray, *Indian Painting* (Geneva, 1963). Manuscript illustration has been surveyed by J. P. Losty in *The Art of the Book in India* (London, 1982). Few definitive studies of individual schools have been published, but among the best are W. G. Archer, *Indian Painting from the Punjab Hills* (London, 1973); M. Zebrowski, *Deccani Painting* (London, 1982); M. C. Beach, *Rajput Painting at Bundi and Kotah* (Ascona 1974); A. Topsfield, *Paintings from Rajasthan in the Collection of the National Gallery of Victoria, Melbourne* (1980). For Mughal painting, no one has yet produced a definitive modern history, so that exhibition or collection catalogues remain for the present the most useful books on the subject. These include: *The Library of A. Chester Beatty: a catalogue of the Indian miniatures*, by Sir Thomas W. Arnold, ed. J. V. S. Wilkinson (London, 1936); *The Grand Mogul* (Williamstown, 1978), and *The Imperial Image* (Washington, 1982), both by M. C. Beach; *The Art of Mughal India*, by S. C. Welch (New York, 1963); and *Indian Miniatures in the India Office Library* (London, 1981), by T. Falk and M. Archer. The pioneering work by F. R. Martin, *The miniature paintings and painters of Persia, India, and Turkey* (London, 1912) is still useful, as are the slightly later *Indian painting under the Mughals* (Oxford, 1924), by P. Brown, and *La peinture indienne a l'époque des grands moghols* (Paris, 1929), by I. Stchoukine.

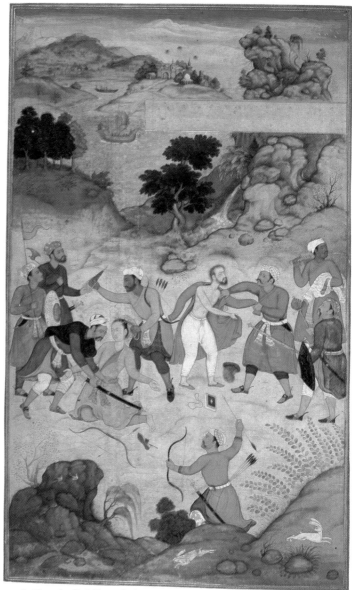

70 (*Above*): Sa'di and the boastful young man.

Mughal, 1605–10.

[OMPB. Or.5302, f.103a (293 × 175 mm).]

The poet and moralist Sa'di tells the story of how he had set off through a wild region in the company of a well-armed young man, who had boasted of his skill at arms. On being attacked, however, the man was the first to beg the robbers to spare his life.

Sa'di ruefully declares that one should not put trust in boasters.

This is one of the most successful Mughal attempts at depicting a receding landscape, which, combined with the three-dimensional studies of the robbers and their victims, makes it also one of the most naturalistic. The type of faces and stances suggests an attribution to Sur Das Gujarati (see **25**).

five-star food

When it comes to making delicious meals the Food Optimising way, five is definitely the magic number! Every recipe in this essential collection of more than 60 irresistibly easy taste sensations uses just five ingredients. It'll transform how you cook – and make losing weight a daily delight!

We've sorted the recipes into six simple chapters – beef, lamb, pork, poultry, fish and vegetables – and you can choose from perfect plates including hot chilli sausage salad, saucy beef & bean hotpot and cod with shrimps & samphire.

Every dish can be enjoyed just as it is – though if you feel like adding potatoes, rice, extra Speed veggies or salad, go for it! As well as being our simplest cookbook yet, many meals are Free and lots are ideal for Extra Easy *SP*.

your storecupboard

There are just three ingredients that we haven't counted among the five for each recipe. We're pretty sure you'll have them in your kitchen already!

- salt (sea salt for the best flavour)
- black pepper (freshly ground if possible)
- low-calorie cooking spray

it's as easy as
1,2,3, . . .*4, take* **5**

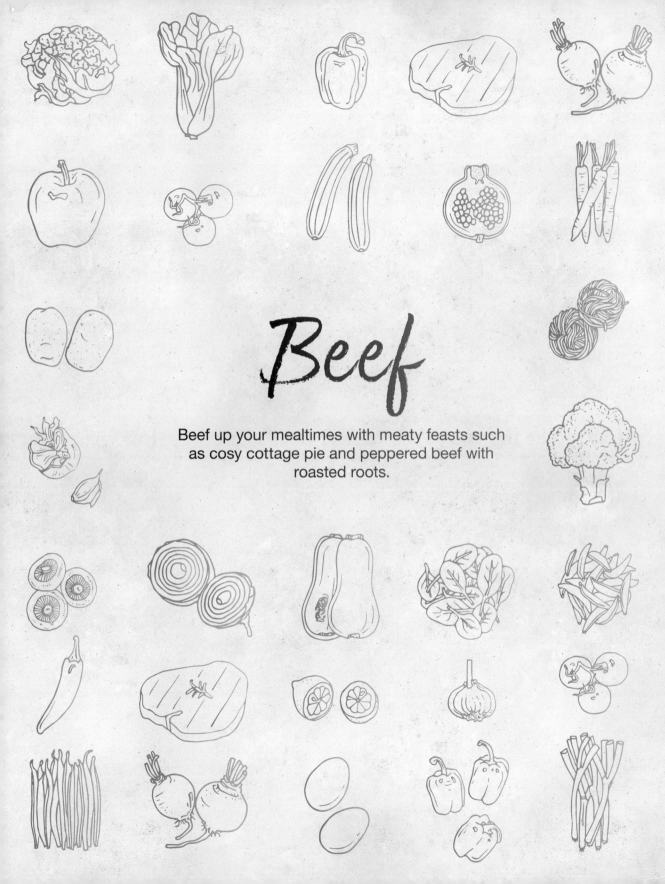

Beef

Beef up your mealtimes with meaty feasts such as cosy cottage pie and peppered beef with roasted roots.

500g lean beef mince
(5% fat or less)

2 x 400g cans chopped
tomatoes with onion
and garlic

3 aubergines, sliced

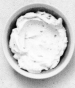

150g extra-light soft
cheese with garlic
and herbs

3 eggs, beaten

beef and aubergine bake

Beef goes brilliantly with smoky aubergines in this delicious dish – make sure you get a good charring on the aubergines for maximum smokiness!

serves 4

2½ **Syns** per serving

ready in 1 hour 20 minutes

Preheat the oven to 190°C/fan 170°C/gas 5.

Spray a large non-stick frying pan with low-calorie cooking spray and place over a medium heat. Add the beef and cook for about 5 minutes or until browned, breaking up any lumps with the back of a wooden spoon. Drain off any fat then stir in the chopped tomatoes and bring to the boil over a high heat. Cover, reduce the heat to low and simmer for 15 minutes. Season to taste.

Meanwhile, spray the aubergines with low-calorie cooking spray on both sides and season lightly. Place a non-stick griddle pan or frying pan over a high heat and, working in batches, cook the aubergines for 4 minutes or until charred. Turn, spray with more low-calorie cooking spray, season and cook for a further 2-3 minutes.

Add alternating layers of beef and aubergine to a 1.5-litre ovenproof dish, finishing with a layer of aubergines. Beat the soft cheese and eggs together, pour over the top and bake for 40 minutes or until golden.

If you have some ground cinnamon, add 1 tsp with the beef to turn this into an easy moussaka!

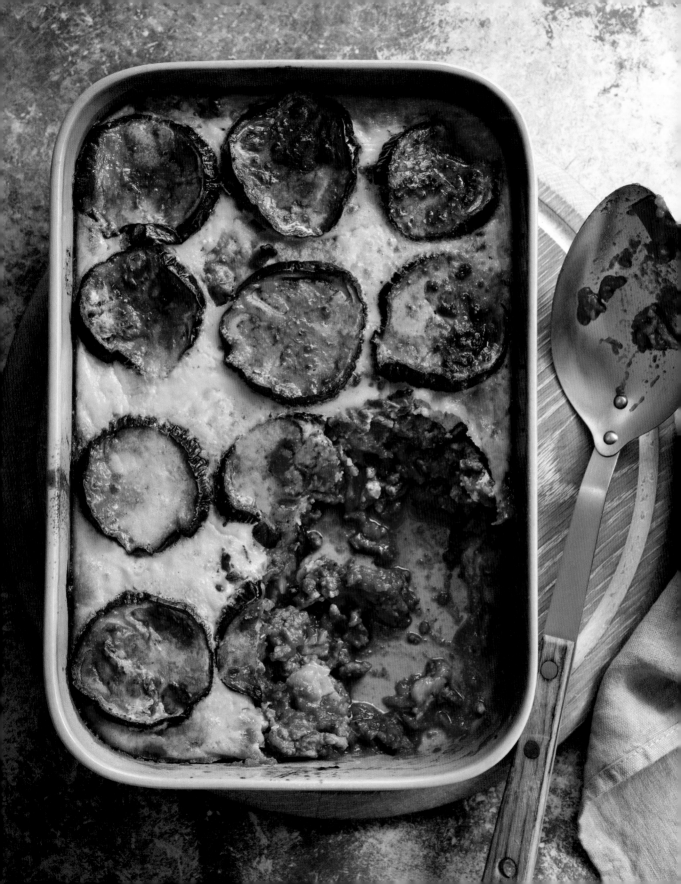

4 large red onions

300g fat-free natural Greek yogurt

2 tbsp curry powder (heat to your taste)

800g lean beef medallion steaks, visible fat removed

4 peppers (any colours), deseeded and cut into large chunks

beef tikka kebabs

These Indian-style skewers make a great midweek meal all year round and they're also a hit on the barbecue (see our tip below).

serves 4 (makes 8)

Free

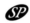

ready in 30 minutes, plus marinating

Roughly chop 1 onion and put in a food processor with the yogurt and curry powder. Whizz to a smooth paste, season lightly and transfer to a bowl. Cut the beef into large chunks, add to the bowl and toss to coat well. Cover and chill for 2 hours or longer if you have time.

Preheat the grill to high.

Cut the remaining onions into large chunks and thread on to 8 skewers (if you're using wooden skewers, soak them in water for at least 20 minutes first) along with the marinated beef and the peppers. Arrange in a single layer on a foil-lined grill pan, season with freshly ground black pepper and grill for 8-10 minutes on each side or until juicy and beginning to brown.

These spicy skewers are perfect on your barbecue: cook over direct high heat for 10-12 minutes, turning once.

675g lean beef
casserole steak,
visible fat removed

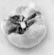

750g mixed casserole
veg or casserole
veg pack

1 garlic bulb, halved
through the cloves

small pack fresh thyme

400g long-stem broccoli

hearty beef stew

This easy stew has a wonderful flavour thanks to the mashed garlic and thyme – you'd never know there are only five ingredients!

serves 4

Free

SP (if your casserole veg are all Speed)

ready in 2 hours
15 minutes

Preheat the oven to 180°C/fan 160°C/gas 4.

Spray a heavy-based non-stick casserole pan with low-calorie cooking spray and place over a medium heat. Cut the beef into chunks, add to the pan and brown in batches. Transfer each batch to a plate and set aside.

If you're using a casserole veg pack with whole vegetables, peel the veg and cut into bite-size chunks. Spray the pan with a little more low-calorie cooking spray and fry the casserole vegetables for about 5 minutes. Return the beef to the pan, add the garlic, pour over 600ml boiling water and push most of the thyme under the water. Season lightly, bring to the boil and cover. Transfer to the oven and cook for 1½ hours or until tender.

Remove the pan from the oven and discard the thyme. Pop the garlic cloves from their skins into a bowl, discarding the skins. Add a large spoonful of vegetables from the pan, purée with a stick blender and return to the pan. Pop the pan back in the oven for another 30 minutes or until the beef is meltingly tender.

When the stew is nearly ready, boil or steam the broccoli until tender and drain well. Pick the leaves from the remaining thyme sprigs.

Ladle the stew into shallow bowls, scatter over the thyme and serve with the broccoli.

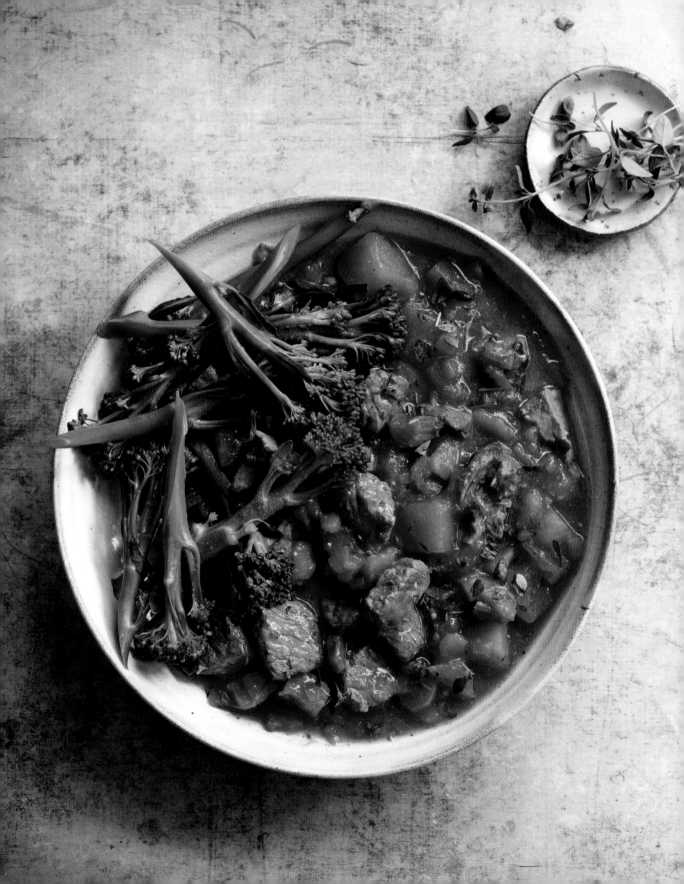

500g lean beef mince
(5% fat or less)

3 peppers (any colours),
deseeded and cut
into chunks

400g can mixed beans
in a mild chilli sauce

2 large courgettes

50g reduced-fat Cheddar
cheese, coarsely grated

saucy beef and bean hotpot

The whole family will love this easy everyday meal, with the quirky courgette topping making a great alternative to potatoes.

serves 4

2 Syns per serving

ready in 1 hour

Preheat the oven to 200°C/fan 180°C/gas 6.

Spray a large non-stick frying pan with low-calorie cooking spray and place over a medium heat. Add the beef and brown for about 5 minutes, breaking up any lumps with the back of a wooden spoon. Drain off any fat then stir in the peppers, beans and the chilli sauce in the can. Bring to the boil, cover and simmer over a low heat for 15 minutes.

Meanwhile, peel the courgettes into long thin ribbons using a vegetable peeler, pat dry with kitchen paper and spray with low-calorie cooking spray.

Tip the beef mixture into a 1.5-litre ovenproof dish, season lightly and arrange the courgettes in ripples on top to cover the beef mixture completely. Scatter over the cheese and bake for 25 minutes or until golden.

For a really golden topping, pop the finished dish under the grill for 5-10 minutes.

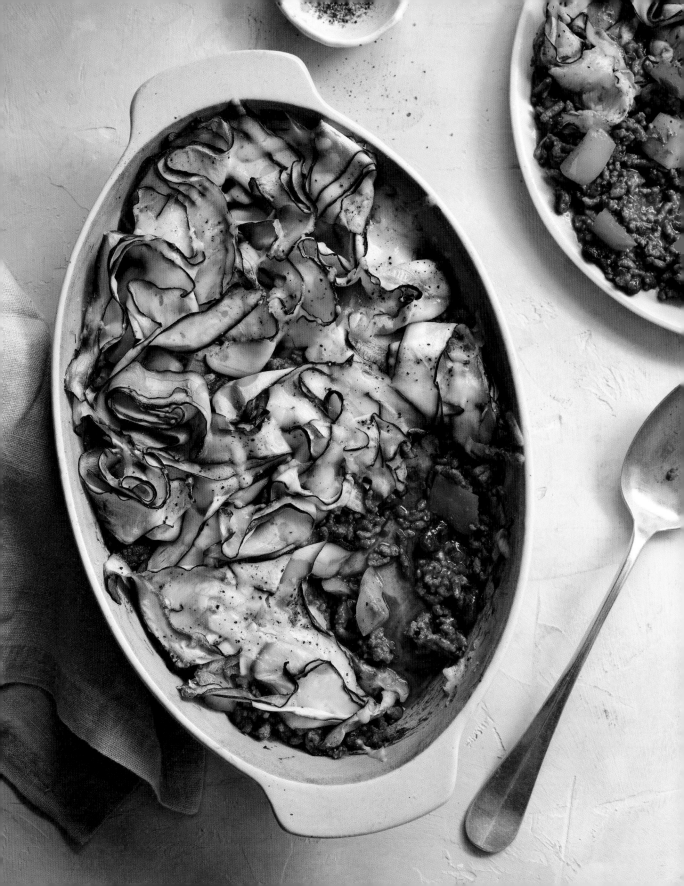

600g lean beef steak, visible fat removed, sliced

4 level tbsp teriyaki sauce

300g dried egg noodles

600g mixed stir-fry vegetables (see tip)

1 heaped tsp Chinese five-spice powder

beef teriyaki with five-spice noodles

Teriyaki is a Japanese method of cooking using a sweet, salty marinade and it works like a charm with beef in this sizzling stir-fry.

serves 4

1 Syn per serving

ready in 15 minutes, plus marinating

Toss the steak and teriyaki sauce in a bowl to coat well then cover and leave to marinate for 20 minutes or longer if you have time.

Cook the noodles according to the pack instructions then drain well, rinse under cold water and set aside.

Spray a large non-stick wok or frying pan with low-calorie cooking spray and place over a high heat. Stir-fry the beef in batches for 2 minutes or until browned, then transfer to a bowl and keep warm.

Wipe the wok, spray with a little more low-calorie cooking spray and stir-fry the vegetables for 1-2 minutes. Mix the five-spice powder with 150ml cold water, add to the vegetables and bring to the boil. Return the beef to the wok, add the noodles and stir-fry for a further 2 minutes to heat through. Serve hot.

Look for colourful stir-fry mixes made with lots of different vegetables and textures, all cut to a similar size to ensure even cooking.

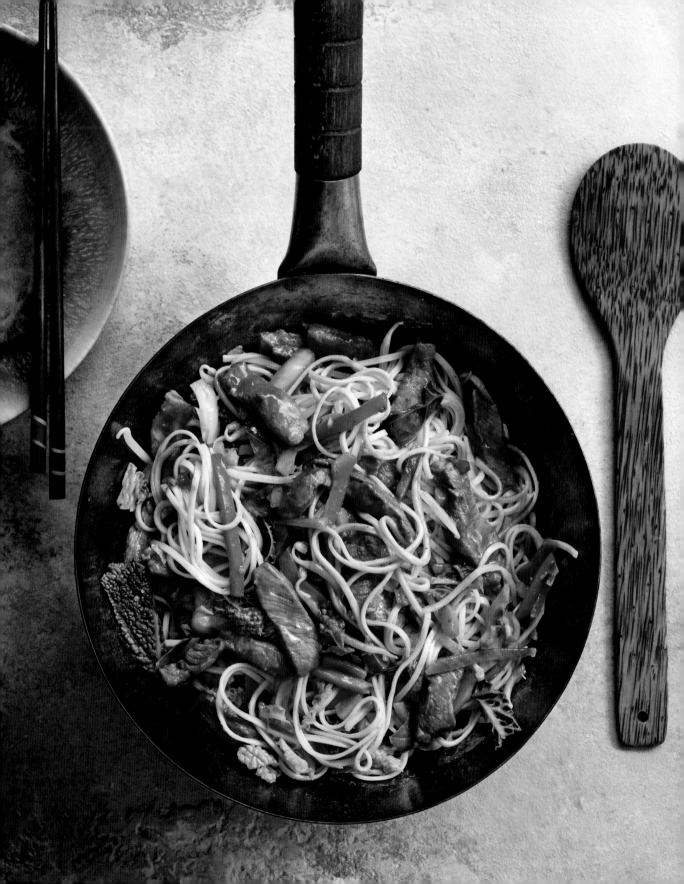

4 medium sweet potatoes, peeled and cut into chunks

400g green beans, trimmed

4 lean beef steaks, visible fat removed

300g mini portobello or chestnut mushrooms

1 tbsp chopped fresh rosemary, plus sprigs to garnish

steak and mushrooms

Meat-lovers will adore this simple yet very special steak supper, served with delicious mushrooms, green beans and filling sweet potato mash.

serves 4

Free

ready in 20 minutes

Cook the sweet potatoes in a saucepan of boiling water over a high heat for 12-15 minutes or until tender. Drain well, mash and season to taste.

Meanwhile, put the green beans in another saucepan of boiling water over a high heat and cook for 8-10 minutes. Drain well.

Once the green beans are cooking, place a large non-stick griddle pan or frying pan over a high heat (you might need to use 2 pans or cook in batches). Spray the steaks and mushrooms on both sides with a little low-calorie cooking spray and season lightly. Fry the steaks and mushrooms for 2 minutes, turning the mushrooms often to stop them catching. Sprinkle over the rosemary, turn the steaks and cook for a further 1-2 minutes (see tip).

Rest the steaks for a few minutes then pile on to plates with the mushrooms, mash and green beans. Garnish with rosemary sprigs and serve hot.

The frying times above are for rare steaks. Cook for 3 minutes each side for medium and 4 minutes each side for well done.

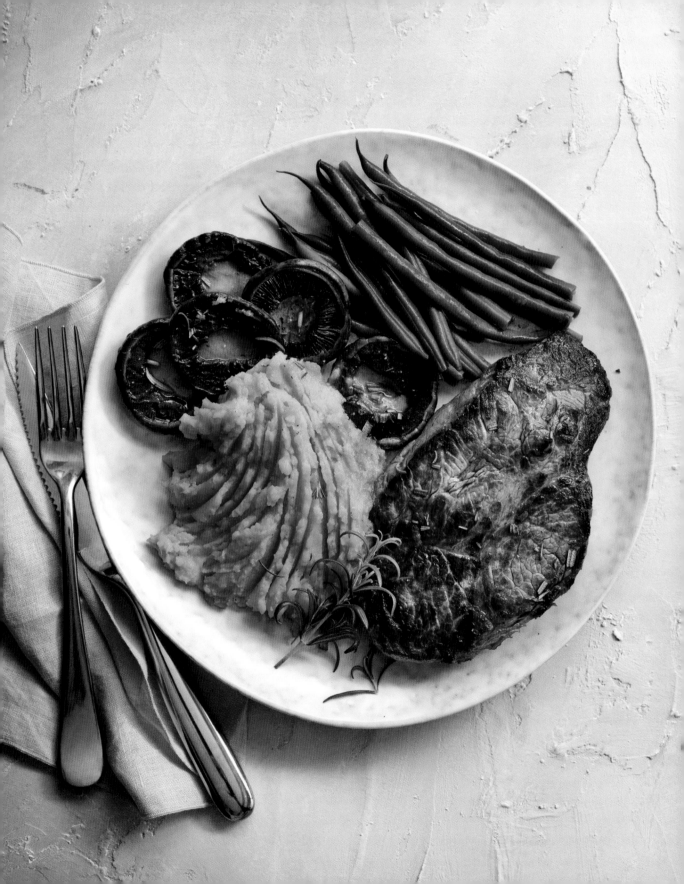

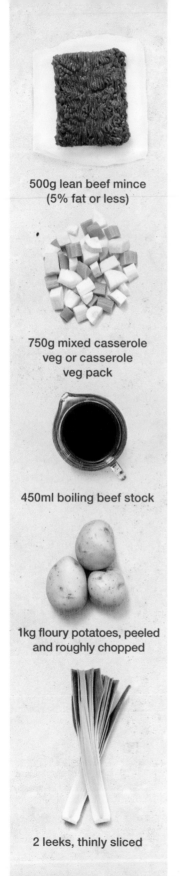

500g lean beef mince
(5% fat or less)

750g mixed casserole
veg or casserole
veg pack

450ml boiling beef stock

1kg floury potatoes, peeled
and roughly chopped

2 leeks, thinly sliced

cosy cottage pie

On a cold night, this satisfying Free beefy pie topped with leek and potato mash is just what the doctor ordered!

serves 4
Free
ready in 45 minutes

Spray a large non-stick frying pan with low-calorie cooking spray. Place over a medium heat, add the beef and brown for about 5 minutes, breaking up any lumps with the back of a wooden spoon. Drain off any fat.

If you're using a casserole veg pack with whole vegetables, peel and chop the veg. Add the casserole veg to the pan along with the stock. Bring to the boil over a high heat, stirring occasionally, then reduce the heat to low, cover and simmer for 30 minutes.

Meanwhile, cook the potatoes in a saucepan of boiling water over a high heat for 12 minutes or until just tender. Add the leeks and cook for a further 4-5 minutes. Drain well, tip back into the saucepan and leave to steam for a few minutes to drive off any excess moisture. Mash well and season to taste.

Uncover the beef, bring to the boil over a high heat and cook for 5 minutes to reduce any liquid to a nice coating consistency. Season to taste.

Preheat the grill to hot.

Tip the beef mixture into a 1.5-litre ovenproof dish, spoon over the mash to cover completely and smooth with a fork. Spray with low-calorie cooking spray and grill for 3-4 minutes or until golden.

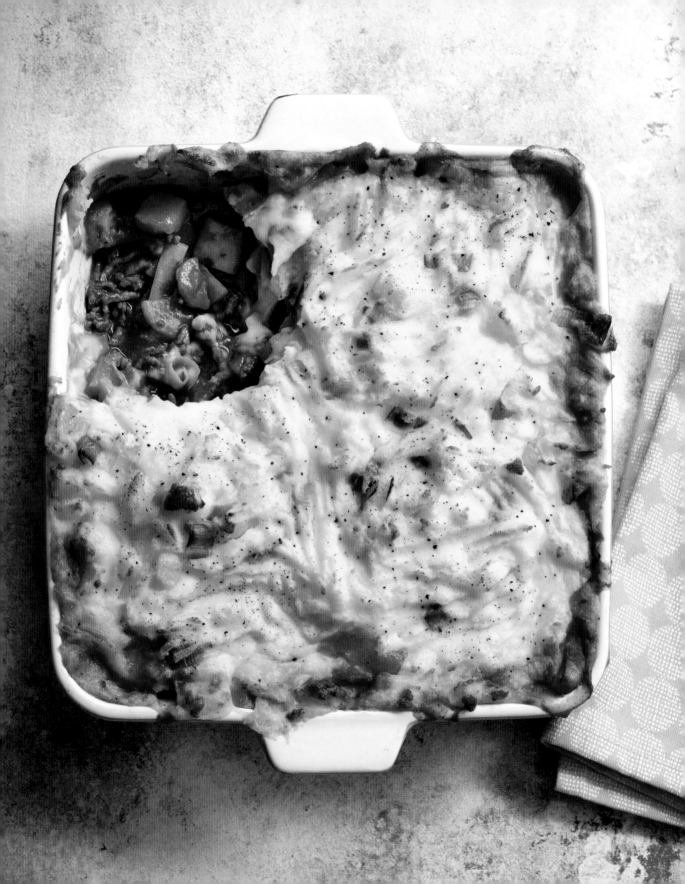

small pack fresh
coriander, leaves and
stalks roughly chopped

500g lean beef mince
(5% fat or less)

2 tbsp tikka curry
powder (or to taste)

2 carrots, peeled and
coarsely grated

198g can sweetcorn
with peppers,
drained and dried

beef and sweetcorn koftas

These mouth-watering meatballs are sensational
eaten straight from the oven – and just as tasty
eaten cold as food on the go.

serves 4 (makes 24)

Free

❄ (uncooked koftas)

ready in 40 minutes

Preheat the oven to 200°C/fan 180°C/gas 6.

Put most of the coriander in a large bowl,
reserving a few chopped leaves. Add the
beef, curry powder, carrots, sweetcorn and
a little seasoning. Mix well and divide the
mixture into 24 equal-sized balls.

Arrange the koftas on a baking tray, spaced
well apart, spray with low-calorie cooking
spray and bake for 25-30 minutes or until
cooked through and beginning to brown.

Scatter with the remaining coriander to serve.

*These tempting koftas
are fantastic with a little
mango chutney (1 level
tbsp is 1½ Syns).*

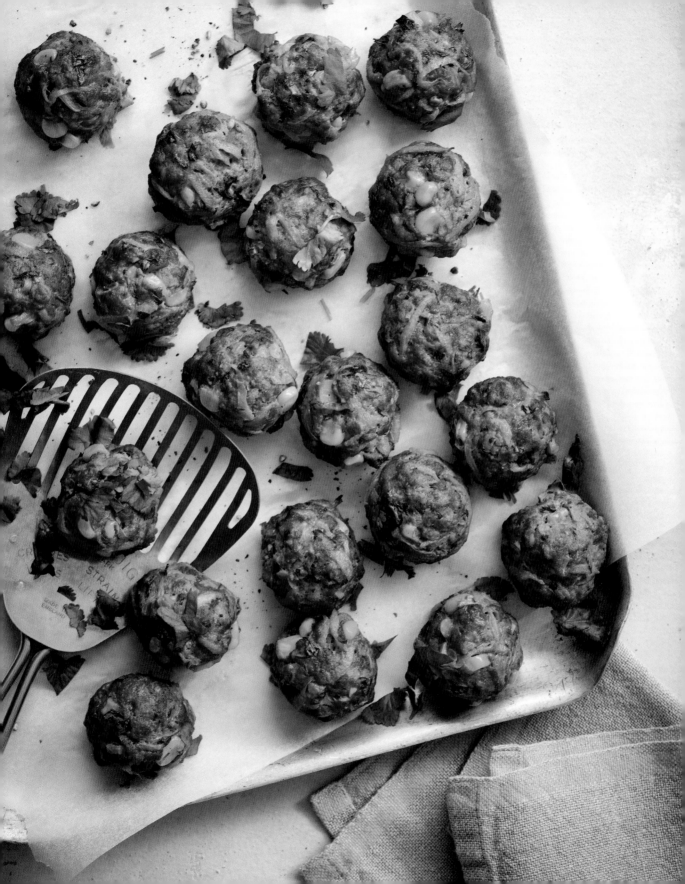

6 carrots, peeled and quartered

6 parsnips, peeled and quartered

4 beetroots, peeled and cut into wedges

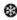

a few fresh rosemary sprigs, leaves picked, plus sprigs to garnish

1.5kg corner cut topside of beef, visible fat removed

peppered beef with roasted roots

Sunday lunch doesn't get any simpler than this: just five fab and Free ingredients all cooked in one tin.

serves 4

Free

❄️

ready in 1½ hours, plus resting

Preheat the oven to 240°C/fan 220°C/gas 9.

Pile the veg into a large roasting tin and add the rosemary. Spray with a little low-calorie cooking spray, toss well and spread out the veg in an even layer.

Lightly crush 2 tbsp peppercorns from your pepper mill (mixed peppercorns are ideal if you have them) and spread them out on a large board or plate. Spray the beef joint with a little low-calorie cooking spray and roll in the pepper to coat. Season with a little salt and arrange on top of the vegetables. Put the tin in the oven, reduce the temperature to 200°C/fan 180°C/gas 6 and cook for 30 minutes.

Remove the tin from the oven and shake well to toss the vegetables. Return to the oven and cook for another 45 minutes.

Remove the tin from the oven, cover the meat with foil and set aside to rest for 10 minutes. Transfer the veg to a hot plate, cover and keep hot. Add a splash of boiling water to the roasting tin, scrape up the tasty bits and pour the juices into a heatproof jug, skimming off any fat with a spoon.

Carve the beef and put on to plates with the root vegetables and the cooking juices poured over. Garnish with rosemary sprigs to serve.

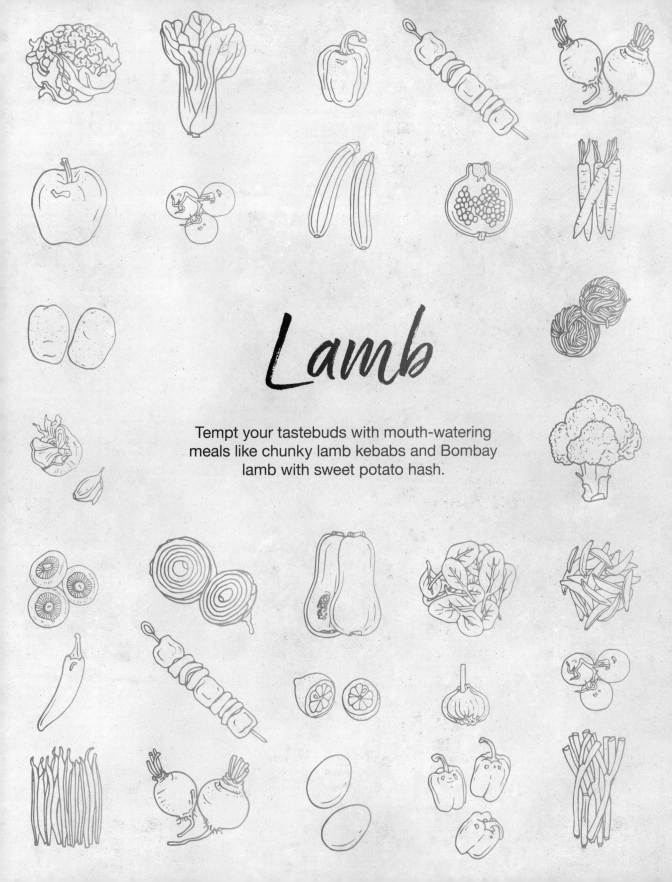

Lamb

Tempt your tastebuds with mouth-watering meals like chunky lamb kebabs and Bombay lamb with sweet potato hash.

4 medium sweet potatoes, peeled and cut into small chunks

1 tbsp tikka curry powder

2 red chillies, 1 finely chopped and 1 sliced

500g lean lamb leg steaks, visible fat removed, cut into bite-size chunks

200g Savoy cabbage, cored and shredded

bombay lamb and sweet potato hash

Lamb, sweet potatoes and sizzling spices go together brilliantly in this Indian-style feast.

serves 4

Free

ready in 30 minutes

Spray a large non-stick frying pan with low-calorie cooking spray and place over a medium heat. Add the sweet potatoes and fry for 5 minutes or until they begin to colour, shaking the pan often.

Sprinkle over the curry powder and stir-fry for 1-2 minutes. Add the chopped chilli and pour over 300ml boiling water. Bring to the boil over a high heat, cover and cook for a further 7-8 minutes or until the sweet potatoes are tender. Drain, tip into a bowl and keep warm (or use the liquid as a sauce if you like).

Wipe the pan and spray with a little more low-calorie cooking spray. Add the lamb and cook for 2-3 minutes or until browned then scatter over the cabbage and cook for a further 3 minutes, stirring frequently.

Return the sweet potatoes to the pan and stir-fry for 1 minute more to heat through. Season to taste, scatter over the sliced chilli and serve hot.

For a milder, more savoury dish, swap the chilli for 3 chopped garlic cloves, adding them with the boiling water.

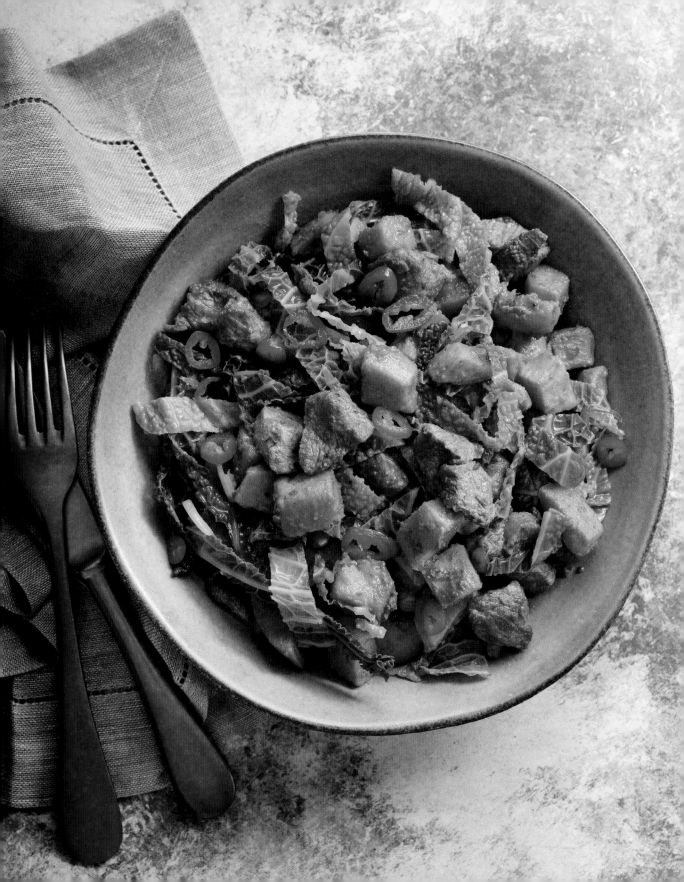

3cm piece fresh root ginger

3 large garlic cloves, crushed

8 small or 4 large lean lamb leg steaks, visible fat removed

2 large red chillies, deseeded and chopped

450g spring greens, sliced

chargrilled lamb with chilli greens

Stir-fries don't get any simpler than this and the lamb steaks are a delicious treat for meat-lovers.

serves 4

Free

ready in 15 minutes, plus marinating

Peel the ginger, cut half into matchsticks and finely grate the rest. Strain the juice from the grated ginger into a shallow dish, discarding the pulp, and add one-third of the garlic and a little seasoning. Stir then add the lamb steaks and turn to coat well. Cover and marinate for 15 minutes.

Place a large non-stick griddle pan or frying pan over a high heat. When it's smoking hot, add the lamb steaks and cook for 2½ minutes on each side or until nicely charred on both sides. Lift on to a plate, cover and leave to rest for 5 minutes.

Meanwhile, spray a large non-stick wok or frying pan with low-calorie cooking spray and place over a high heat. Stir-fry the ginger matchsticks, remaining garlic and most of the chilli for 30-40 seconds. Add the spring greens and 3 tbsp water and stir-fry for 3-4 minutes.

Divide the greens and steaks between plates and serve hot with the remaining chilli scattered over.

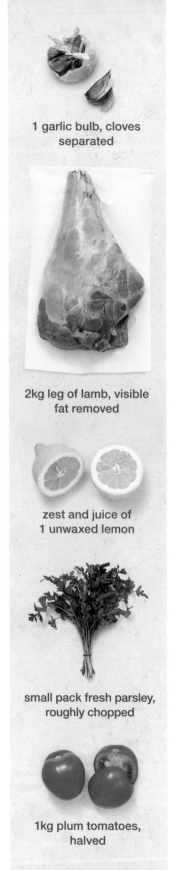

1 garlic bulb, cloves
separated

2kg leg of lamb, visible
fat removed

zest and juice of
1 unwaxed lemon

small pack fresh parsley,
roughly chopped

1kg plum tomatoes,
halved

roast lamb with gremolata

This Sunday roast is full of fresh and zingy flavours – perfect for a special lunch with friends or family.

serves 6

Free

ready in 2 hours
15 minutes, plus resting

Preheat your oven to 180°C/fan 160°C/gas 4.

Peel half of the garlic cloves and cut each of them into 3-4 thick slivers. Make small cuts in the flesh of the lamb and push in the garlic slivers. Season lightly and place in a roasting tin. Spray with low-calorie cooking spray and roast for 2 hours 5 minutes for medium (if your lamb leg isn't 2kg, roast for 25 minutes per 500g, plus 25 minutes).

To make the gremolata, peel 2 garlic cloves and grate into a bowl. Add the lemon zest and parsley. Season, mix and set aside.

About 1 hour before the end of the cooking time, scatter the remaining garlic cloves, skins left on, around the lamb. About 30 minutes before the end of the cooking time, scatter the tomatoes into a second roasting tin, cut-side up. Spray with low-calorie cooking spray and season lightly. Pick out the garlic cloves from the lamb tin and remove the skins, then mash the garlic, cover and set aside. Roast the lamb and tomatoes for the final 30 minutes.

Turn off the oven, remove the lamb, cover with foil and rest for 15 minutes. Leave the tomatoes in the oven while the lamb is resting.

Spoon some gremolata on to the lamb and tomatoes then carve the lamb. Sprinkle over the lemon juice then mix any tomato juices with the mashed garlic and serve with the lamb, tomatoes and remaining gremolata.

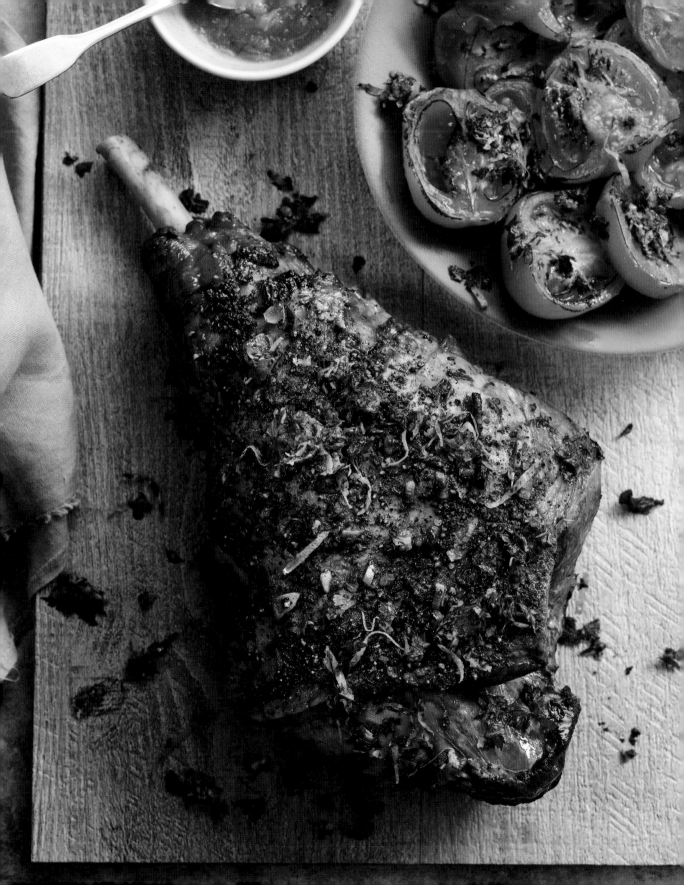

3 unwaxed lemons

2 tsp sweet
smoked paprika

500g lean lamb leg
steaks, visible
fat removed

3 peppers (any colours),
deseeded and cut
into chunks

2 medium courgettes,
sliced

chunky lamb kebabs

For the best flavour, prepare these tasty skewers in advance and marinate in the fridge until your guests arrive. They're also fab on the barbie (see our tip)!

serves 4 (makes 8)

Free

ready in 30 minutes,
plus marinating

Finely grate the zest and squeeze the juice from 1 lemon into a bowl and stir in the paprika and a little seasoning. Cut the lamb into bite-size chunks, add to the bowl and mix to coat well. Cover and leave to marinate for a few hours if you have time.

Preheat the grill to medium.

Cut the remaining lemons into thin wedges and thread on to 8 metal skewers (or wooden skewers that have been soaked for 20 minutes) along with the lamb, peppers and courgettes, taking care not to pack everything too closely together or the lamb won't cook evenly.

Arrange the skewers in a single layer on a foil-lined grill pan and grill for 15-20 minutes or until cooked to your liking, turning frequently. Serve hot, discarding the lemon wedges as you eat.

These kebabs are also fantastic on the barbecue. Cook over a direct medium heat for 8 minutes for medium-rare or 12 minutes for well done, turning frequently.

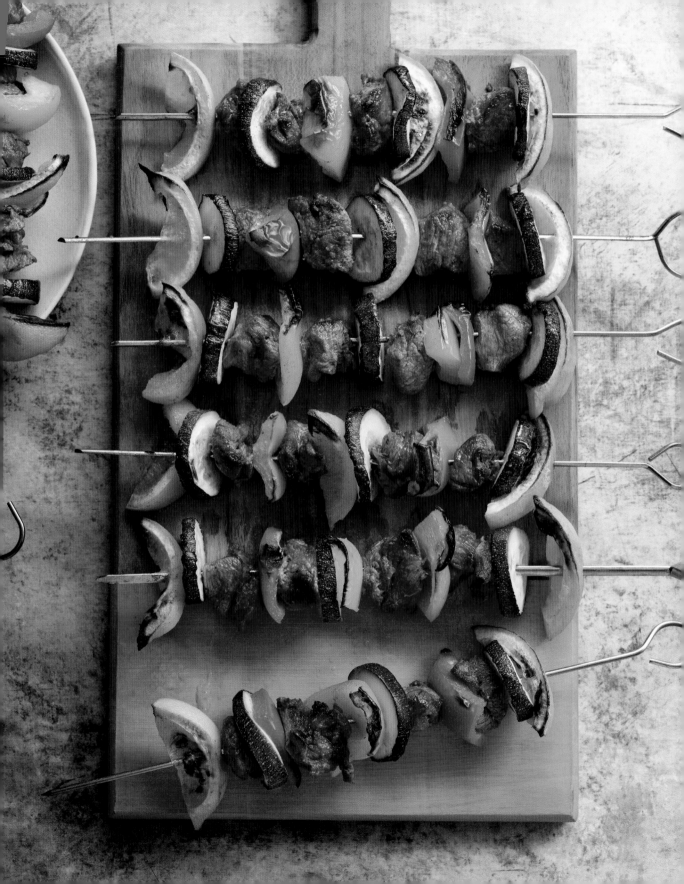

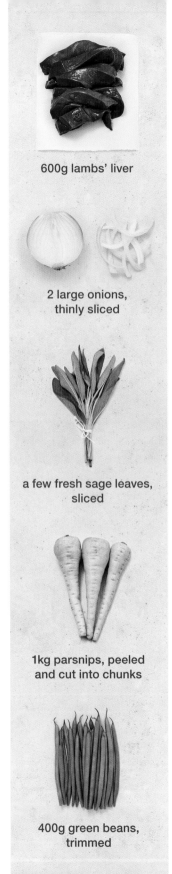

600g lambs' liver

2 large onions, thinly sliced

a few fresh sage leaves, sliced

1kg parsnips, peeled and cut into chunks

400g green beans, trimmed

lambs' liver with parsnip mash

Cooked just right, liver has a marvellous melt-in-the-mouth texture – we've served it with a delicious fresh sage and onion sauce.

serves 4

Free

ready in 40 minutes

Rinse the liver under cold running water, trim away and discard any sinew and slice thickly. Pat dry with kitchen paper and season lightly. Cover and set aside.

Spray a large non-stick saucepan with low-calorie cooking spray and place over a medium heat. Add the onions and cook for 8-10 minutes or until nicely coloured.

Add the sage, pour in 450ml boiling water and simmer over a low heat for 15 minutes or until the onions are soft. Purée a little of the onion mixture with a stick blender and keep warm over a low heat.

Meanwhile, cook the parsnips in a saucepan of boiling water for 10-12 minutes or until tender. Drain well and mash, season to taste and keep warm.

Cook the green beans in a saucepan of boiling water over a high heat for 3-4 minutes or until just tender. Drain well, return to the pan off the heat and cover so they can steam for a while.

Spray a large non-stick frying pan with low-calorie cooking spray and place over a high heat. Add the liver and cook for 3 minutes, then turn and cook for a further 2-3 minutes. Pour over the onion sauce and scrape up any tasty bits in the frying pan. Bubble for 1 minute and serve hot with the mash and green beans.

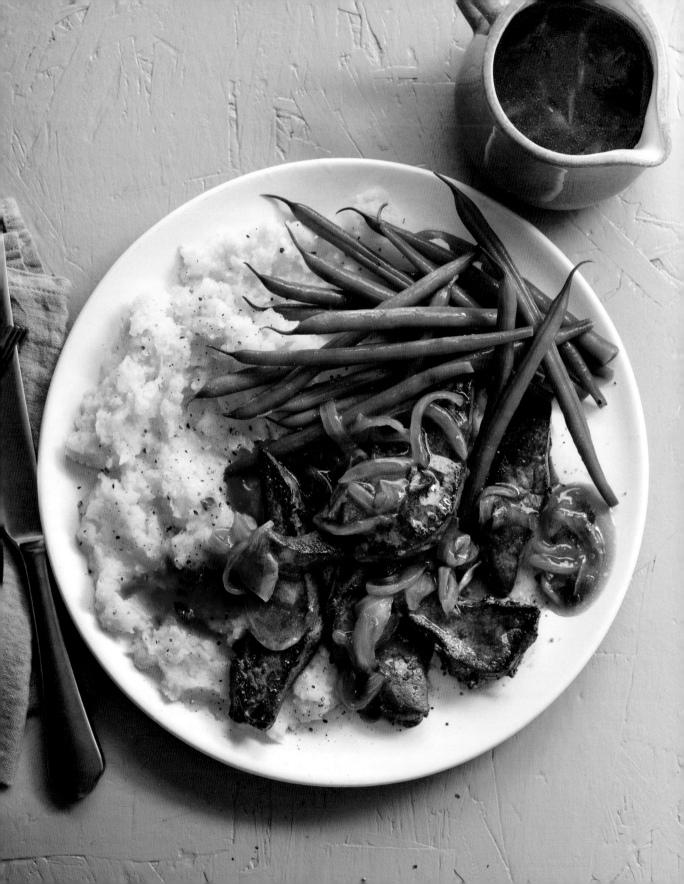

Pork

Enjoy delicious dishes including hot chilli
sausage salad, Cajun pork & apple burgers and
a gammon & summer veg grill.

14 spring onions

750g lean pork mince
(5% fat or less)

1 medium eating apple,
peeled, cored
and grated

2 tbsp Cajun seasoning

600g baby sweetcorn

cajun pork and apple burgers

Grated apple helps keep these burgers nice and juicy while they're cooking and the Cajun spice gives them an irresistible blast of flavour.

serves 4

½ **Syn** per serving

❄ (uncooked burgers only) *SP*

ready in 25 minutes

Preheat the grill to high.

Finely chop 6 spring onions and put them in a large bowl with the pork, apple and most of the Cajun seasoning. Mix well to combine, divide into 12 equal portions and shape into burgers. Arrange the burgers on a foil-lined grill pan and grill for 8 minutes on each side or until cooked through.

While the burgers are cooking, place a non-stick griddle pan or frying pan over a high heat. When it's smoking hot, spray the baby sweetcorn with low-calorie cooking spray and toss with the remaining Cajun seasoning to coat. Cook for 2-3 minutes, stirring often to stop them sticking. Halve another 6 spring onions, add to the pan and cook for 1 minute.

Put the pork and apple burgers on to plates with the baby sweetcorn and spring onions. Quickly slice the remaining spring onions and scatter over to serve.

4 lean gammon steaks, visible fat removed

400g cherry tomatoes

3 peppers (any colours), deseeded and chopped or sliced

3 red onions, cut into wedges

small bag of watercress

gammon and summer veg grill

This fast and filling feast is terrific served up as a midweek meal or tempting weekend brunch.

serves 4

Free

 SP

ready in 15 minutes

Place a large non-stick griddle pan or frying pan over a high heat. Spray the gammon steaks and tomatoes with low-calorie cooking spray and, when the pan is smoking hot, cook them for 3 minutes on one side. Turn the gammon steaks and tomatoes and cook for a further 2-3 minutes or until the gammon is cooked through and nicely charred.

Meanwhile, spray another non-stick griddle pan or frying pan with low-calorie cooking spray and place over a high heat. Add the peppers and onions and cook for 4-5 minutes or until cooked to your liking, turning occasionally.

Divide the gammon steaks and tomatoes between plates, add the peppers and onions and serve hot with the watercress.

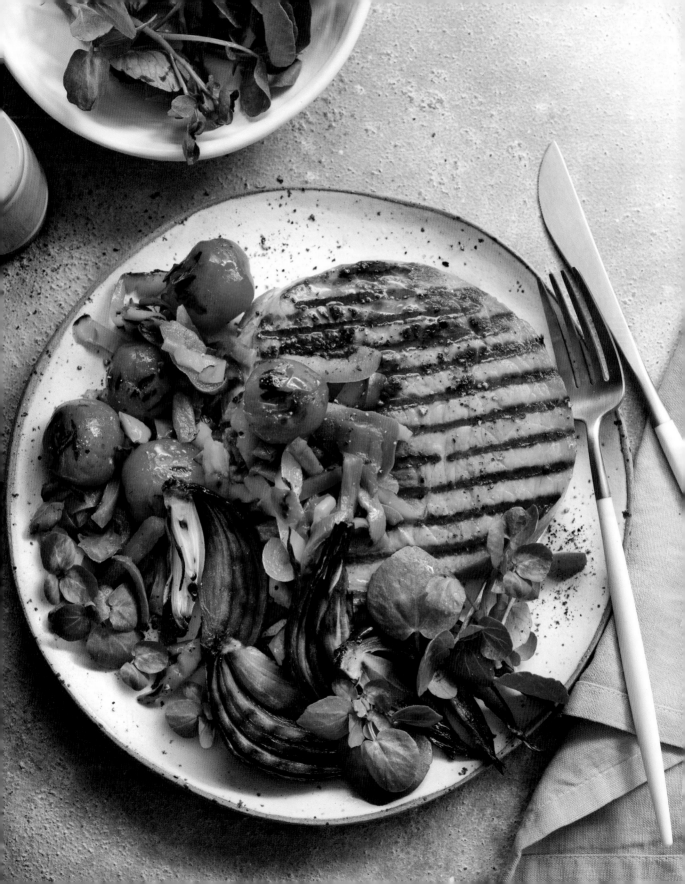

500g lean pork fillet
(tenderloin), visible
fat removed

400g mixed exotic
mushrooms, sliced
(or see tip)

8 spring onions, each
cut into 3 pieces

200ml boiling
vegetable stock

4 level tbsp
teriyaki sauce

sticky pork stir-fry

Sweet, salty teriyaki adds a wonderful richness
to this simple stir-fry of pork and mushrooms.

serves 4

1 Syn per serving

ready in 20 minutes

Spray a large non-stick wok or frying pan
with low-calorie cooking spray and place
over a high heat. Cut the pork into strips
or chunks, add half to the pan and fry
for 2-3 minutes or until cooked through.
Transfer to a bowl and keep warm while
you cook the remaining pork.

Spray the wok or frying pan with more
low-calorie cooking spray, add the
mushrooms and stir-fry for 3 minutes.
Add the spring onions and stir-fry for
1 minute.

Return the pork to the pan, pour in the
stock and bubble until reduced by half.
Stir in the teriyaki sauce, heat through
and serve hot.

*Exotic mushrooms include
shiitake, oyster and enoki
– if you can't get them, sliced
regular mushrooms will
be just fine.*

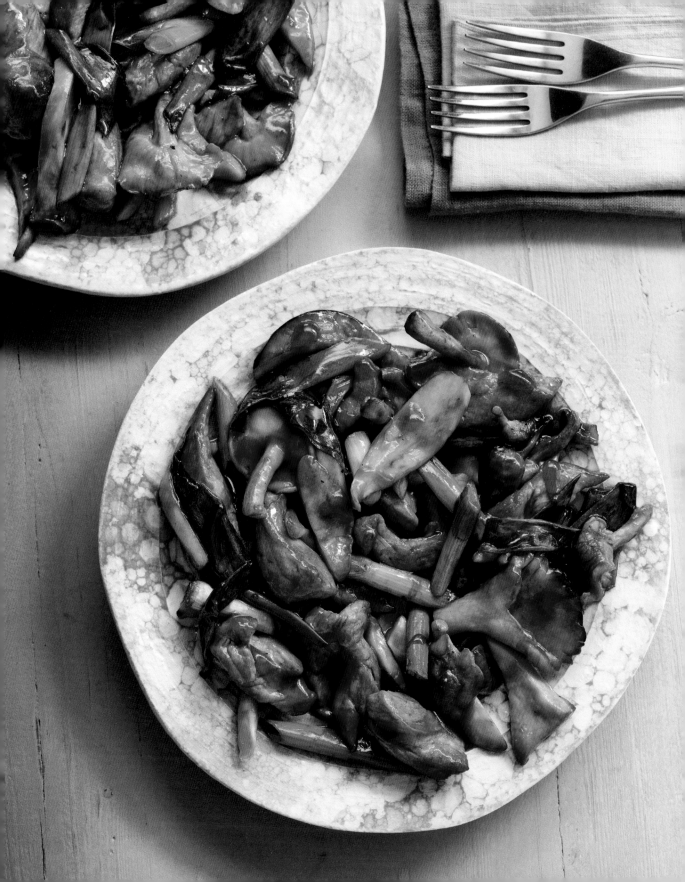

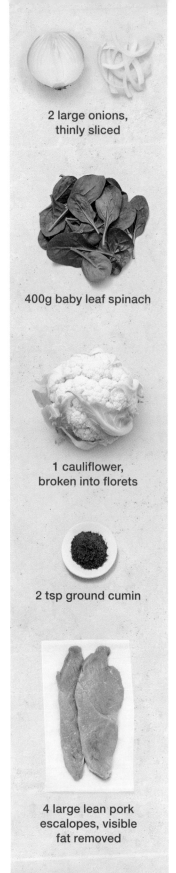

2 large onions,
thinly sliced

400g baby leaf spinach

1 cauliflower,
broken into florets

2 tsp ground cumin

4 large lean pork
escalopes, visible
fat removed

pork escalopes with cauliflower rice

Cumin gives these fab cuts of pork a lovely warmth and we've served them with cauliflower rice and lots of tasty veg to make a perfect meal.

serves 4

Free

ready in 25 minutes

Spray a deep non-stick saucepan with low-calorie cooking spray and place over a low heat. Add the onions, cover and cook for 8-10 minutes, stirring occasionally.

Add 150ml water, increase the heat to high and bring to the boil. Cook for 5-6 minutes, stirring frequently, until the onions have softened and the water has evaporated. Remove from the heat and add the spinach. Cover and set aside so that the steam can wilt the spinach.

Meanwhile, put the cauliflower into a food processor and pulse until it looks like rice. Tip into a microwaveable bowl, cover with cling film and cook on high for 7 minutes. Season to taste and keep warm.

Mix the cumin with 2 tbsp water to make a smooth paste and spread it over the pork. Place a non-stick frying pan or griddle pan over a high heat. When it's smoking hot, fry the pork for 2 minutes each side or until cooked through.

Stir the spinach and onion mixture together and spoon on to plates. Add the cauliflower rice and pork escalopes and serve hot.

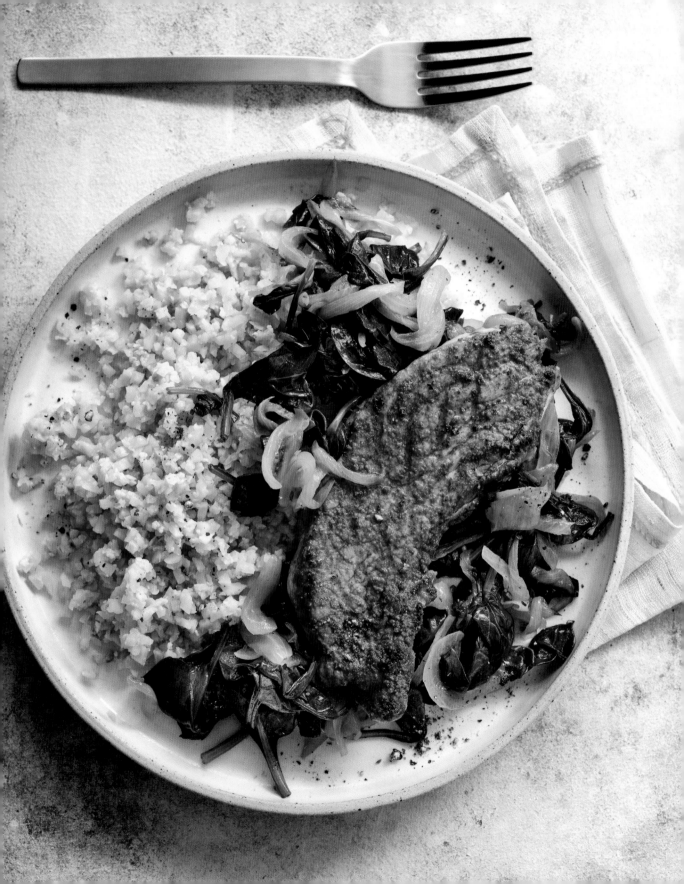

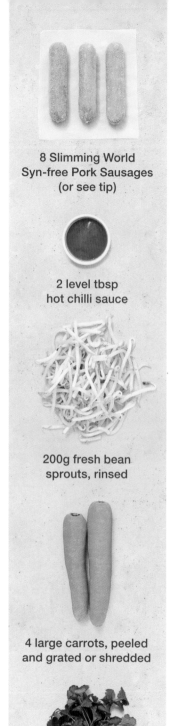

8 Slimming World Syn-free Pork Sausages (or see tip)

2 level tbsp hot chilli sauce

200g fresh bean sprouts, rinsed

4 large carrots, peeled and grated or shredded

½ small pack fresh coriander, roughly chopped

hot chilli sausage salad

A little bit of chilli sauce goes a long way in this sizzling supper, and the cool, crunchy salad is the perfect partner for the spicy sausages.

serves 4

½ **Syn** per serving

SP

ready in 20 minutes

Preheat the grill to hot.

Arrange the sausages in the grill pan and brush with the chilli sauce to coat. Grill for 15 minutes, turning the sausages frequently.

Meanwhile, blanch the bean sprouts in a saucepan of boiling water over a high heat for 40 seconds then drain, plunge them into iced water, drain again and tip into a large bowl. Add the carrots and coriander and stir well.

Cut each sausage into 3-4 pieces on the diagonal and add them to the salad to serve.

If you can't get Slimming World Sausages, use another low-fat sausage instead and count the Syns.

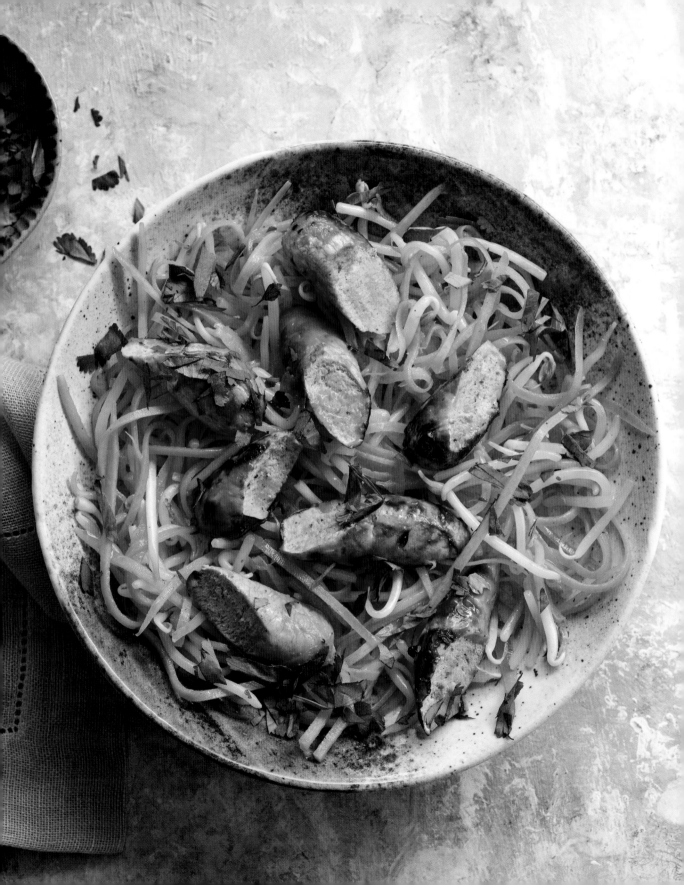

3 oranges

**2 heaped tbsp
piri-piri seasoning**

**4 lean pork loin steaks,
visible fat removed**

**400g green beans,
trimmed**

**large bag of salad
leaves**

zesty
piri-piri pork

Piri-piri seasoning combines delicious flavours
including smoked paprika, chilli, lemon and garlic,
and gives these juicy chops plenty of kick.

serves 4

½ **Syn** per serving

SP

ready in 15 minutes,
plus marinating

Finely grate the zest from 1 orange and put it
in a shallow dish with the piri-piri seasoning.
Juice the grated orange and add 2 tsp juice
to the piri-piri, setting the rest aside in a bowl.
Stir the piri-piri mixture to a smooth paste
and season lightly, then add the steaks and
turn to coat them well. Cover and chill for
20 minutes.

Remove the peel and pith from the other
2 oranges, slice them into segments and
set aside.

Preheat the grill to hot.

Arrange the pork steaks on the grill rack,
spray with low-calorie cooking spray and
grill for 5-6 minutes on each side or until
cooked through.

Meanwhile, cook the green beans in a
saucepan of boiling water over a high heat
for 3-4 minutes, then drain and rinse under
cold running water.

Pile the green beans, salad leaves and
orange segments on to plates, drizzle
over the reserved orange juice and toss
well. Slice the pork steaks and arrange
on top of the salad to serve.

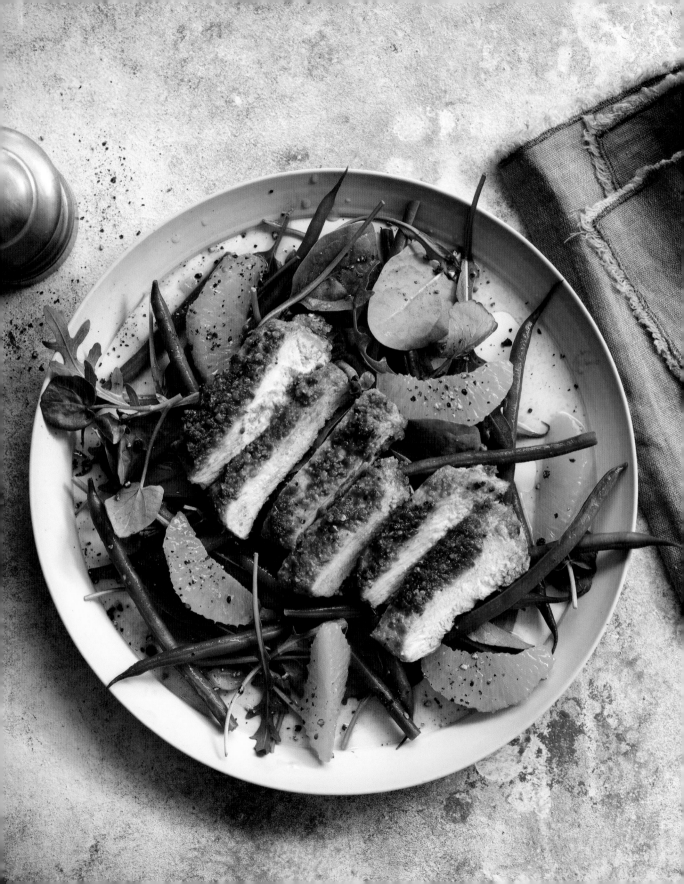

3 large aubergines,
sliced

grated zest of
1 unwaxed lemon
and the juice of 2

150g pomegranate
seeds

500g lean pork fillet
(tenderloin), visible
fat removed

2 tsp baharat seasoning
(or use ras-el-hanout)

middle eastern pork and aubergine

Baharat is a spice widely used in Middle Eastern cooking and it goes a treat with the sticky lemon glaze on the pork.

serves 4
Free
ready in 20 minutes

Spray both sides of the aubergine slices with low-calorie cooking spray and season lightly. Place a non-stick griddle pan over a high heat and, when it's smoking hot, fry the aubergines for 4 minutes or until attractively charred (you might need to do this in batches). Turn and cook for a further 2-3 minutes. Arrange on plates and scatter over half of the lemon zest, half of the lemon juice and half of the pomegranate seeds. Cover with foil and set aside.

Cut the pork into 1.5cm thick slices and rub over the baharat seasoning to coat well. Spray a large non-stick frying pan with low-calorie cooking spray and place over a medium heat. Add the pork and fry for 6-7 minutes on each side. Add the remaining lemon juice and toss the pork in it until you have a sticky glaze.

Divide the pork between the plates of aubergine and scatter over the remaining lemon zest and pomegranate seeds to serve.

Swap the pomegranate seeds for sliced spring onions if you're having an Extra Easy SP day.

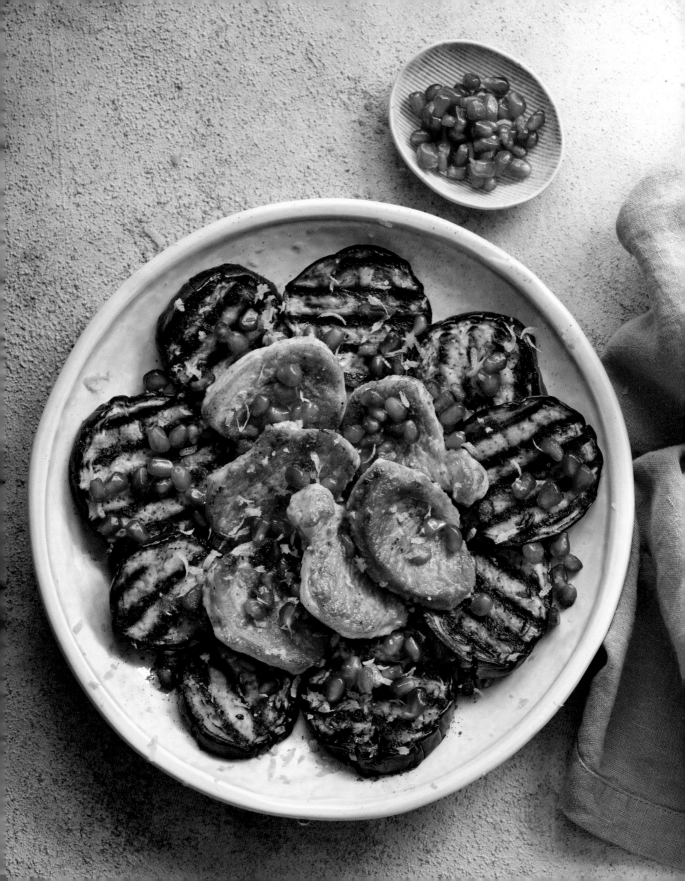

Poultry

Tuck into chicken, turkey and duck delights like cheesy chicken risotto, turkey jalfrezi and duck with beetroot salad.

1 tbsp Chinese
five-spice powder

4 large skinless
and boneless
chicken breasts

400g pak choi, white
and green parts
separated, sliced

2 level tbsp Shaoxing
rice wine (or see tip)

3 tbsp light soy sauce

shanghai chicken

This tasty chicken stir-fry inspired by China's second city showcases the lovely crunch and flavour of pak choi.

serves 4

Free

ready in 15 minutes

Put the five-spice powder and some freshly ground black pepper in a large bowl and mix well. Cut the chicken into bite-size chunks, add to the mixture and stir to coat well.

Spray a large non-stick wok or deep frying pan with low-calorie cooking spray and place over a high heat. Add the white part of the pak choi and the chicken and stir-fry for 5 minutes or until just beginning to brown.

Add the Shaoxing rice wine, soy sauce and 3 tbsp water and bubble for 3-4 minutes or until the sauce is reduced and everything is coated in a sticky glaze. Scatter over the green pak choi leaves and cook for 1 minute or until the pak choi greens have wilted and the chicken is cooked through.

Serve hot in shallow bowls.

Most large supermarkets stock Shaoxing rice wine in their specialist ingredient aisles but if you can't get it, use dry or medium sherry instead and add ½ Syn per serving.

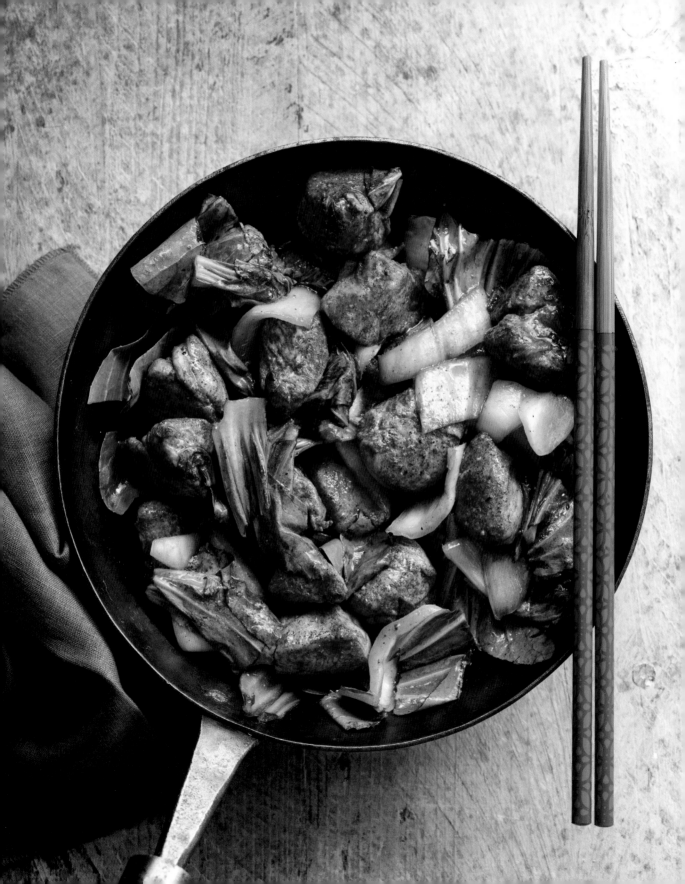

4 large skinless and boneless chicken breasts

350g dried risotto rice

1.2 litres boiling chicken stock

2 leeks, thinly sliced

4 level tbsp freshly grated Parmesan cheese

cheesy chicken risotto

Generous chunks of chicken and perfectly cooked rice make this easy risotto so comforting and the sprinkling of Parmesan is a real treat.

serves 4

1 Syn per serving

ready in 35 minutes

Spray a large non-stick frying pan or sauté pan with low-calorie cooking spray and place over a high heat. Cut the chicken into bite-size chunks, add to the pan and fry for 5 minutes or until beginning to brown.

Reduce the heat to medium-low and add the rice and stock (don't worry if you don't have room for all the stock – you can add it in stages as you stir the risotto). Simmer for 10 minutes, stirring frequently to give a lovely creamy texture.

Stir in the leeks and simmer for a further 10-15 minutes or until the rice is just cooked and most of the stock has been absorbed, stirring frequently.

Sprinkle over the Parmesan, grind over a little black pepper and serve hot.

Leave out the Parmesan to make this recipe completely Free!

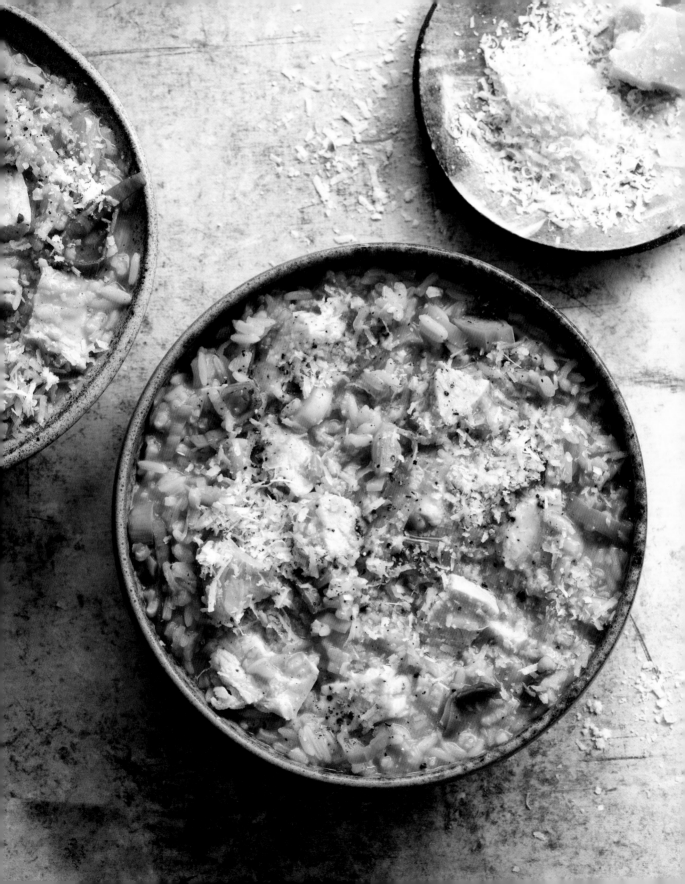

12 chicken drumsticks

2 tsp piri-piri seasoning

**1 tbsp sweet
smoked paprika**

**1 butternut squash,
peeled, deseeded and
cut into large chunks**

**6 spring onions,
thinly sliced**

piri-piri chicken
and squash

Your oven will do all the work for you with this
irresistible tray bake, leaving you free to enjoy the
spicy roast chicken and soft, sweet squash.

serves 4

Free

ready in 1 hour

Preheat the oven to 200°C/fan 180°C/gas 6.

Skin the drumsticks by peeling a little skin
away at the thicker end, getting a good grip
with a bit of kitchen paper and pulling it off
over the bony bit. Make a few slashes in the
flesh of each drumstick.

Put the piri-piri seasoning, paprika and
2 tbsp water in a bowl and mix to make
a smooth paste. Add the drumsticks and
stir to coat well.

Arrange the squash chunks in a large
non-stick roasting tin, season lightly and
arrange the drumsticks on top. Spray with
low-calorie cooking spray and roast for
40 minutes.

Scatter half of the spring onions around the
tin and cook for another 10 minutes or until
the chicken is cooked through. Scatter over
the remaining spring onions to serve.

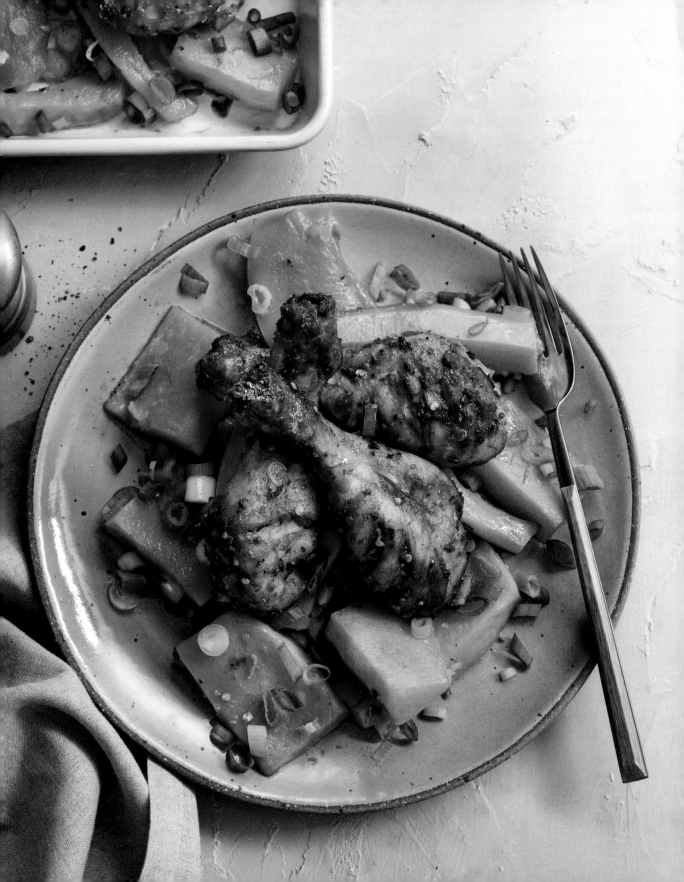

4 thin-cut turkey steaks, visible fat removed

4 Parma ham slices (see tip)

4 large fresh sage leaves

200ml boiling chicken stock

400g mangetout, shredded

turkey saltimbocca

This Italian dish means 'jumps in the mouth' because it tastes so good, and we've used traditional Parma ham and sage leaves with lean turkey steaks.

serves 4

½ **Syn** per serving

SP

ready in 15 minutes

Season the turkey on both sides with freshly ground black pepper (you probably won't need salt as Parma ham is quite salty). Arrange a slice of Parma ham and a sage leaf on top of each turkey steak and secure with cocktail sticks.

Spray a large non-stick frying pan with low-calorie cooking spray and place over a medium-high heat. Cook the turkey steaks ham-side up for 2 minutes then turn and cook the other side for 2 minutes, leaving the cocktail sticks in.

Pour over the stock (be careful, it will bubble in the hot pan) and cook for 1 minute. Lift the turkey steaks on to a hot plate, remove the cocktail sticks and cover with foil to keep warm.

Increase the heat and add the mangetout to the stock in the pan. Cook rapidly for 1-2 minutes or until the mangetout are hot and the stock has thickened a little.

Divide the mangetout between plates and top with the turkey. Pour the sauce into a jug to serve with the turkey.

Use prosciutto if you can't get Parma ham.

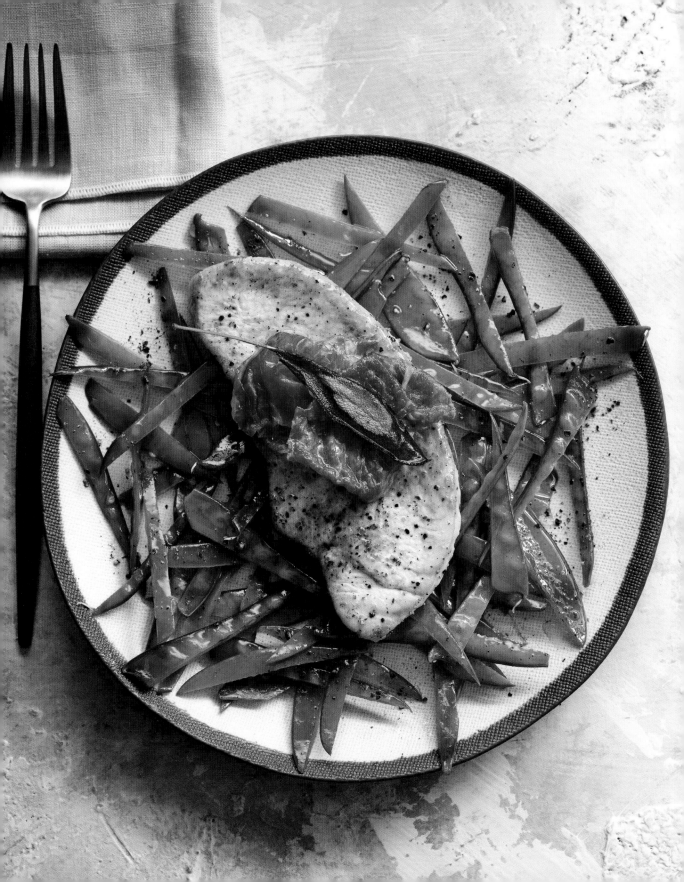

12 skinless and boneless chicken thighs

1 large red onion, cut into wedges

3 peppers (any colours), deseeded and sliced

2 tsp smoked paprika or mild chilli powder (or see tip)

400g can chopped tomatoes with onion and garlic

mexican chicken stew

Smoked paprika brings spice and warmth to this winning mix of chicken, peppers and onion.

serves 4

Free

❄ *SP*

ready in 45 minutes

Spray a deep, non-stick frying pan with low-calorie cooking spray and place over a high heat. Cut the chicken into large chunks and cook for 5-6 minutes or until browned on all sides.

Reduce the heat to medium, add the onion, peppers and paprika or chilli powder and stir-fry for 2-3 minutes.

Add the chopped tomatoes then half-fill the can with water and add that too. Season lightly and bring to the boil then cover, reduce the heat to low and simmer for 25 minutes or until the chicken is cooked through.

Serve hot in shallow bowls.

Swap the paprika or chilli powder for dried chipotle chilli flakes if you can get them.

Slimming World's take 5 | **poultry**

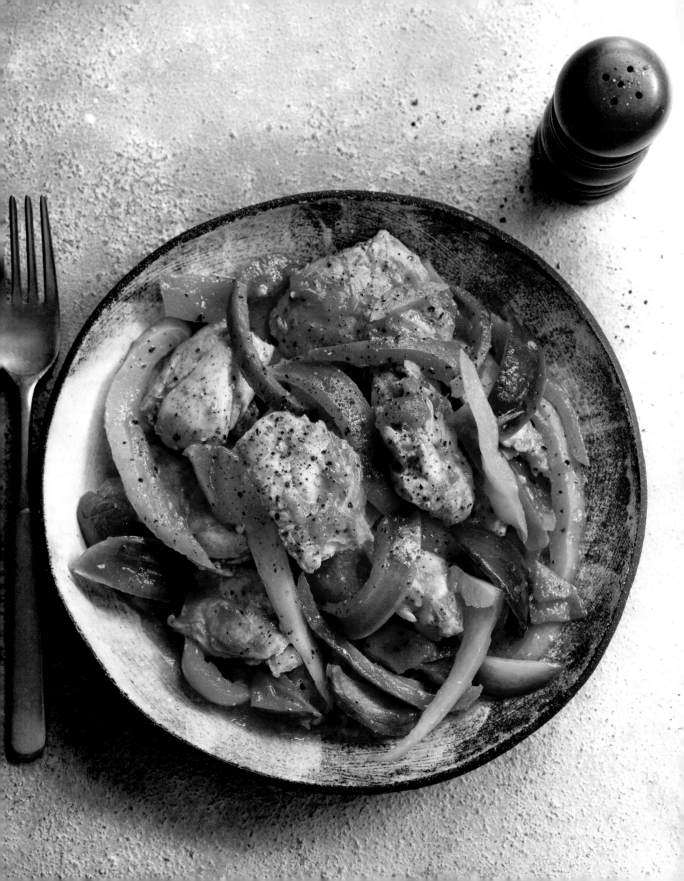

1kg Charlotte or other waxy potatoes, halved lengthways

1 large garlic bulb, cloves separated

grated zest and juice of 2 unwaxed lemons

12 skinless and boneless chicken thighs

200g kale, shredded (or see tip)

chicken, potato and kale bake

This tempting tray bake makes midweek cooking a breeze, with crispy kale adding a delicious twist to the classic combo of chicken and potatoes.

serves 4

Free

ready in 1 hour

Preheat the oven to 200°C/fan 180°C/gas 6.

Cook the potatoes in a saucepan of boiling water over a high heat for 12-15 minutes. Drain well and tip into a roasting tin.

Peel and finely grate 3 garlic cloves, mix with half of the lemon zest and all of the lemon juice and rub into the chicken to coat. Season lightly, slash the flesh of each chicken thigh a few times and arrange on top of the potatoes. Tuck the remaining garlic cloves around the potatoes. Spray with a little low-calorie cooking spray and cook in the oven for 20 minutes.

Spray the kale with low-calorie cooking spray, scatter over the chicken and cook for a further 15 minutes or until the kale is crispy and the chicken is cooked through.

Pop the garlic cloves from their skins, mash and toss through the chicken and veg. Scatter the remaining lemon zest to serve.

Kalettes are bite-size kale cabbages. If you can get them, use 200g instead of the kale.

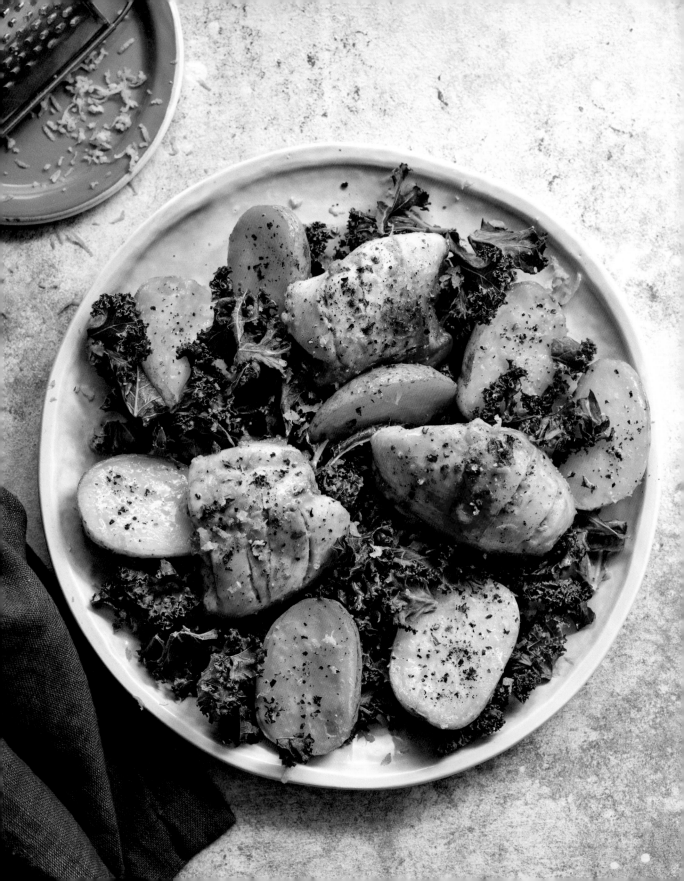

8 large chicken thighs and/or drumsticks

150g fat-free natural yogurt

4 tbsp tandoori masala curry powder

grated zest and juice of 1 unwaxed lemon

roughly chopped fresh coriander, to serve

tandoori masala roast chicken

The Indian-style yogurt crust locks so much fabulous flavour into these more-ish chicken portions.

serves 4

Free

ready in 1 hour, plus marinating

First skin the thighs and drumsticks (for the drumsticks, peel a little skin away at the thicker end, get a good grip with a bit of kitchen paper and pull it all off over the bony end). Make a few slashes in the flesh of each chicken portion.

Mix the yogurt, curry powder, lemon zest and juice in a large bowl and season lightly. Add the chicken portions, stir to coat well and set aside to marinate for at least 30 minutes (or overnight if you have time).

Preheat your oven to 190°C/fan 170°C/gas 5.

Arrange the chicken portions on a rack set over a roasting tin and roast for 40 minutes or until the chicken is cooked through (they're done if the juices run clear when the thickest part is pierced with a metal skewer).

Scatter with the coriander to serve.

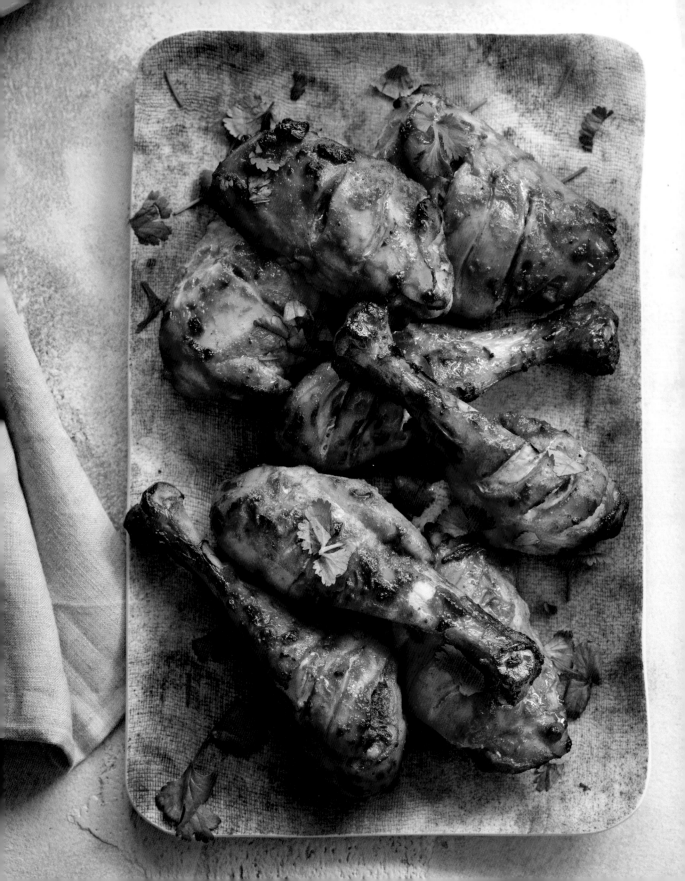

4 skinless and boneless chicken breasts

2 leeks, thinly sliced

1 tbsp fresh thyme leaves, plus sprigs to garnish

300g fat-free natural fromage frais

2 level tbsp freshly grated Parmesan cheese

chicken with creamy leeks

Leeks go brilliantly with chicken, and the Parmesan and fromage frais give this elegant meal a touch of luxury.

serves 4

½ **Syn** per serving

ready in 30 minutes

Preheat your oven to 200°C/fan 180°C/gas 6.

Spray a non-stick roasting tin with low-calorie cooking spray, add the chicken breasts and season lightly. Cook in the oven for 20-25 minutes or until cooked through, turning halfway.

Meanwhile, spray a large non-stick frying pan with low-calorie cooking spray and place over a medium heat. Add the leeks, thyme and 150ml boiling water and cook for 10-12 minutes or until the leeks have softened and most of the liquid has gone, stirring occasionally (you might need to add a little more water).

Reduce the heat to as low as possible, stir in the fromage frais and most of the Parmesan and cook for 1-2 minutes or until just heated through, stirring often. Season to taste.

Spoon the creamy leeks into shallow bowls and top with the chicken breasts. Sprinkle with the remaining Parmesan and garnish with thyme sprigs to serve.

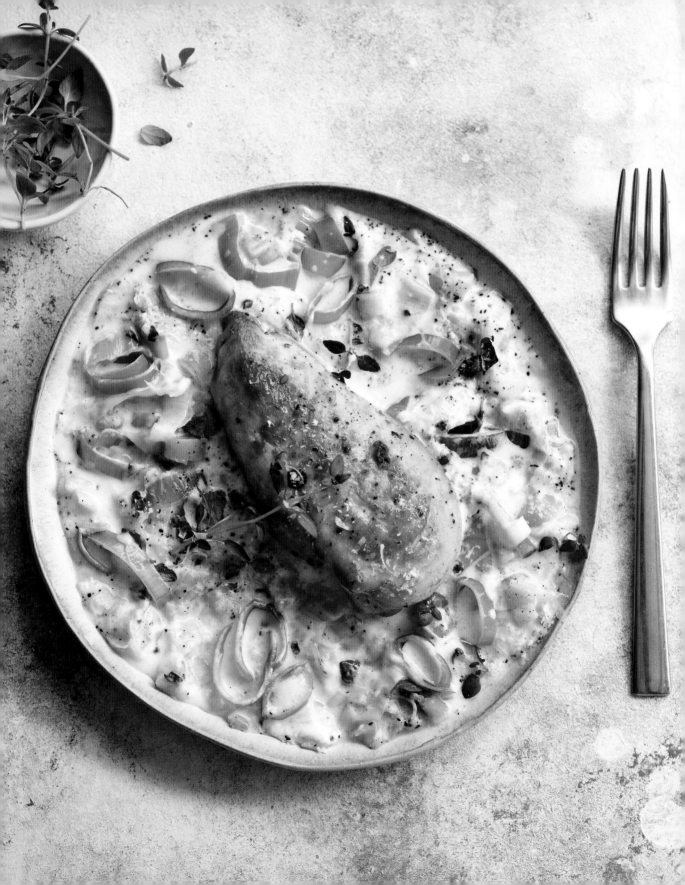

1 large cauliflower, broken into florets

2 tbsp tikka curry powder

8 skinless and boneless chicken thighs (or see tip)

400g red and yellow cherry tomatoes, halved

200g baby leaf spinach

curried chicken and cauliflower

Roasting Speed vegetables like cauliflower and tomatoes concentrates their flavours, making them perfect partners for tender chicken thighs.

serves 4

Free

ready in 45 minutes

Preheat the oven to 200°C/fan 180°C/gas 6.

Cook the cauliflower florets in a saucepan of boiling water over a high heat for 5 minutes or until just tender. Drain well.

Meanwhile, mix the curry powder and 3 tbsp water in a shallow dish to make a smooth paste. Make a few slashes in each chicken thigh, add to the paste and toss to coat evenly. Arrange the chicken thighs in a large roasting tin sprayed with low-calorie cooking spray.

Toss the cauliflower with any remaining curry paste to coat the florets lightly and add to the tin around the chicken thighs. Season lightly, spray with low-calorie cooking spray and roast for 10 minutes. Scatter over the tomatoes and cook for a further 20 minutes or until the chicken is cooked through.

Just before the end of the cooking time, place the spinach in a large colander over the sink and wilt it by pouring over a kettle of boiling water. Drain well, add to the chicken and cauliflower and serve hot.

Squeeze another 4 skinless chicken thighs into your roasting tin if it's big enough!

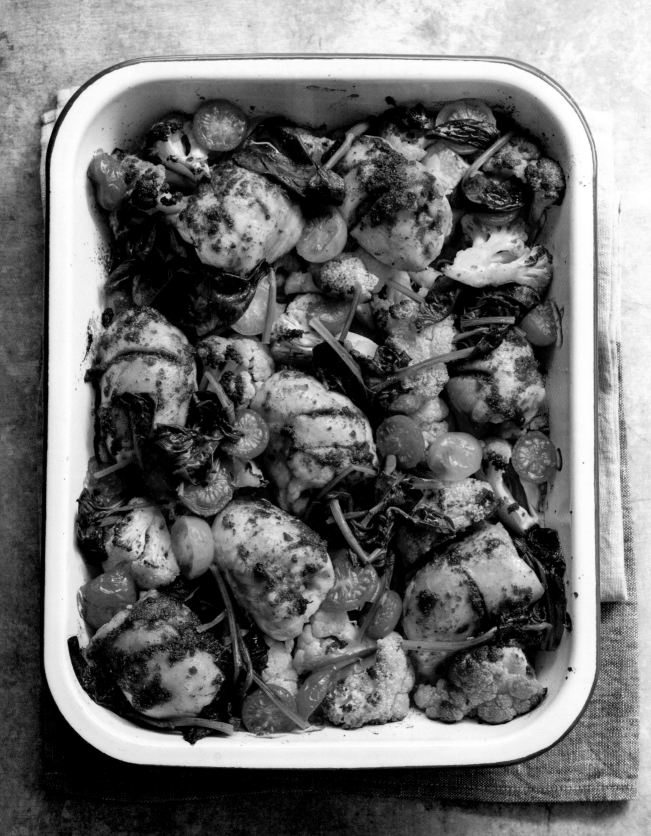

1 large red onion,
cut into chunks

3 peppers (any colours),
deseeded and cut
into chunks

2 tbsp mild curry
powder

500g lean turkey mince
(5% fat or less)

400g can chopped
tomatoes with onion
and garlic

turkey jalfrezi

Our Free version of the much-loved curry is so simple
to make: start with a spicy stir-fry of peppers and
onion then simmer slowly for maximum flavour!

serves 4

Free

ready in 45 minutes

Spray a large, lidded non-stick wok or frying
pan with low-calorie cooking spray and place
over a medium heat. Add the onion and
peppers and stir-fry for 2 minutes, then add
the curry powder and cook for 1 minute.

Add the turkey and stir-fry for 5 minutes,
breaking up the mince with the back of
a spoon. Drain off any fat.

Tip in the chopped tomatoes then fill the
can with water and pour that in too. Season
lightly, cover and simmer over a low heat for
20 minutes. Uncover and simmer for about
5 minutes more to thicken the sauce to your
liking. Serve hot.

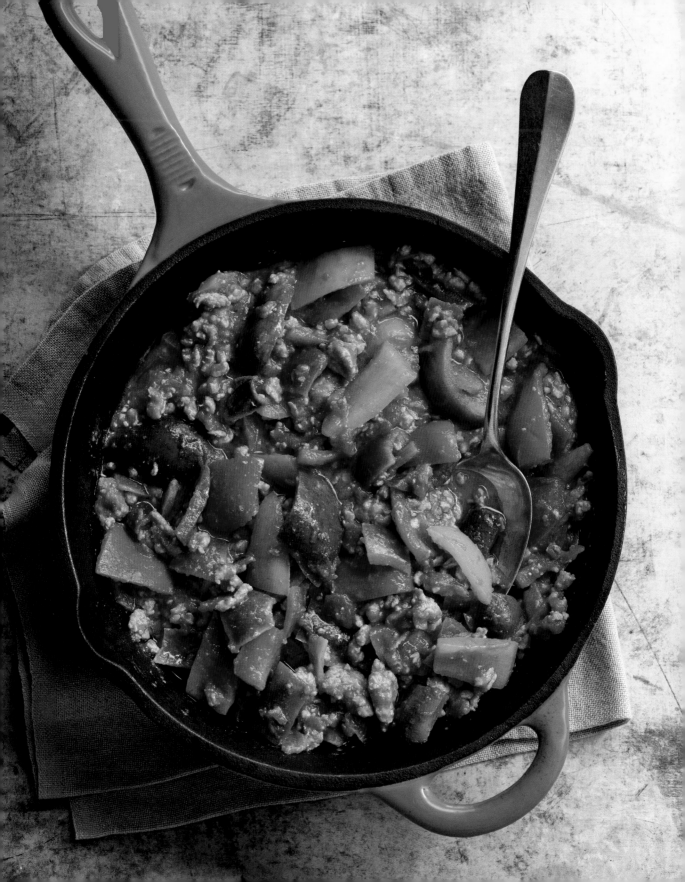

250g red and yellow
cherry tomatoes, sliced

200g beetroot, peeled
and thinly sliced
(or see tip)

4 duck breasts, skinned,
visible fat removed

6 red peppers
(ramiro if possible),
deseeded and chopped

2 tsp balsamic vinegar

duck with beetroot salad

Duck is a great choice for a special occasion and it's so easy to cook. Serve slightly pink for best results.

serves 4

Free

ready in 35 minutes

Put the tomatoes in a bowl, season lightly and set aside for 30 minutes (this really brings out their flavour). Preheat your oven to 160°C/fan 140°C/gas 3.

Meanwhile, put the beetroot in a saucepan, cover with water and bring to the boil over a high heat. Reduce the heat to low, cover and simmer for 25 minutes or until tender.

Once the beetroot is cooking, place a large non-stick frying pan over a medium-high heat. Spray the duck breasts with low-calorie cooking spray, season lightly and sear for 2 minutes on each side or until coloured. Transfer to a roasting tin and roast for 10 minutes if you want them a little bit pink in the middle (add another 5 minutes if you prefer them well done). Remove the duck from the oven, cover and rest for 10 minutes.

Once the duck breasts are in the oven, add the peppers to the frying pan and stir-fry for 15-20 minutes over a medium heat. Drain the beetroot and add to the peppers. Drizzle over the vinegar and stir in the tomatoes plus their juices. Slice the duck and serve with the veg.

Use vacuum-packed beetroot instead if you like.

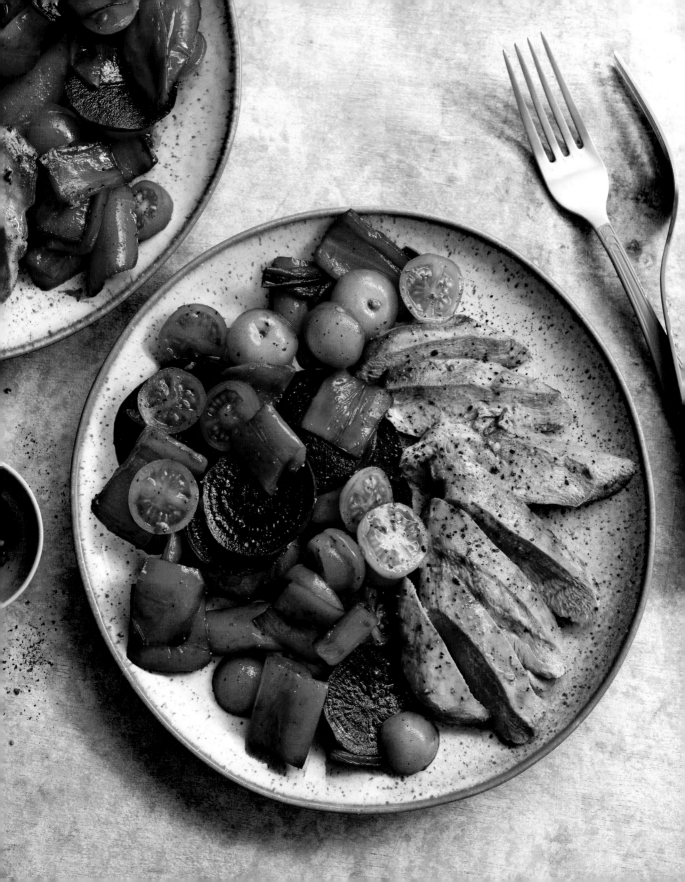

12 chicken drumsticks

2 level tbsp sriracha (see tip)

2 tbsp soy sauce

300g dried egg noodles

350g mixed stir-fry veg

sriracha chicken with veg noodles

These finger-lickin' drumsticks are marinated using sriracha, a popular chilli and garlic sauce from Thailand (caution – it's hot!).

serves 4

½ **Syn** per serving

ready in 50 minutes

Preheat your oven to 200°C/fan 180°C/gas 6 and line a roasting tin with kitchen foil.

Skin the drumsticks by peeling a little skin away at the thicker end, getting a good grip with a bit of kitchen paper and pulling it all off over the bony end. Make a few slashes in the flesh of each drumstick.

Mix the sriracha and soy sauce in a large bowl then add the drumsticks to the bowl and turn to coat evenly (leave them to marinate for at least 30 minutes if you have time). Tip the drumsticks into the roasting tin and roast for 35-40 minutes or until golden and cooked through.

About 10 minutes before the end of the cooking time, cook the noodles according to the pack instructions. Drain and set aside.

Spray a large non-stick wok or frying pan with low-calorie cooking spray and place over a high heat. Add the mixed vegetables and stir-fry for 2 minutes then add the noodles and toss well.

Serve the drumsticks hot with the veg noodles.

If you can't find sriracha, just use another hot chilli sauce instead.

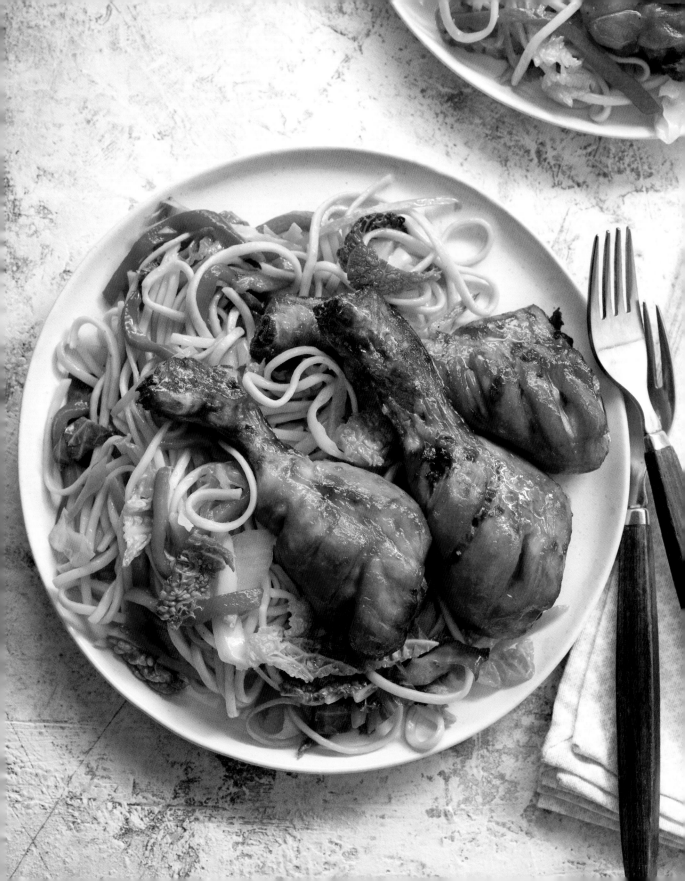

Fish

Dive into our round-up of fishy favourites,
including Scandinavian roast salmon and
courgetti linguine with scallops.

3 peppers (any colours), deseeded and sliced

1 tbsp Cajun seasoning

200g dried long-grain rice

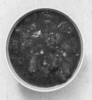

400g can chopped tomatoes with garlic and herbs

400g cooked and peeled king prawns

king prawn jambalaya

This wonderful one-pot spicy rice dish hails from Louisiana in America's 'Deep South' – and it's completely Free!

serves 4

Free

ready in 35 minutes

Spray a large, heavy-based, non-stick casserole pan or saucepan with low-calorie cooking spray and place over a medium heat. Add the peppers, cover and cook for 5 minutes or until they're beginning to soften, stirring occasionally.

Sprinkle over the Cajun seasoning and cook for 1 minute, stirring. Stir in the rice, chopped tomatoes and 700ml boiling water and bring to the boil over a high heat. Cover, reduce the heat to very low and cook for 20 minutes.

Remove the lid, add the prawns and cook for 2-3 minutes, stirring occasionally. Season to taste and serve hot.

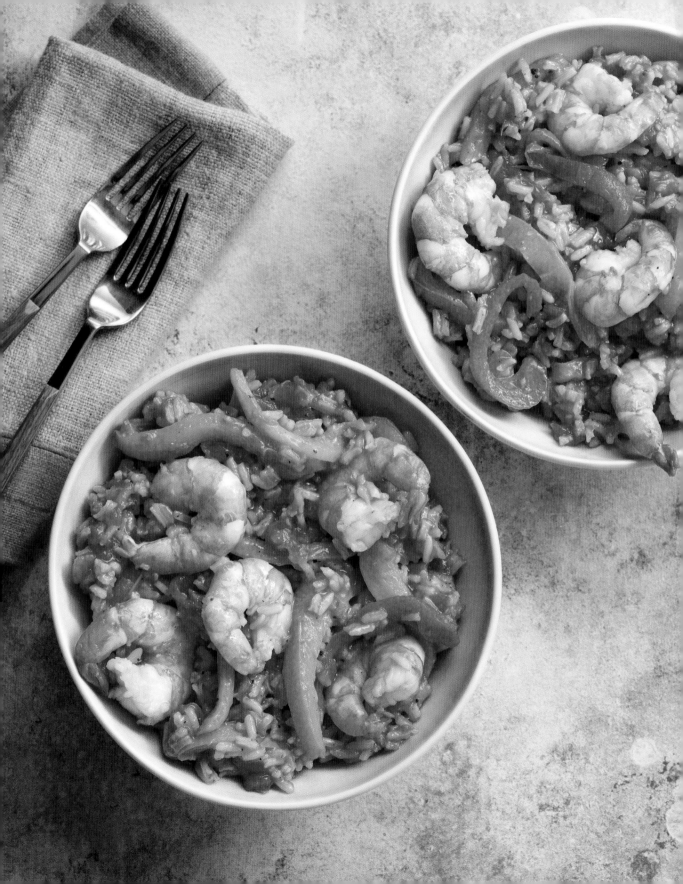

250g beetroot,
peeled and diced
(or see tip)

4 boneless salmon fillets

750g Charlotte
potatoes, halved
or quartered

4 tbsp fat-free natural
fromage frais

2 level tsp
horseradish sauce

salmon with beetroot salad

This quick and easy fish supper is delicious hot or cold and works just as well with hot-smoked salmon or trout.

serves 4

½ **Syn** per serving

ready in 20 minutes

Preheat the oven to 200°C/fan 180°C/gas 6 and line a baking tray with non-stick baking paper.

Put the beetroot in a large saucepan, add enough boiling water to just cover and bring to the boil over a high heat. Reduce the heat to low, cover and simmer for about 25 minutes or until tender.

Meanwhile, arrange the salmon fillets skin-side down on the baking tray and season lightly. Spray with a little low-calorie cooking spray and bake for 15 minutes or until cooked through.

Add the potatoes to the beetroot pan for the last 15 minutes of the cooking time, topping up the water if necessary.

In a large bowl, mix together the fromage frais and horseradish and season lightly.

Drain the potatoes and beetroot, rinse under cold running water and drain again. Tip into the bowl of dressing then toss well and put on to plates with the salmon, discarding the skin if you prefer. Grind over some black pepper to serve.

Use vacuum-packed beetroot instead if you like.

150g dried basmati
and wild rice

2 x 170g cans white
crabmeat, drained

4 tbsp fat-free natural
fromage frais

½ small pack fresh
coriander, roughly
chopped

3-4 Little Gem lettuces,
leaves separated (see tip)

crab and wild rice lettuce cups

Perfect for a packed lunch! Pack the leaves separately to keep them crisp and fresh until you're ready to eat.

serves 4 (makes about 16)

Free

ready in 30 minutes,
plus cooling

Rinse the rice in a sieve under cold running water, then tip into a saucepan and cover with cold water. Season with salt, bring to the boil over a high heat and simmer for 20-25 minutes or until tender. Drain and leave to cool.

Meanwhile, mix together the crab, fromage frais and coriander and season to taste. Finely shred any lettuce leaves that are too small to stuff and stir them into the crab mixture too.

Stir the cooled rice into the crab mixture and spoon into the lettuce leaves to serve.

For more of a flavour contrast, scoop the mixture into red chicory leaves instead.

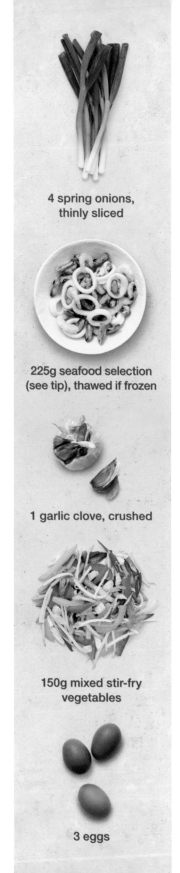

**4 spring onions,
thinly sliced**

**225g seafood selection
(see tip), thawed if frozen**

1 garlic clove, crushed

**150g mixed stir-fry
vegetables**

3 eggs

korean seafood
pancake

Koreans love their spring onion pancakes (known
as 'pajeon') and we think you'll want every day to be
pancake day once you've tried these Free delicacies!

serves 1

Free

ready in 10 minutes

Spray a non-stick frying pan (about 22cm
across) with low-calorie cooking spray and
place over a medium heat. Add the spring
onions, seafood, garlic and stir-fry vegetables
and stir-fry for 3-4 minutes or until piping hot.

Preheat the grill to hot.

Lightly beat the eggs, season lightly and pour
over the fish mixture. Fry for 2-3 minutes or
until the bottom is set, then finish under the
grill for 1-2 minutes or until crispy and golden.
Serve hot.

*Most supermarkets sell
mixed seafood packs, which
usually contain prawns,
mussels and squid.*

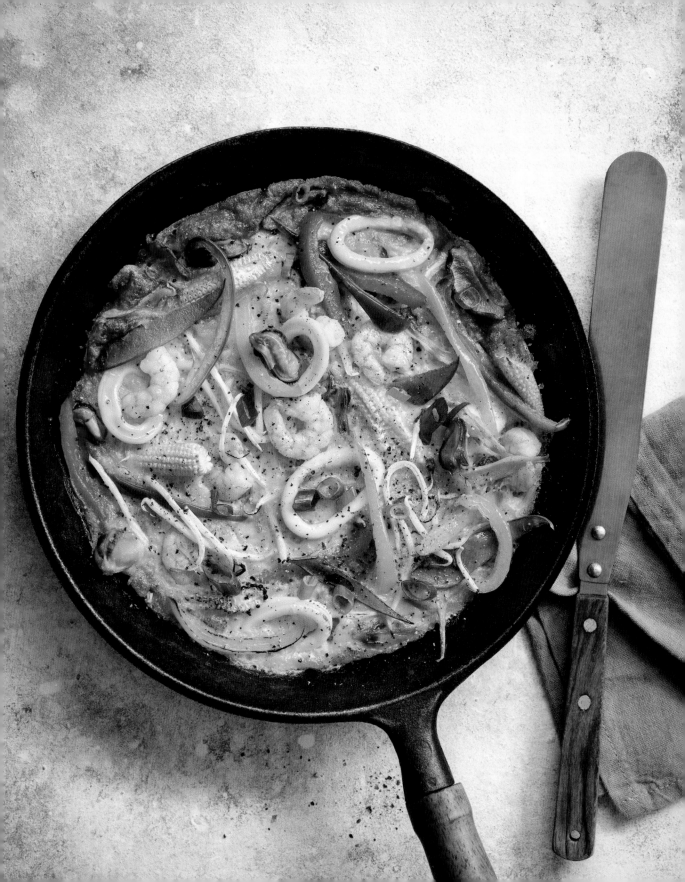

500g dried spaghetti

**grated zest and juice
of 1 large unwaxed lemon**

**300g smoked salmon,
sliced (see tip)**

**1 large red chilli,
deseeded and chopped**

small bag of rocket leaves

smoked salmon and chilli spaghetti

If you've never thought of using smoked salmon in pasta, give this fiery feast a go!

serves 4

Free

ready in 15 minutes

Cook the pasta according to the pack instructions.

Meanwhile, mix the lemon juice, salmon, chilli and rocket in a bowl.

Drain the pasta and return to the saucepan. Toss through the smoked salmon mixture, divide between shallow bowls and scatter with lemon zest to serve.

If you're on a budget, look out for smoked salmon trimmings on the fish aisle or the fish counter at your supermarket. They're not as pretty but cost a lot less!

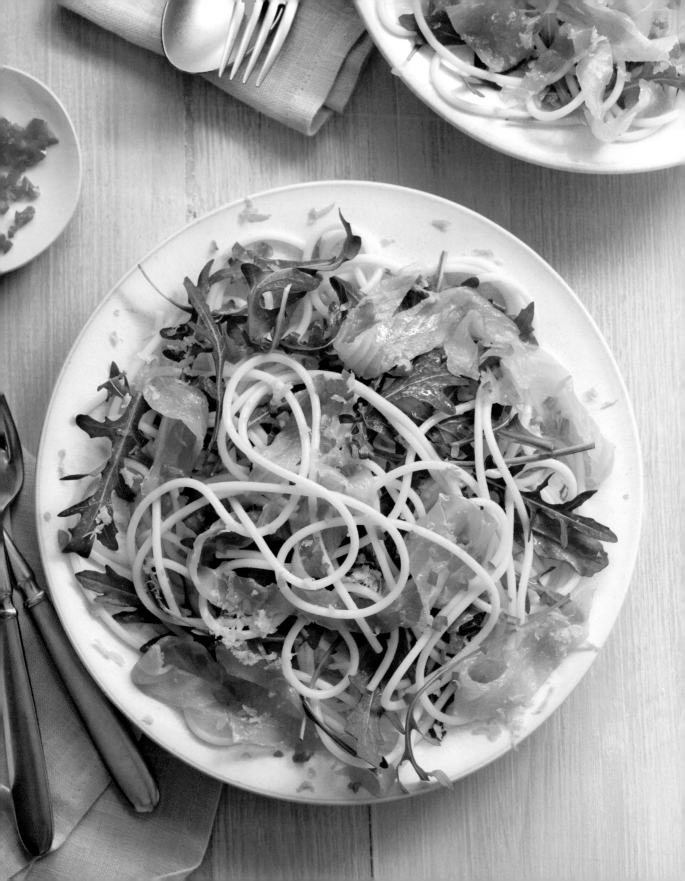

3 large unwaxed lemons

400g red and yellow
cherry tomatoes, halved

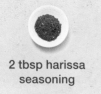

2 tbsp harissa
seasoning

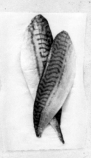

8 boneless
mackerel fillets

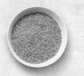

175g dried bulgar wheat

harissa-spiced mackerel

If you love strong flavours you'll love this North African-style dish! Fresh mackerel is a real bargain and it's so good for you.

serves 4

Free

ready in 20 minutes

Finely grate the zest of 1 lemon into a bowl, squeeze in the juice and toss with the tomatoes. Season lightly and set aside.

Juice another lemon into a shallow dish, mix in the harissa seasoning and season lightly. Add the mackerel and turn to coat well. Arrange the fish in a single layer on a large foil-lined grill pan, skin-side down, and marinate for 5 minutes.

Preheat the grill to high.

Bring a large saucepan of water to the boil over a high heat. Add the bulgar wheat and cook for 8-10 minutes or until just tender. Drain well and add to the tomatoes. Cover and set aside.

While the bulgar wheat is cooking, grill the mackerel for 3-4 minutes on each side.

Divide the bulgar wheat and tomatoes between plates and add the mackerel. Cut the remaining lemon into wedges to serve.

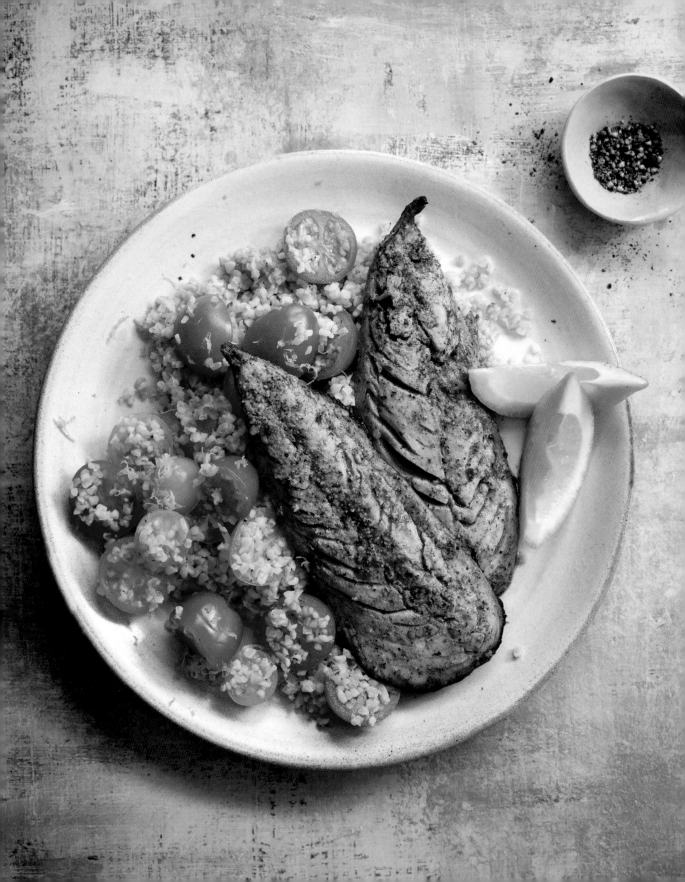

4 tsp Cajun seasoning

4 tuna steaks

400g red and yellow cherry tomatoes, halved

200g baby leaf spinach

300g mangetout, halved lengthways

cajun tuna with squished salad

You're guaranteed to fill rumbling tummies with these meaty tuna steaks, and their firm flesh means they're also brilliant on the barbecue (see our tip).

serves 4

Free

SP

ready in 10 minutes

Place a large non-stick griddle pan over a high heat. Sprinkle the Cajun seasoning on both sides of the tuna steaks, spray with low-calorie cooking spray and, when the pan is smoking hot, cook for 2 minutes on each side. (This will give you tuna that's seared on both sides and pink in the centre – if you prefer your tuna cooked all the way through, go for 3 minutes on each side.)

Meanwhile, squish the tomatoes slightly in a large bowl (using a fork or a masher) so that you catch all the juices. Stir in the spinach and mangetout and season to taste.

Pile the salad on to plates and top with the tuna steaks to serve.

For barbecued tuna steaks, cook them over direct medium heat for 6 minutes, turning once.

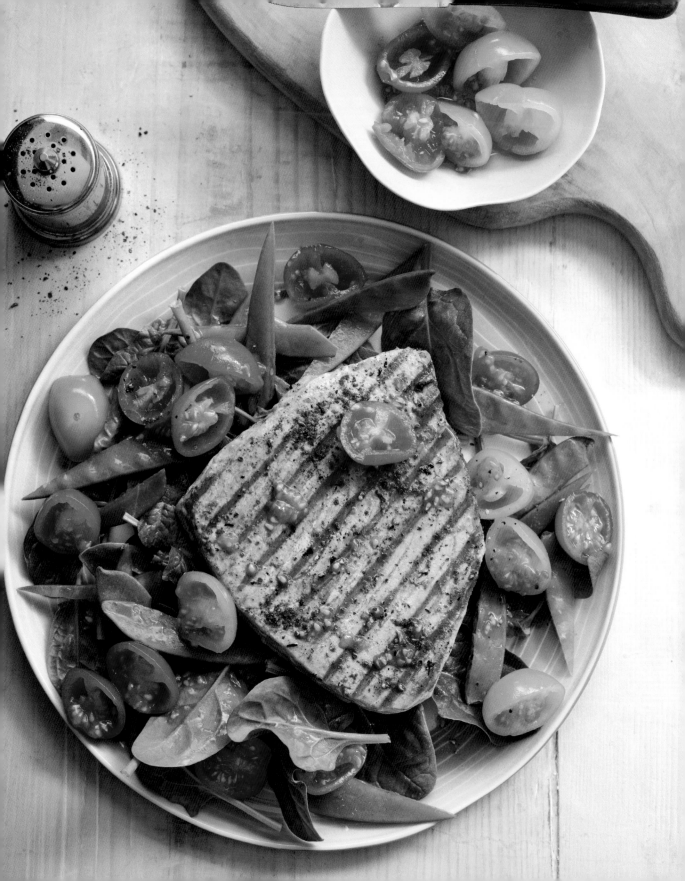

4 large baking potatoes, peeled and cut into chunky chips

3 large unwaxed lemons

4 thick-cut skinless and boneless cod fillets

200g samphire

150g brown shrimps (or see tip)

cod with shrimps and samphire

Think fish and chips but like never before – ideal if you're having friends or family round for dinner!

serves 4

Free

ready in 45 minutes

Preheat the oven to 200°C/fan 180°C/gas 6.

Cook the chips in a saucepan of boiling water over a high heat for about 5 minutes. Drain in a colander, put the colander back over the saucepan off the heat and cover. Leave to steam for 5 minutes then spread out the chips in a single layer in a large roasting tin. Spray with low-calorie cooking spray, season and roast at the top of the oven for 30 minutes or until golden.

Meanwhile, grate the zest of 1 lemon into a bowl and add the juice of 2 lemons. Cut the third lemon into wedges and set aside.

Spray a large non-stick frying pan with low-calorie cooking spray and place over a high heat. Add the fish and cook for 2-3 minutes then spray with more low-calorie cooking spray and turn over. Add the lemon zest and juice, samphire and 200ml boiling water to the pan, cover and cook for 3-4 minutes. Add the shrimps and cook for 1 minute. Drain well.

Serve the fish hot with the samphire, shrimps, chips and lemon wedges, plus a sprinkling of salt.

If you can't get shrimps, use small cooked prawns instead.

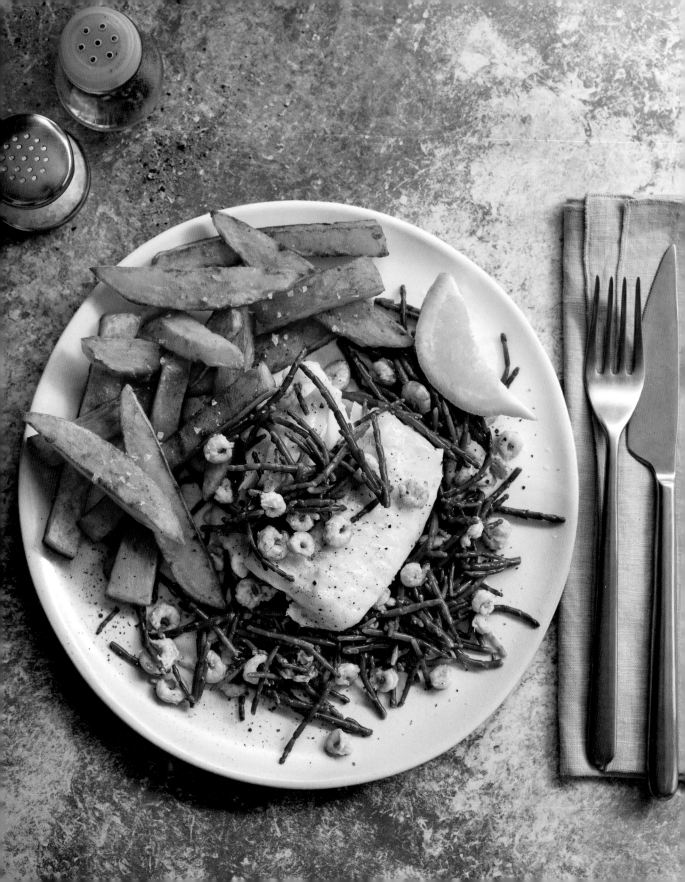

**2 large garlic cloves,
crushed**

**1 tsp smoked paprika,
plus extra to serve**

2 unwaxed lemons

**12 prepared sardines
(about 80g each)**

800g long-stem broccoli

smoky sardines
with garlic broccoli

These silvery gems are a real treat! Get your
fishmonger to do the dirty work of preparing
them and they'll be on the table in no time!

serves 4

Free

ready in 20 minutes,
plus marinating

Put two-thirds of the garlic in a shallow dish
with the paprika. Grate in the zest of 1 lemon,
squeeze in its juice and mix well to combine.

Using a sharp knife, make a few cuts in
both sides of each sardine. Add them to the
marinade and turn to coat well. Cover and
leave for 30 minutes.

Blanch the broccoli in a large saucepan of
boiling water over a high heat for 2 minutes.
Drain well and toss with the remaining
garlic. Heat a large non-stick griddle pan or
frying pan over a high heat and, when it's
smoking hot, add the broccoli and cook for
3 minutes or until nicely charred. Tip it into a
bowl, cover and leave to steam.

Spray the sardines with low-calorie cooking
spray and cook in the same griddle or frying
pan for 2-3 minutes on each side or until
nicely charred.

Put the broccoli and sardines on to plates,
grate over the zest of the remaining lemon
and sprinkle over the extra paprika, then
cut the zested lemon into wedges to serve.

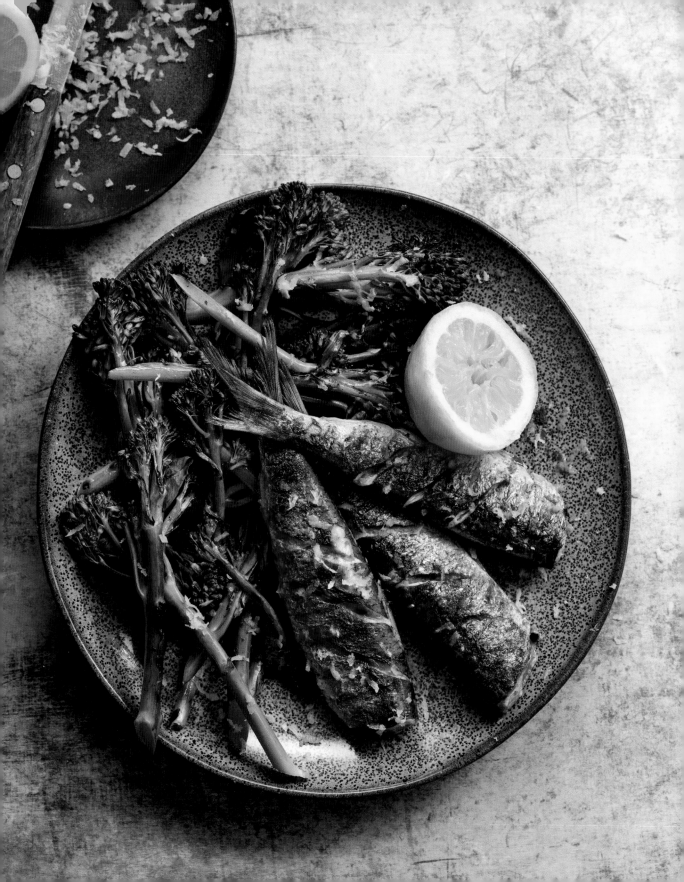

500g dried linguine or spaghetti

2 x 300g bags courgetti (see tip)

12 king scallops, orange corals left on if you like

150g plain quark

zest and juice of 1 unwaxed lemon

courgetti linguine with scallops

Choose plump scallops for this dish, with or without the orange corals. For the best flavour they should be golden on the outside and just heated inside.

serves 4

Free

ready in 15 minutes

Cook the pasta according to the pack instructions, adding the courgetti 2 minutes before the end of the cooking time.

About 5 minutes before the end of the pasta cooking time, preheat a non-stick griddle pan or frying pan over a high heat. Lightly season the scallops, spray with low-calorie cooking spray and add to the pan. Cook for 1½ minutes then turn and cook for a further 1½ minutes or until golden and seared.

Mix the quark with the lemon juice, most of the zest and some black pepper.

Drain the pasta, reserving a little of the cooking liquid, and return the pasta to the pan. Toss through the quark mixture, adding some of the reserved cooking liquid if you want to loosen the sauce a little. Spoon the pasta into shallow bowls and top with the scallops and remaining lemon zest to serve.

You can buy courgetti in most supermarkets. To make your own, use 3 large courgettes and spiralise, grate or peel into ribbons using a peeler.

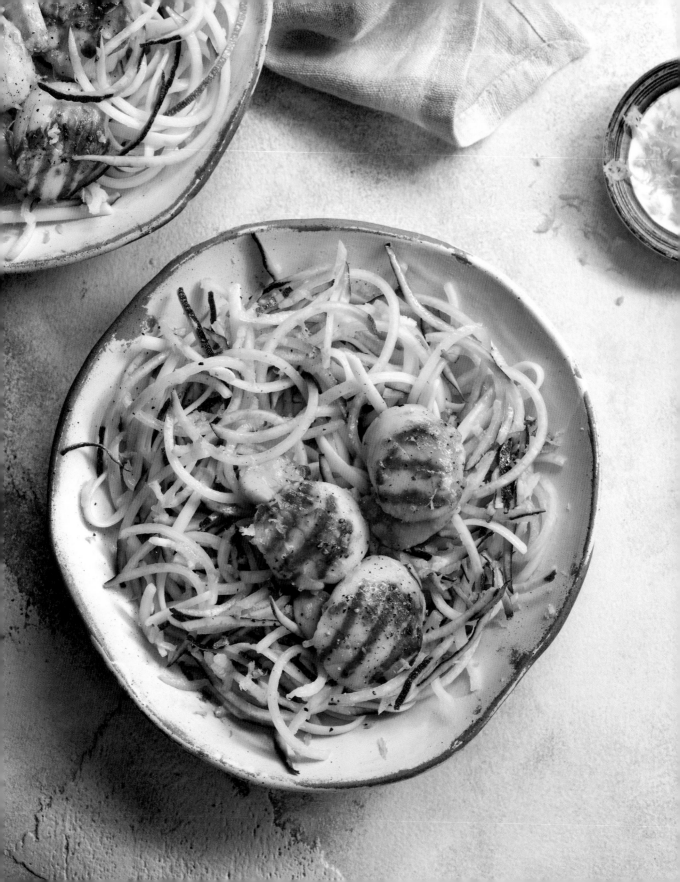

2 large fennel bulbs,
sliced, feathery tops
(fronds) reserved

750g Charlotte or other
waxy potatoes, thickly
sliced lengthways

2 lemons,
cut into wedges

300ml boiling fish stock

750g piece boneless
salmon fillet, skinned

scandinavian roast salmon

This all-in-one fish dish is a great way to feed
a crowd, with fennel's feathery tops adding a
lovely garnish.

serves 4

Free

ready in 1 hour

Preheat the oven to 220°C/fan 200°C/gas 7.

Put the fennel and potatoes in a large
roasting tin, spray with low-calorie cooking
spray and season lightly. Squeeze over
2-3 lemon wedges and tuck all but 4 of
the remaining lemon wedges around the
potatoes and fennel. Roast for 30 minutes
or until the veggies are beginning to soften
and brown.

Pour the stock over the potatoes and fennel
and arrange the salmon skinned-side down
on top. Spray the fish with a little low-calorie
cooking spray and season lightly. Bake for
another 20-25 minutes or until the salmon
is cooked through and the potatoes and
fennel are tender (poke them with a fork or
skewer to check and give them a bit longer
if necessary).

Roughly tear the fennel fronds, scatter them
over the fish and veg and serve hot with the
reserved lemon wedges to squeeze over.

*If you'd rather use individual
salmon fillets, they'll need about
15 minutes in the oven on top of
the potatoes.*

1 cucumber

grated zest and juice of ½ unwaxed lemon

300g cooked and peeled king prawns

200g fat-free natural fromage frais

2 tbsp capers, drained and rinsed

prawn and cucumber salad

Tuck into plump prawns and the zing of capers and lemon for all the pleasure of a prawn cocktail without the high-Syn Marie Rose sauce!

serves 4

Free

ready in 20 minutes

Slice the cucumber into ribbons with a peeler. Put the cucumber ribbons in a bowl and toss with a splash of lemon juice.

Put the prawns in another bowl and toss with half of the lemon zest, another splash of lemon juice and a little seasoning.

Put the fromage frais, two-thirds of the capers, 1 tsp lemon juice (or to taste) and a little salt in a food processor and whizz to make a rich dressing.

Arrange the cucumber and prawns in shallow bowls, drizzle the dressing on top and scatter with the remaining lemon zest and capers plus a good grind of black pepper to serve.

2 onions, thinly sliced

1-2 tbsp mild curry powder (to taste)

2 x 400g cans chopped tomatoes

small pack fresh coriander, roughly chopped

500g skinless and boneless firm white fish fillets, cut into chunks

indian-spiced fish curry

If you want your curry in a hurry, this sizzlingly simple deep-sea delight is for you!

serves 4

Free

ready in 35 minutes

Spray a large, lidded non-stick casserole pan with low-calorie cooking spray and place over a medium heat. Add the onions, cover and cook for 8-10 minutes, stirring occasionally.

Sprinkle the curry powder over the onions and cook for 1-2 minutes, stirring. Stir in the tomatoes, half the coriander and 600ml boiling water, reduce the heat to low and simmer for 10 minutes, uncovered.

Lightly season the fish and tuck the chunks into the tomato sauce. Cover and simmer for 10 minutes or until the fish is cooked through.

Scatter over the remaining coriander and serve hot.

Use raw peeled king prawns instead of the fish if you like – they're done when they turn pink.

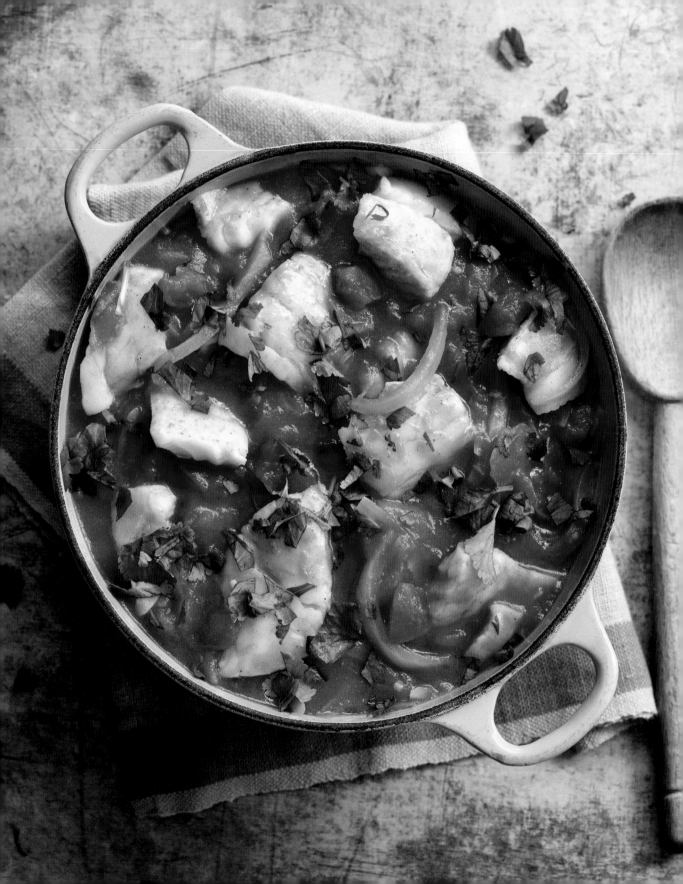

grated zest and juice
of 2 large limes, plus
wedges to serve

2 tsp garlic granules

8 small or 4 large
boneless trout fillets

2 large courgettes,
sliced

6 tomatoes,
thickly sliced

trout with lime and black pepper

Tangy lime and fiery pepper really make fresh trout fillets sing in this fabulous fish dish.

serves 4

Free

ready in 15 minutes

Preheat your grill to medium-high.

Mix together the lime zest and juice, garlic granules, a little salt and 1 tsp coarsely ground black pepper on a plate. Press the trout fillets lightly into the mixture to coat on both sides. Arrange the trout fillets skin-side down on your grill pan and grill for 6-8 minutes (there's no need to turn them).

Meanwhile, spray 2 large non-stick griddle pans or frying pans with low-calorie cooking spray and place over a high heat. Put the courgettes into 1 and the tomatoes into the other, fry for 2 minutes then turn and cook for another 2 minutes or until charred to your liking.

Discard the trout skin if you like and put the trout and veg on to plates. Serve hot with lime wedges.

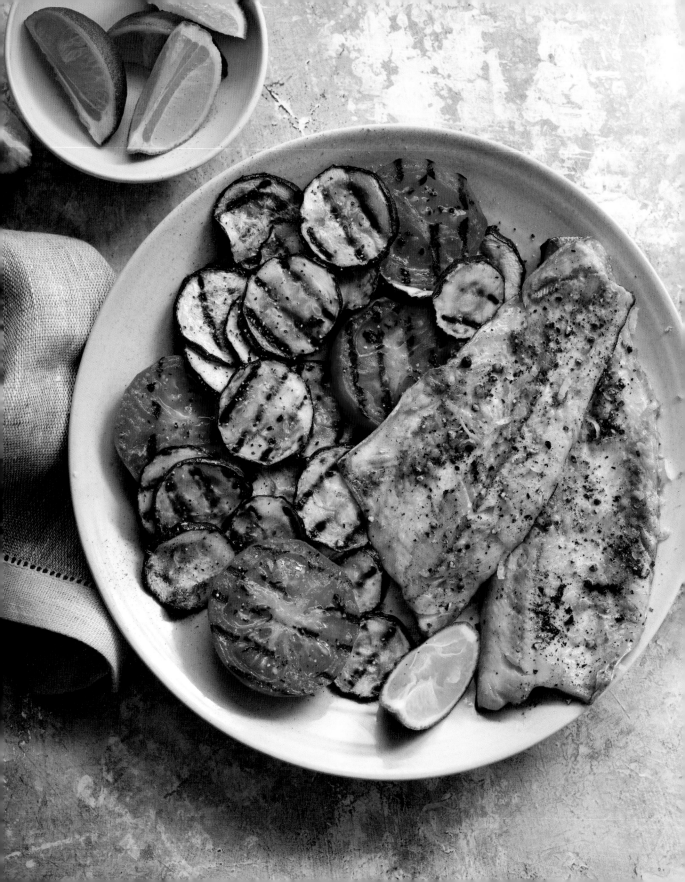

2 fennel bulbs, roughly chopped, feathery tops (fronds) reserved

300g dried risotto rice

1.2 litres boiling fish stock

450g seafood selection (see tip, page 86), thawed if frozen

2 ripe tomatoes, deseeded and roughly chopped

seafood and fennel risotto

We've packed the fruits of the ocean into the classic Italian rice dish.

serves 4

Free

ready in 40 minutes

Spray a deep, lidded non-stick frying pan with low-calorie cooking spray and place over a low-medium heat. Add the fennel, cover and cook for 8-10 minutes, stirring occasionally.

Add the rice to the pan and stir well, then pour in the stock and bring to the boil over a high heat. Reduce the heat to medium-low and simmer uncovered for 15-18 minutes or until the rice is almost tender, stirring frequently. Add a little more stock or water if necessary.

Stir in the seafood and tomatoes and cook for 3-4 minutes or until the risotto is creamy and piping hot. Season to taste.

Roughly chop the feathery tops (fronds), scatter them over the risotto and serve hot.

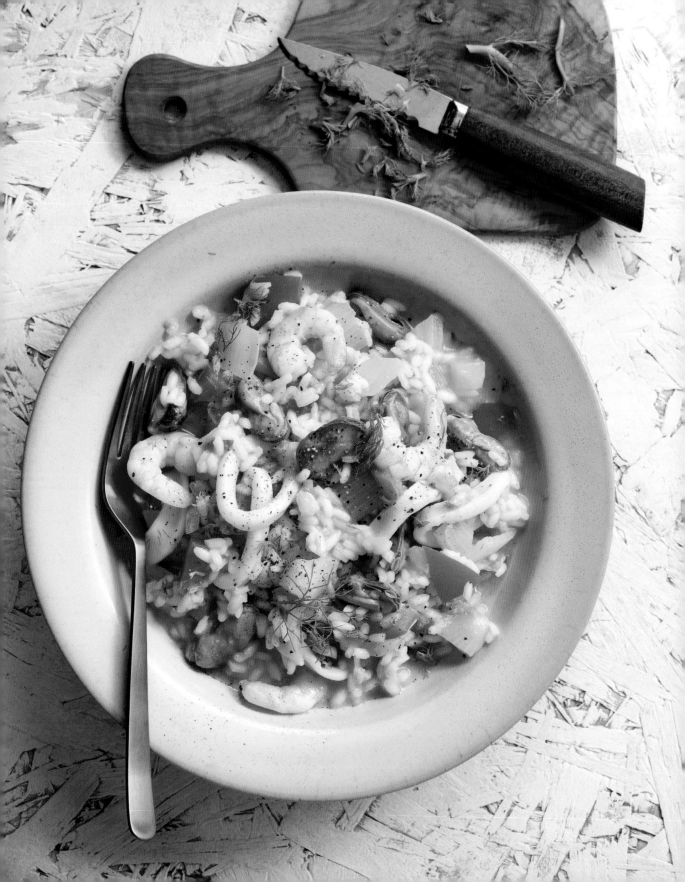

Vegetables

Dig into our selection of vegetarian and vegan meals such as spring greens mac 'n' cheese and smoky yakitori aubergine skewers.

250g baby leaf spinach

160g extra-light soft cheese

2 large courgettes

400g can chopped tomatoes with onion and garlic

2 level tbsp freshly grated Parmesan cheese (or vegetarian alternative)

spinach and tomato rotolo

Italians traditionally make rotolo using fresh pasta dough but our clever Food Optimising version uses courgette ribbons instead.

serves 4

2½ Syns per serving

❄ Ⓥ (if the cheese is vegetarian)

ready in 50 minutes

Cook the spinach in a saucepan of boiling water over a high heat for 1 minute. Drain well and cool slightly. Wrap the spinach in a clean cloth or a few pieces of kitchen paper and squeeze out as much water as possible, then put it in a food processor with the soft cheese and process until smooth. Season to taste.

Preheat the oven to 200°C/fan 180°C/gas 6.

Peel 1 courgette lengthways into long thin ribbons using a vegetable peeler. Arrange the best 24 ribbons in a single layer on a clean work surface, butting up side by side. Pat dry with kitchen paper and season lightly. Spread the spinach mixture over the courgette strips to cover and roll each strip into a spiral (a bit like little Swiss rolls).

Spray a large non-stick frying pan with low-calorie cooking spray and place over a high heat. Roughly chop what's left of your courgettes and fry for 2-3 minutes or until softened. Remove from the heat, stir in the chopped tomatoes and season lightly.

Spoon the tomatoes into an ovenproof dish and spread it out to cover the base. Arrange the courgette spirals on their sides in the tomato sauce, sprinkle with the Parmesan and bake for 20 minutes or until bubbling. Serve hot.

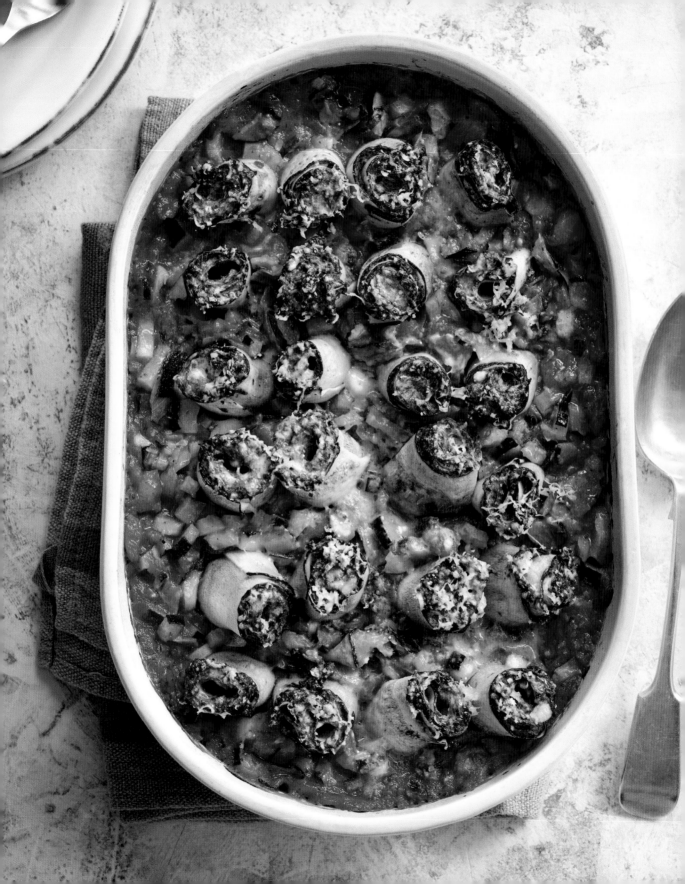

225g dried rice noodles

100ml reduced-fat coconut milk (see tip)

3 tbsp light soy sauce

2 level tbsp reduced-fat crunchy peanut butter

450g mixed stir-fry vegetables

satay noodles

Peanut butter and coconut is a match made in heaven… and we've added filling noodles and veg to make a perfect Food Optimising fakeaway.

serves 4

3 Syns per serving

Ⓥ vegan

ready in 10 minutes

Cook the noodles according to the pack instructions then drain and set aside.

Meanwhile, put the coconut milk, soy sauce and peanut butter in a small saucepan over a medium heat and simmer for 3-4 minutes to heat through. Stir well and season with freshly ground black pepper.

At the same time, spray a large non-stick wok or frying pan with low-calorie cooking spray and place over a medium heat. Add the vegetables and stir-fry for about 5 minutes. Add the noodles and peanut sauce and continue stir-frying for 1-2 minutes or until everything is piping hot.

Check the seasoning and serve.

Shake your can of coconut milk before opening in case the cream and milk have separated. Any coconut milk left over can be frozen and used at a later date.

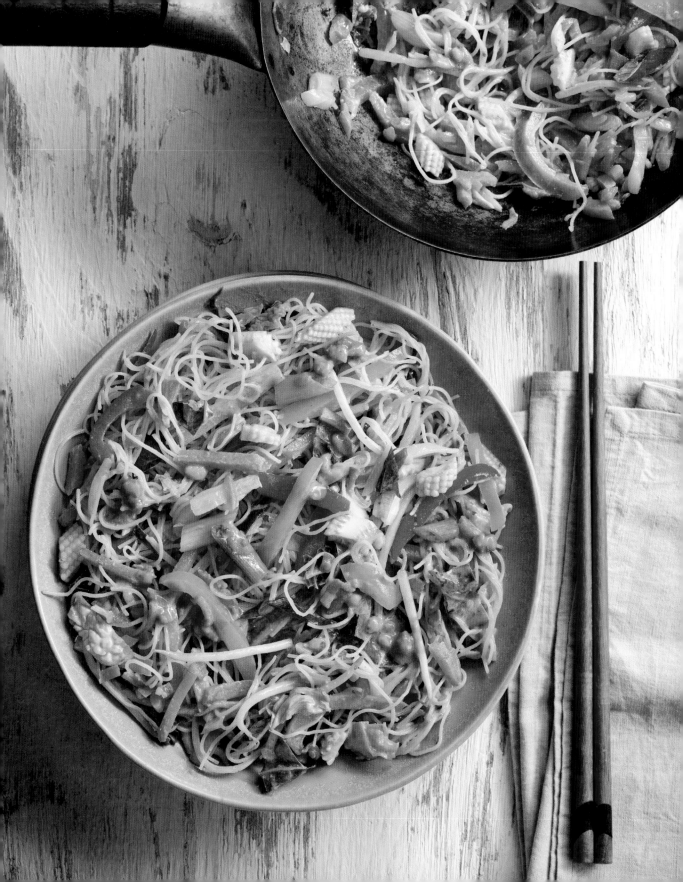

250g fine asparagus, trimmed

4 medium eggs

200g plain quark

100g reduced-fat feta cheese, crumbled

1½ level tbsp Dijon mustard

asparagus and feta crustless mini quiches

These mouth-watering quiches are so versatile – serve a few for a light meal, include them in a lunchbox or enjoy as a low-Syn snack.

makes 10

1 Syn per quiche

🅥 (if the cheese is vegetarian)

ready in 50 minutes

Preheat your oven to 200°C/fan 180°C/gas 6.

Cut off and reserve the asparagus tips, and thickly slice the remaining stalks. Add the sliced stalks to a small saucepan of boiling water over a high heat and cook for 4 minutes or until just tender. Drain in a colander and refresh under the cold tap.

Whisk the eggs, quark, mustard and a little seasoning in a large bowl, then stir in the feta and the cooked asparagus stalks.

Spray 10 holes in a non-stick muffin tin with low-calorie cooking spray and spoon the mixture into the holes (or see tip). Lightly spray the reserved asparagus tips with low-calorie cooking spray, season lightly and scatter the tips over the quiches. Bake for 30-35 minutes or until set and patched with gold.

Leave the quiches to cool (they will sink a little bit) before easing them out of the tin to serve.

You can also make these quiches in silicone muffin cases.

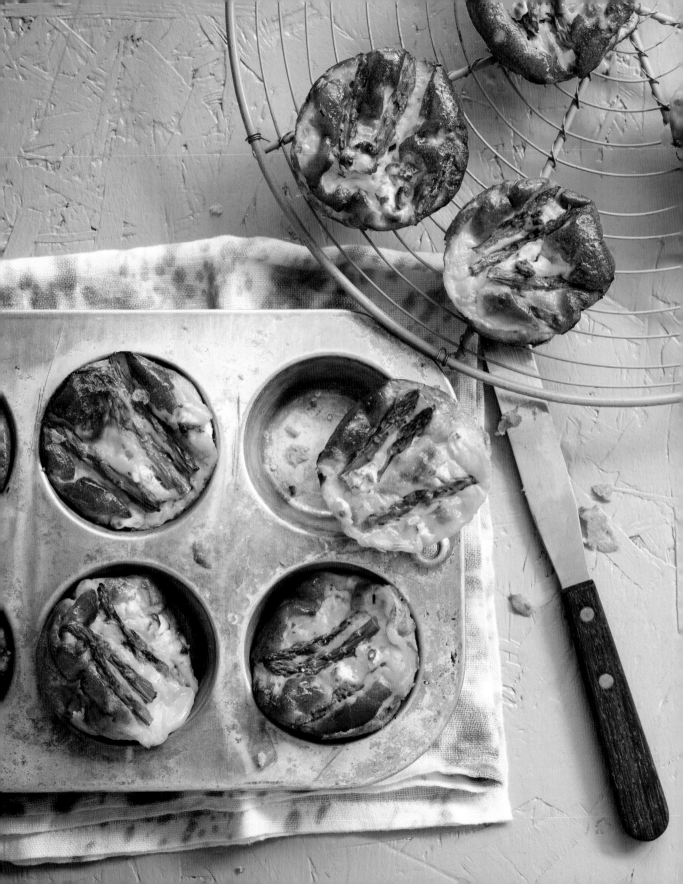

200g dried pearl barley

1 medium butternut
squash, peeled, halved,
deseeded and sliced

1 tbsp Schwartz
Fajita Seasoning

400g can chopped
tomatoes with
onion and garlic

1 tbsp fresh thyme
leaves, plus extra
to serve

squash and pearl barley

Filling pearl barley, sizzling spices and satisfying squash make this a real meat-free masterpiece.

serves 4

Free

❄ Ⓥ **vegan**

ready in 2 hours

Cook the pearl barley according to the pack instructions and drain well.

Meanwhile, put the squash in a saucepan of boiling water over a high heat and cook for 10 minutes. Drain well.

Preheat your oven to 190°C/fan 170°C/gas 5.

In a 2.2-litre ovenproof dish, mix together the pearl barley, 2 tsp fajita seasoning, the chopped tomatoes and the thyme. Season lightly and stir well.

Add the squash in a layer to cover the pearl barley. Spray with low-calorie cooking spray and sprinkle with the remaining fajita seasoning. Cover with foil and bake for 20-25 minutes.

Remove the foil and bake for a further 30 minutes or until all the liquid has been absorbed and the squash is tender. Scatter with the extra thyme leaves to serve.

Experiment with other Free spice blends such as Cajun, piri-piri and ras-el-hanout if you fancy giving the flavour a twist.

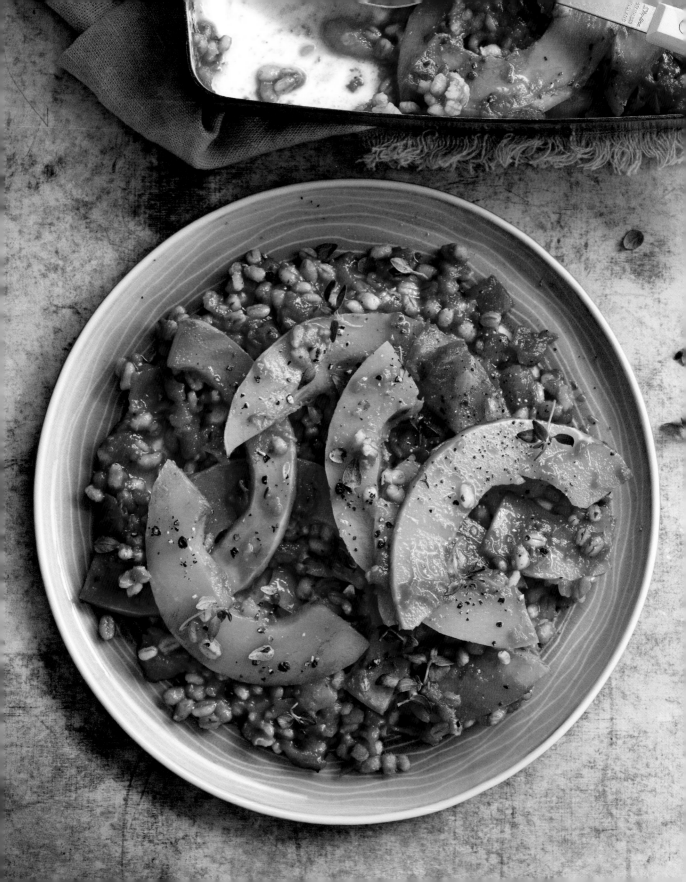

2 tsp Cajun seasoning

2 eggs, lightly beaten

75g corn flakes, crushed

**350g pack Quorn
Chicken-style Pieces**

2-3 Little Gem lettuces

popquorn

These tasty Quorn bites are perfect for a light meal, with a spicy kick and a crispy coating that'll have you coming back for more… and more!

serves 4

3½ Syns per serving

ready in 30 minutes

Preheat your oven to 200°C/fan 180°C/gas 6.

Put the Cajun seasoning in a shallow bowl, the beaten eggs in a second shallow bowl and the crushed corn flakes in a third.

Pat the Quorn pieces dry with kitchen paper and toss in the Cajun seasoning. Dip the seasoned Quorn in the egg and then the corn flakes to coat well. Arrange the Quorn on a baking tray sprayed with low-calorie cooking spray and bake for 20-25 minutes or until crisp.

Separate the Little Gem leaves, arrange the largest leaves on plates and top with the popquorn to serve.

300g dried macaroni

300g spring greens, sliced

160g extra-light soft cheese with garlic and herbs

350g fat-free natural fromage frais

2 level tbsp freshly grated Parmesan cheese (or vegetarian alternative)

spring greens mac 'n' cheese

When you need a comfort food fix, this oh-so-easy version of the classic dish ticks all the boxes!

serves 4

3 Syns per serving

ⓥ (if the cheese is vegetarian)

ready in 15 minutes

Cook the macaroni according to the pack instructions, adding the spring greens 3 minutes before the end of the cooking time.

Meanwhile, preheat the grill to high.

Beat together the soft cheese and fromage frais and season lightly.

Drain the pasta and greens well and tip into a 2-litre ovenproof dish. Stir in the soft cheese mixture to coat the pasta well, sprinkle over the Parmesan and grill until golden. Serve hot.

Swap the spring greens for other Speed veg like kale or leeks.

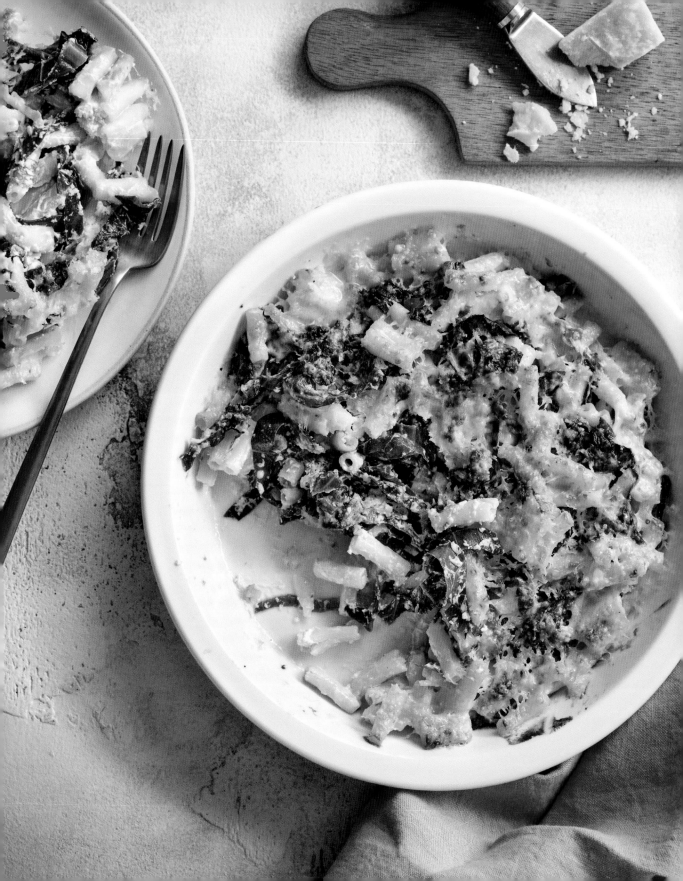

750g mixed casserole veg or casserole veg pack

500g passata

2 tbsp soy sauce

400g can green lentils, drained and rinsed

100g kale, roughly chopped

lentil and kale ragù

This comforting meal in a bowl is perfect for vegetarians, vegans and everyone else!

serves 4

Free

Ⓥ vegan 𝒮𝒫 (if the veg are all Speed)

ready in 40 minutes

If you're using a pack of whole casserole vegetables (see tip), peel and dice them.

Spray a large, deep saucepan with low-calorie cooking spray and place over a medium heat. Add the casserole veg to the pan, cover and cook for 8-10 minutes, stirring occasionally and spraying with a little more low-calorie cooking spray if necessary.

Add the passata and soy sauce and season with freshly ground black pepper. Pour 200ml water into the passata container, shake well and add to the pan. Bring to the boil over a high heat then cover the pan, reduce the heat to low and simmer for 20 minutes.

Stir in the lentils and kale and simmer for 5 minutes to heat through. Season to taste and serve hot.

Most supermarkets sell casserole veg packs, which usually contain 1 small swede, 1 onion, 1 parsnip and 2-3 carrots. Leave out any parsnips to keep your meal 𝒮𝒫.

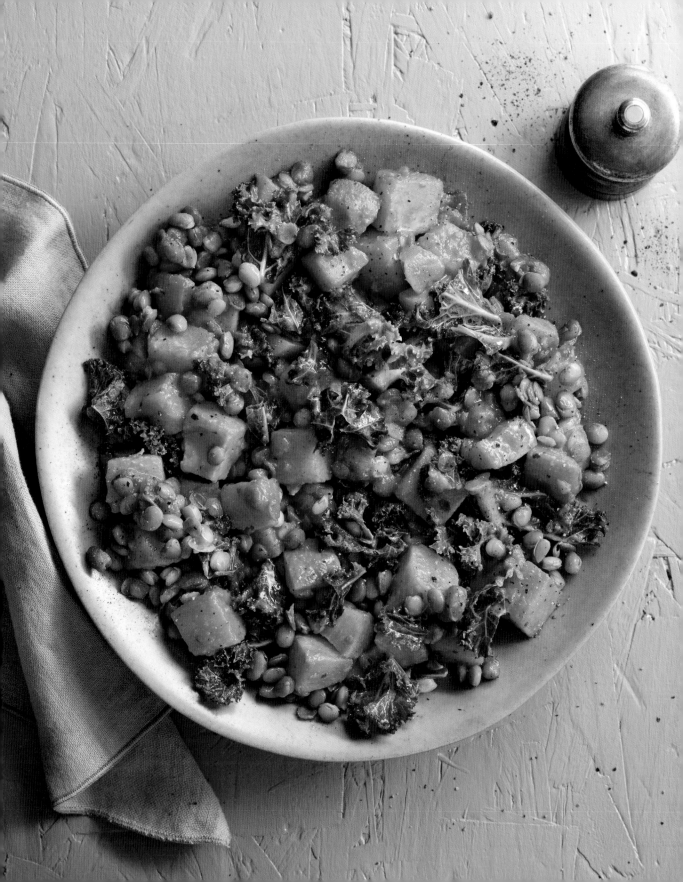

1 cucumber

3 tbsp rice vinegar, seasoned

2 level tbsp teriyaki sauce (see tip)

2 medium aubergines, thinly sliced lengthways

16 spring onions, each cut into 3 pieces

smoky yakitori aubergine skewers

We've served these stylish skewers with delicious pickled cucumber. Keep basting the aubergine while it cooks for the best flavour.

serves 4 (makes 8)

½ **Syn** per serving

Ⓥ **vegan** (if the vinegar and teriyaki are vegetarian/vegan) *SP*

ready in 25 minutes

Using a vegetable peeler, peel the cucumber into ribbons and place in a large bowl. Pour over 2 tbsp vinegar and mix well then cover and chill. Mix the remaining vinegar with the teriyaki sauce and set aside.

Steam the aubergine slices for 5 minutes to soften them (if you don't have a steamer, use a covered colander over a saucepan of simmering water). Cool slightly.

Fold the aubergine slices and thread on to 8 skewers (if using wooden skewers, soak them in water for 20 minutes first) along with the spring onions. Brush with a little of the teriyaki mixture, season with black pepper and spray with low-calorie cooking spray.

Place a large non-stick griddle pan or frying pan over a high heat. When it's smoking hot, cook the skewers for 8-10 minutes, turning frequently and basting with the remaining marinade from time to time until charred, soft and smoky. Serve hot with the pickled cucumber.

Swap teriyaki sauce for soy sauce to make these sizzling skewers Free.

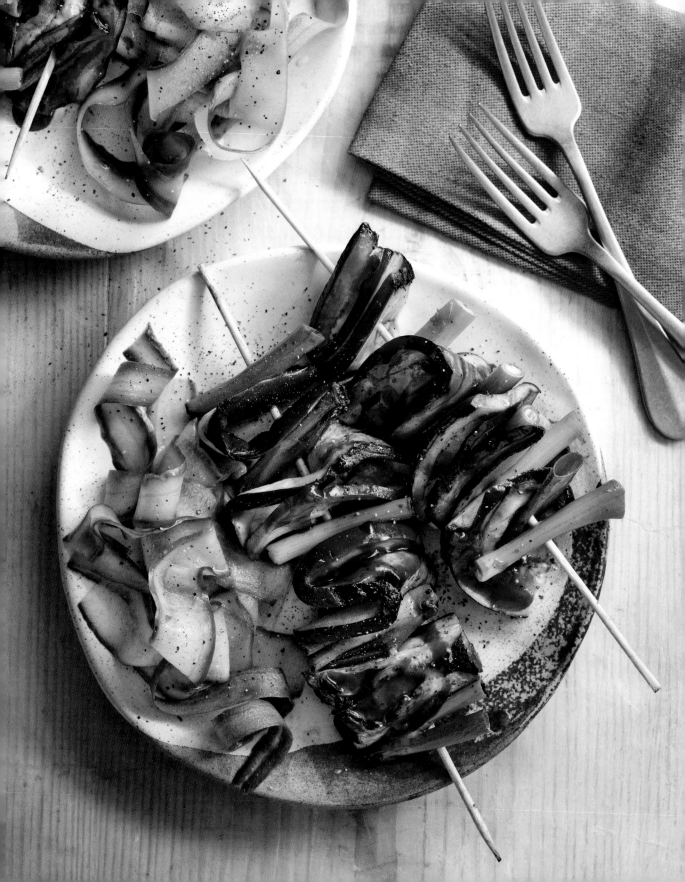

4 large sweet potatoes

8 spring onions

400g can baked beans in tomato sauce

200g red and yellow cherry tomatoes, halved

50g reduced-fat feta cheese, crumbled

loaded sweet potato jackets

Colourful, filling and very tasty… and as an added bonus there's hardly any washing-up!

serves 4

1 Syn per serving

Ⓥ (if the cheese is vegetarian)

ready in 50 minutes

Preheat the oven to 200°C/fan 180°C/gas 6.

Scrub the sweet potatoes, prick them with a fork and arrange them on a non-stick baking tray. Bake for 45 minutes or until tender.

Meanwhile, shred the green parts of the spring onions and put them in a bowl of cold water. Cover and set aside until ready to use. Thinly slice the white parts of the spring onions and put them in a small saucepan with the baked beans and cherry tomatoes. Set aside.

About 5 minutes before the sweet potatoes are ready, heat the beans and tomatoes until the tomatoes have softened.

Halve the sweet potatoes, divide between plates and spoon over the bean mixture. Scatter over the shredded spring onions and the feta, season to taste and serve hot.

Swap the feta for low-fat natural cottage cheese to make these delicious jackets completely Free.

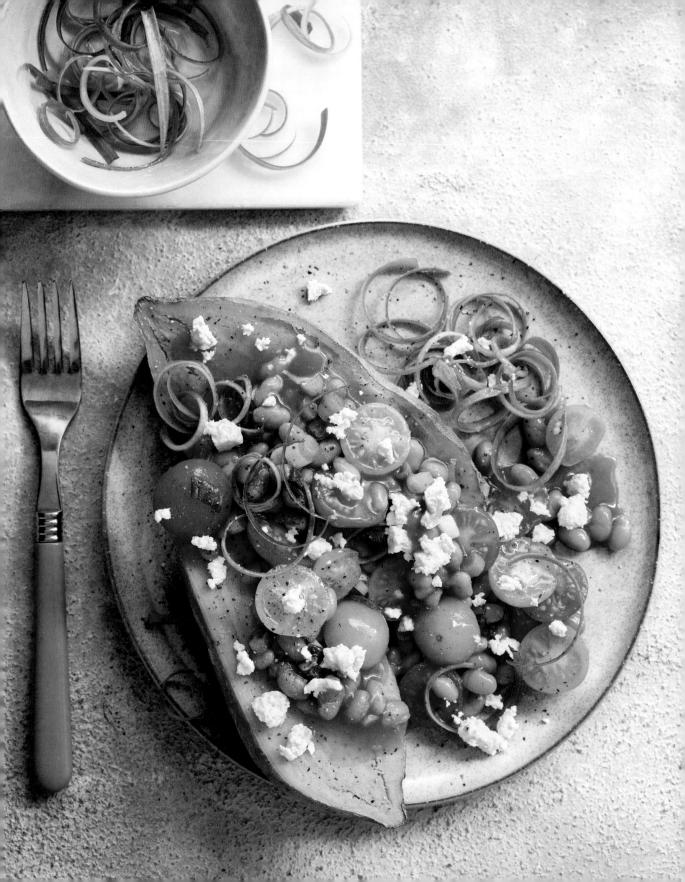

1 large cauliflower

2 red onions, cut into thin wedges

1 garlic bulb, halved through the cloves

grated zest and juice of 1 unwaxed lemon, plus wedges to serve

1½ level tbsp za'atar spice

za'atar-roasted cauliflower

Za'atar is a Middle Eastern blend of sesame seeds, herbs and spices – and it adds a wonderfully exotic flavour to the veg in this simple recipe.

serves 4

1 Syn per serving

Ⓥ vegan 𝒮𝒫

ready in 40 minutes

Preheat the oven to 200°C/fan 180°C/gas 6.

Break the cauliflower into florets (you'll need about 900g), then drop the florets into a large saucepan of boiling water over a high heat and cook for 2-3 minutes. Drain well and spread out in a single layer in a large roasting tin lined with non-stick baking paper.

Add the onion wedges and garlic bulb to the tin and sprinkle over the lemon zest and juice plus the za'atar. Spray with low-calorie cooking spray, toss well and roast for 25-30 minutes or until the cauliflower is tender and beginning to turn golden brown.

Squeeze the garlic flesh from the bulbs, mash in a bowl and toss through the cauliflower (or just use the garlic bulb halves as a garnish if you prefer). Serve hot with lemon wedges to squeeze over.

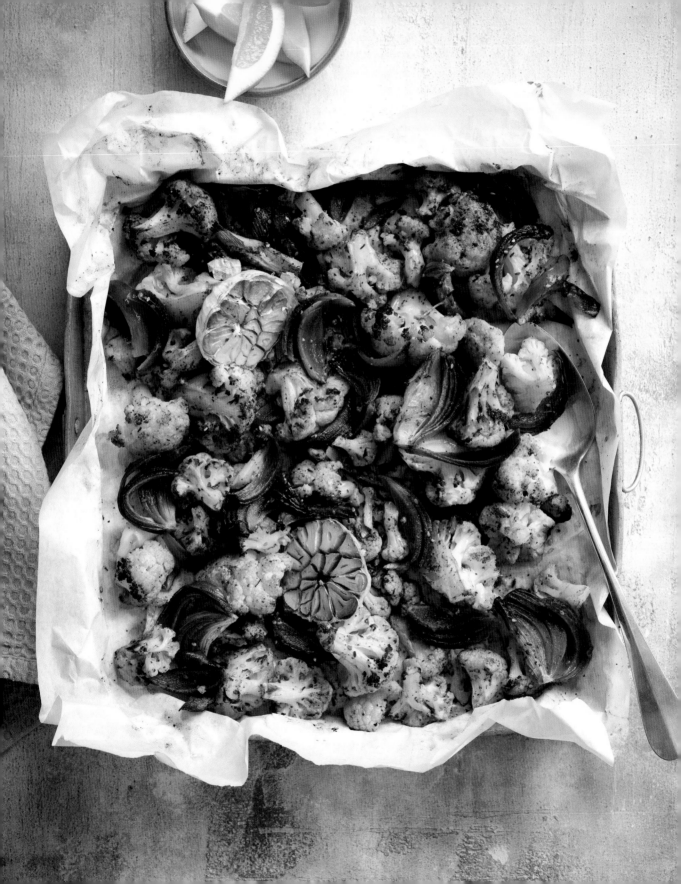

1 large courgette

50g plain flour

50ml semi-skimmed milk

6 medium eggs*

200g baby leaf spinach

courgette fritters with eggs florentine

This veggie treat makes a terrific all-day breakfast or brunch. For a bit of extra spice, drizzle with hot chilli sauce (adds ½ Syn per level tbsp).

serves 4

2½ Syns per serving

ready in 25 minutes

Pregnant women, the elderly, babies and toddlers are advised to choose eggs showing the British Lion stamp if eating raw or partially cooked eggs.

Coarsely grate the courgette, wrap in a clean cloth or several pieces of kitchen paper and squeeze out as much liquid as possible. Tip the courgette into a bowl and add the flour, milk and 2 eggs. Beat until well combined and season lightly.

Spray a wide, non-stick frying pan with low-calorie cooking spray and place over a medium-low heat. Drop a couple of spoonfuls of the fritter mixture into the pan and flatten out with the back of a spoon to make neat circles about 10cm across. Add 2 more spoonfuls to give 4 fritters in total then cook for 2-3 minutes on each side or until golden. Set aside and keep warm.

Meanwhile, put the spinach in a large heatproof bowl and pour over enough boiling water to cover. Set aside.

Wipe the frying pan, spray with low-calorie cooking spray and place over a medium heat. Break the eggs into the pan and fry for 2-3 minutes or until done to your liking.

Drain the spinach and pat dry with kitchen paper. Arrange the fritters on plates, spoon over the spinach and top with the fried eggs. Grind over some black pepper to serve.

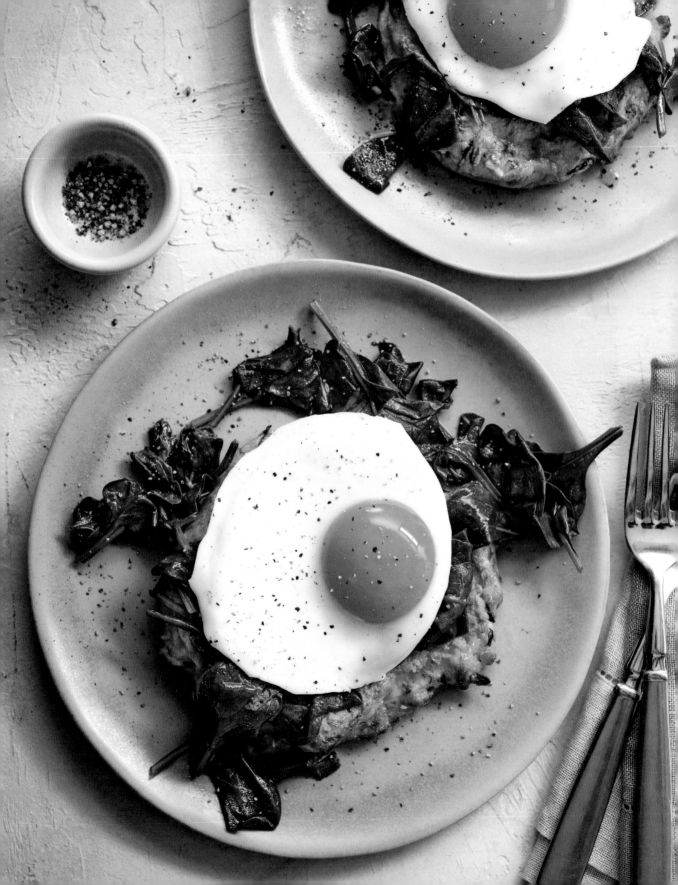

5 large sweet potatoes,
peeled

4 large parsnips, peeled

2 level tbsp plain flour

small pack fresh mint,
finely chopped

400g beetroot, peeled
and coarsely grated

beetroot burgers
with root fries

These vibrant burgers have a sensational flavour and are a doddle to make, while the fries are a lovely way to enjoy root vegetables.

serves 4

1 Syn per serving

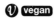 vegan

ready in 45 minutes

Preheat your oven to 200°C/fan 180°C/gas 6.

Finely chop 1 sweet potato and cook in a saucepan of boiling water over a high heat for 8 minutes or until tender.

Meanwhile, cut the remaining sweet potatoes and the parsnips into fries and spread out in a single layer on a large baking tray (you might need 2 trays). Spray with low-calorie cooking spray, season lightly and cook on the top shelf of the oven for 30 minutes.

Drain the chopped sweet potato and return to the pan for 30-40 seconds to drive off any excess moisture. Remove from the heat and mash then tip into a bowl and stir in the flour and mint.

Squeeze out any excess liquid from the grated beetroot using a clean cloth or lots of kitchen paper, add to the sweet potato mixture and mix well. Season, shape into 4 chunky burgers and arrange on a baking tray sprayed with low-calorie cooking spray. Put the burger tray in the middle of the oven and cook for 20 minutes. Serve hot with the fries.

500g asparagus spears, trimmed

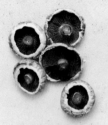

500g dried tagliatelle pasta (see tip)

400g mushrooms, sliced if large

2 large garlic cloves, chopped

2 roasted red peppers in brine from a jar, drained and sliced

asparagus and mushroom pasta

This pretty pasta dish makes full use of asparagus, with the thick ends used to make a delicious sauce.

serves 4

Free

V **vegan**

ready in 25 minutes

Cut off the asparagus tips and set aside. Roughly chop the stalks and cook in a saucepan of boiling water over a high heat for 6 minutes or until tender. Remove with a slotted spoon and put in a food processor with 150ml of the cooking liquid. Purée, season to taste and keep warm.

Top up the pan with boiling water and cook the pasta according to the pack instructions, adding the asparagus tips 3 minutes before the end of the cooking time.

Meanwhile, spray a large non-stick frying pan with low-calorie cooking spray and place over a high heat. Add the mushrooms and fry for 3 minutes then reduce the heat to low, add the garlic and fry for a further 1 minute.

Drain the pasta and asparagus tips and return to the pan. Stir in the peppers, mushrooms and asparagus sauce and serve in shallow bowls.

Spaghetti or linguine will also be great in this recipe if you can't get tagliatelle.

Slimming World's take 5 | **vegetables**

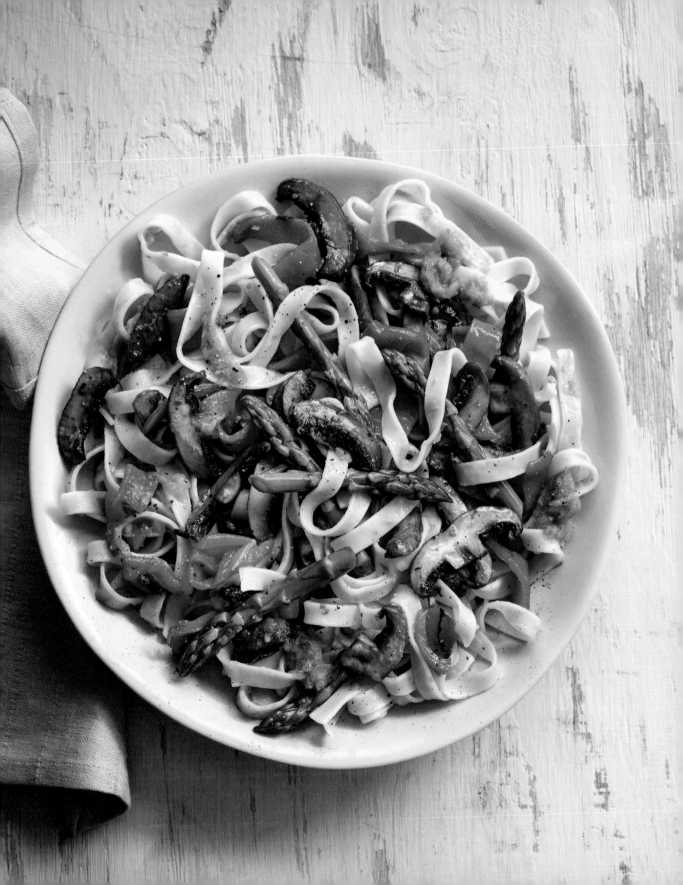

1 small butternut squash, peeled, halved, deseeded and sliced

½-1 tsp dried chilli flakes

400g long-stem broccoli

6 medium eggs

250ml skimmed milk

squash and broccoli bake

This super-simple veggie bake makes a delicious midweek meal and it's just as good eaten cold in a packed lunch.

serves 4

1 Syn per serving

Ⓥ 🅢🅟

ready in 1 hour

Preheat your oven to 200°C/fan 180°C/gas 6.

Put the squash slices in a medium-sized roasting tin (about 30cm x 23cm), spray with a little low-calorie cooking spray and sprinkle with half of the chilli flakes. Season lightly, toss well and roast for 30 minutes or until tender.

When the squash is nearly done, blanch the broccoli in a saucepan of boiling water over a high heat for 2 minutes then drain well, shaking off as much excess water as possible. Add the broccoli to the cooked squash in the roasting tin and toss well.

Whisk together the eggs and milk, season lightly and pour into the roasting tin, tilting the tin so that the egg mixture gets into all the nooks and crannies. Sprinkle over the rest of the chilli flakes and bake for 20 minutes or until set and golden. Serve hot.

Most supermarkets stock prepared butternut squash, which costs a bit more but saves you the time and effort of doing it yourself.

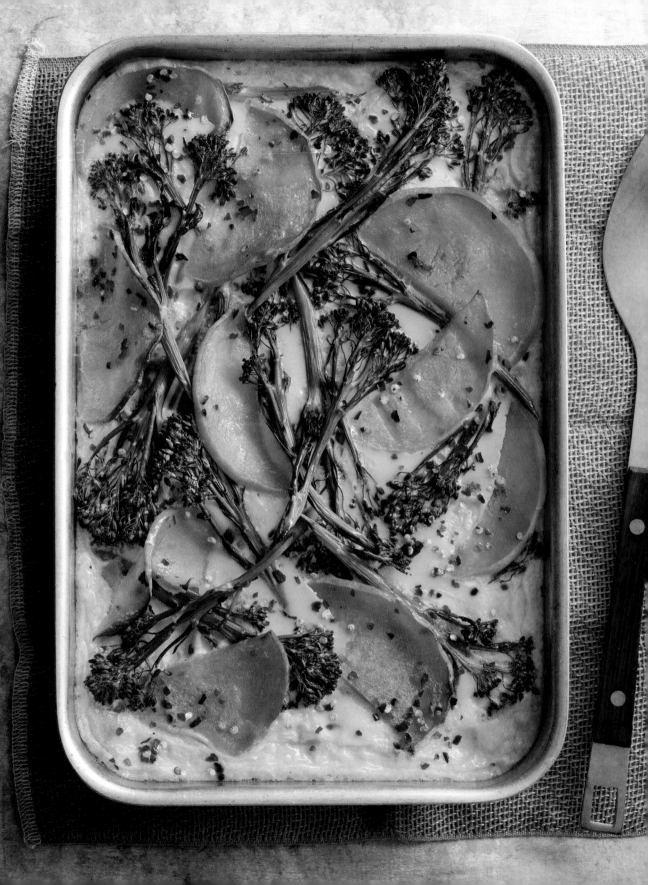

cook's tips

Our handy hints will ensure successful Food Optimising whatever you're cooking, keeping your weight loss perfectly on track.

eggs

Pregnant women, the elderly, babies and toddlers are advised to choose eggs showing the British Lion stamp if eating raw or partially cooked eggs. We'll make a note in any recipes where raw or partially cooked eggs are used.

fat-free natural fromage frais, yogurt and plain quark

These are wonderful ingredients when you're Food Optimising as they give the creamy texture and taste normally achieved with cream. They make great savoury or sweet ingredients. However, they tend to separate when boiled and can make a dish look unappetising. So unless the recipe says otherwise, add fromage frais, yogurt or quark off the heat once all the other ingredients have been cooked and simply heat through.

fresh, canned and frozen

Frozen ingredients and canned veg and beans are great alternatives to fresh foods and are so handy to keep in the cupboard or freezer. They'll keep for much longer, can be quicker to cook and are just as good for you. So feel free to switch between all three – bear in mind cooking times may change slightly.

fruit

While most fresh whole fruit is Free, juiced, canned, puréed or cooked fruit counts as Syns because it isn't as filling and becomes much easier to over-consume. In any recipes where fruit is puréed or cooked, we count it as Syns.

low-calorie cooking spray

Where you do need to use fat then choose a low-calorie cooking spray which contains 1 calorie or less per spray, as these are Free – others would need to be counted as Syns. Ideal for fried eggs, roast potatoes and chips!

meat and poultry

Trim off any visible fat before cooking to make lean meat or poultry Free, and remember to remove the skin before or after cooking poultry. If you cook poultry with the skin on, we'd advise cooking it separately from the other ingredients so that the fat can't run into them (eg. don't roast potatoes in the same tin).

meat and poultry – mince

Lean minced meat (5% fat or less) is a Free Food. Beef, pork and turkey mince are available in most major supermarkets at 5% fat or less – check the nutrition information to be sure. If possible, drain off any fat that comes from the mince while you're cooking it. No chicken and lamb mince is widely available with 5% fat or less so these would have a Syn value… unless you fancy mincing it yourself or you know a friendly butcher.

mustard powder

Made-up mustard in jars has Syns because it contains Synned ingredients while mustard powder is Free, making it a great choice for dressings and sauces.

non-stick pans

To cut down on fat in recipes, we recommend using non-stick cookware/bakeware wherever possible.

seasoning

Where salt and pepper are used, we usually suggest seasoning to taste (you might not need any at all). Official advice is that adults should eat no more than 6g of salt a day – and bear in mind that small amounts can quickly add up. Go for reduced-salt products to reduce your salt intake.

stock

Fresh stock, stock cubes, stock pots, bouillon powder, ready-to-use liquid stock and liquid stock concentrate are all Free but be aware that gravy granules or powder and stock granules are not. Stock should normally be boiling when you add it to the pan, as cold stock will slow down cooking times.

syn measurements

Syns for some ingredients are based on level teaspoons or tablespoons. Without measuring carefully, it's easy to far exceed your intended Syn intake without realising – so scrape a knife along the top of the spoon, knocking the excess back into the container. For best results, invest in a set of measuring spoons.

symbol sense

serves…

This gives you an idea of how many people the recipe can serve. However, feel free to split the recipe between more or fewer people instead, depending on how hungry you are – especially when it's Free!

freezer-friendly ❄

Recipes showing this symbol can be safely frozen for up to 1 month. Keep in mind official advice on freezing safely:

- Label food for the freezer with details of what the meal is and when you cooked it.

- Make sure food has cooled before you put it in the freezer.

- Defrost frozen meals completely and reheat thoroughly before eating.

Batch cooking: Wherever you see the freezer-friendly symbol ❄, you can save time and effort by cooking double or triple amounts and freezing the rest to enjoy at a later date. You'll usually save money too because it's often cheaper to buy ingredients in bulk.

suitable for vegetarians Ⓥ / vegans vegan

Recipes with these symbols are suitable for vegetarians and vegans but we'd always recommend checking the packaging to be sure. For example, some cheeses come in vegetarian and non-vegetarian forms. And while most bread and dried pasta is suitable for vegans, it's always a good idea to check.

Extra Easy SP

For super-charged weight loss, go for dishes marked Extra Easy SP. See your Food Optimising book or ask your Consultant for more details.

ready in…

This gives a guide to how long the recipe will take to prepare and cook.

index

did you know?

10p from the sale of this book goes to our
charitable foundation SMILES (Slimmers
Making It a Little Easier for Someone),
founded in 1997. Our charity partners have
included the NSPCC, Cancer Research UK
and Great Ormond Street Hospital Children's
Charity, and each year we donate around
£100,000 from recipe book sales.

First published in 2018 by Slimming World
(this edition published 2019),
Clover Nook Road, Somercotes,
Alfreton, Derbyshire DE55 4SW, UK
www.slimmingworld.co.uk

Created and designed by
Slimming World's publications team

Publications manager: Allison Brentnall
Editor: Oliver Maxey
Designers: Kathryn Briggs and Emma Hammett
Illustrations: Antonia Caranza and Tricia Fowell

Recipes: Lorna Brash (except pages 74, 102 and 116)
Food styling: Sunil Vijayakar
Recipe photographs: Gareth Morgans
Ingredient photographs: Rosie Alsop
Styling: Morag Farquhar
Food assistant: Jennie Vincent
Proof-reader: Lucy Davey